The Painter's Pocket-book
of Methods and Materials

By the same author

*

NOTES ON THE TECHNIQUE
OF PAINTING

THE
PAINTER'S POCKET-BOOK
OF
METHODS AND MATERIALS

by

HILAIRE HILER

EDITED BY JAN GORDON
AND REVISED BY COLIN HAYES

LONDON
FABER AND FABER LIMITED

FIRST PUBLISHED IN SEPTEMBER 1937
BY FABER AND FABER LIMITED
24 RUSSELL SQUARE LONDON W.C.1
REPRINTED 1942, 1944, 1945, 1947,
1948, 1950, 1956
SECOND EDITION 1962
REPRINTED 1964
THIRD EDITION 1970
ALL RIGHTS RESERVED
PRINTED IN GREAT BRITAIN BY
LATIMER TREND AND CO LTD PLYMOUTH

SBN (paper edition) 571 04696 7
SBN (cloth edition) 571 09383 3

CONTENTS

CONTENTS

EXPLANATION

Other complicated trades have pocket-books containing the essentials of their crafts, as for instance the engineers with their famous Molesworth. The author does not know of a similar book for the use of artists or students of the plastic arts. Yet in painting a knowledge of the materials used and of the best means of knowing the permanence and quality of the materials, as well as an acquaintance with alternative methods of painting, should be the base from which the creative act sets out. The material, which has been condensed and rearranged from the author's larger work *Notes on the Technique of Painting*, has also been rearranged in a much simpler fashion, only those parts of immediately practical use being retained. The contents include a comparative survey of all the best processes of painting, the choice and care of materials and tools, the constituents of pigments with a table showing their principal properties at a glance, and a short appendix on colour theories and measurement. Formulae of too difficult or complicated a nature have been deleted irrespective of their final artistic value, but if this notebook excites the spirit of curiosity or of experiment a full bibliography of the subject will be found in the larger work.

9

PUBLISHER'S NOTE
TO THE THIRD EDITION

We are grateful to Mr. Colin Hayes
who revised this book for the third
edition and to Mr. Robert Massey who
suggested some amendments for the
American edition.

CHAPTER I

DRAWING MATERIALS

§1. *CHARCOAL*

A piece of charcoal and a sheet of charcoal paper—are the simplest materials with which to draw.

CHARCOAL varies in quality, hardness, softness and consistency of texture. Less difficult to use than pencil, it is very easily erased and the drawing can be modified at will. Charcoal may be used with pincers of metal called a HOLDER. STUMPS or TORTILLONS (made of a special soft blotting-like paper rolled into the form of a pencil) are used for shading or blending, but if used too heavily make the charcoal difficult to erase. Small pieces of CHAMOIS LEATHER serve the same purpose, and will remove lines which have been lightly applied.

The student may use a SANDPAPER BLOCK to keep the charcoal sharp, rubbing the point upon it. A number of manufactured charcoals or COMPOSED CHARCOAL CRAYONS (called compressed charcoal in America) have advantages claimed for them of consistency and texture. For this reason the paper takes the pigment in a more uniform fashion and the result is more certain.

Good charcoal papers are thin, have a fairly tough surface and a light grain. The best known varieties in general use are Michallet and Ingres in Europe. The best known American brand is Strathmore.

DRAWING MATERIALS

For Fixing the drawings see Fixatives.

§2. *CRAYONS*

Crayons are short, usually square sticks made from black carbon and a binder of these the well-known Conté Crayons have given a general name to the material. Made in three hardnesses, of which No. 1 is the hardest, they give a dead black line much more difficult to erase than charcoal, but less liable to injury. Thus they are most useful for rapid sketching.

Sanguine is the name for crayons made of red ochre. This is one of the oldest drawing materials known and can be used with effect in combination with Conté.

Crayons may be sharpened like charcoal on a sandpaper block, but if a knife is used it should be very sharp and the crayon cut from the point towards the butt, otherwise the point will continually break off.

Crayons are also set in wood like ordinary pencils. They are then called Carbon Pencils. With Carbon Pencils the wood should be carefully cut in the ordinary way, but the carbon point cut backwards as for crayons.

Some BLACK CHALK pencils are soluble in water and with them interesting effects may be obtained by rubbing the line or tone made with a damp, stiff, hog-hair paint brush. Of a similar nature are the WATER-COLOUR pencils widely manufactured today in a great range of colours. These are soluble in water and can be used for many interesting effects similar in appearance to that of water-colours.

Crayons and Crayon Pencils, soft and hard, are also obtainable in which the pigment is mixed with wax.

These give a hard, shiny line which cannot be rubbed or blended, as can ordinary chalks.

Lithographic Chalks are made of black carbon with a fatty binder, they can be used for drawing as well as for lithography.

Pastels are coloured crayons usually made up with just enough Gum Tragacanth to hold the pigment in shape.

§3. *LEAD PENCIL*

Everyone is acquainted with so-called 'Lead Pencil'. But anyone possessing one which really fitted the name would have a curiosity, as few are in use today. The principal ingredient in modern pencils is graphite, a variety of carbon, and thus very like charcoal. The graphite is mixed with clay, both finely ground. The larger proportion of graphite the softer and blacker the pencil; the more clay the harder. In the ordinary pencil then we see that the graphite forms the PIGMENT or colouring material and the CLAY the BINDER. Pencils range from 6B, the softest grade to 6H, the hardest. These materials are ground, pressed and baked and then inserted into wood (preferably American Red Cedar). The quality of the wood is important. It should be soft enough for easy sharpening, without a tendency to split.

For a fine point finish on the sandpaper block as for charcoal.

A good metal pencil sharpener is useful and compact. This should have two blades, one specially for cutting the wood and a smaller for pointing the lead. Single-bladed sharpeners tend to break the lead and cause waste.

DRAWING MATERIALS

Pencil may be easily erased when lightly drawn. Darks are better produced with a soft-grade pencil than by much rubbing over the same spot, which quickly produces an ugly shine.

A pencil drawing must be fixed like a charcoal drawing unless it is well protected against rubbing or smudging.

Every student and artist should become acquainted with all varieties of crayons and pencils and how to use them. These may be studied in the manufacturers' catalogues or folders and are obtainable at any art store, on request. The medium may be used with water and other liquids, rubbed with the finger, with stumps, wet or damp brushes, powdered on the sand-paper block and spread with cotton wool with or without using stencils, or cut-out pieces of paper or card (cardboard). In America, cotton wool is called absorbent cotton.

§4. *PAPER*

To have the appropriate paper for the sort of work which is to be done is important. This depends largely on the personal preference of the artist. The best paper is made by hand wholly of pure linen rags, and improves with age. Always demand the special paper for the particular type of work—charcoal paper, crayon paper, pastel paper, etc. Get samples and try each sort until you find the kind that you like. Paper of poor quality that will not permit erasing or alteration is discouraging, as it makes the work much more difficult. Good paper will last for hundreds of years, much longer than even the best canvas.

§5. *ERASERS*

CHARCOAL DRAWINGS if lightly done may be erased with fresh bread, which should be kneaded into a small lump, working it between the fingers. Putty rubber is also useful and can be shaped into a point for picking out small details. A putty rubber is called a kneaded eraser in the U.S.

Pencil drawings also may be erased with rubber.

The Crayon line can only be erased if lightly drawn. Wax Crayons and Lithographic Chalks cannot be erased with any benefit to the drawing.

§6. *FIXING*

When a drawing has been made on the appropriate paper with charcoal, pencil, crayon, or pastel, etc., it must be 'fixed', by the application of a liquid which will protect it and hold it firmly to the paper as though it had been varnished by a thin coat of invisible varnish. These liquids are called FIXATIVES.

FIXATIVES

Some formulas for making fixative.

White shellac	5 parts
Venice turpentine[1]	5 ,,
Alcohol	90 ,,

The ordinary method of making this fixative is to put the shellac in a little muslin bag which should be hung in a receptacle containing pure grain alcohol. As the

[1] A soft transparent resin.

shellac dissolves, it sinks through the muslin to the bottom and thus the shellac in the bag is kept constantly in contact with fresh alcohol. When, after a few days, the shellac is dissolved the solutions is filtered and bottled. The proportions should be about one part of shellac to ten of alcohol.

Another fixative, considered excellent, contains copal.

White shellac	5 grammes
Pulverized copal resin	5 ,,

These are placed in a pint of alcohol and stirred from time to time. When they have dissolved, the solution should be filtered and bottled.

A cheap fixative may be made with:

White shellac varnish	1 part
Wood alcohol	1 ,,

Mix well.

To Clarify and Bleach Shellac Fixatives

ANIMAL CHARCOAL in powder form, which can be purchased at any chemist, may be used. It should be heated slightly to drive off moisture and put into a filter paper placed in a glass funnel. As large a quantity of the charcoal as the funnel will conveniently hold should be used and the liquid poured slowly through this simple but efficient filter. In the U.S., chemist corresponds to druggist.

A Rubber Fixative

India rubber	2 parts
Sandarac resin	8 ,,

| Essence of turpentine | 45 parts |
| Benzole | 45 ,, |

In the above formula, the rubber is dissolved in the benzole, the other ingredient in the turpentine, and the two solutions are then mixed. Essence of turpentine is known in the U.S. as pure gum spirits of turpentine, and Benzole can be purchased as benzene.

A Casein Fixative which may be used for Pastels

Mix 20 grammes of casein with an alkaline solution of 4 grammes borax and water. The casein and borax are first mixed with a little water. After a few hours, the syrupy mass thus obtained should be thinned with more water—up to about a pint and a half of solution. Add half a pint of pure grain alcohol, and the solution, after standing to clarify, may then be decanted. The alcohol will preserve the solution. Ammonia may be used instead of borax.

Skim Milk

Henley states that: 'During the Civil War, men were compelled to use the pencil for correspondence of all sorts. Where the communication was of a nature to make its permanency desirable, the paper was simply dipped in skim milk, which effected the purpose admirably. Such documents written with a pencil on unsized paper have stood the wear and rubbing of more than forty years.'

For fixing the drawings should be laid as flat as possible. The fixative may then be blown on the drawing with a vaporizer. Great care must be taken to hold the point of the vaporizer far enough off to get a fine

cloud of spray. Do not hold it vertically over the drawing as drops may form and fall. Watch that the paper is evenly damped but not wetted in patches. In the U.S., a vaporizer is generally referred to as an atomizer.

CHAPTER II

WATER-COLOUR METHODS

After Pencils and Crayons the handiest kinds of materials with which to work are the various techniques that use water as the solvent for the BINDER. There are several and the names that they go under depend on the kind of binder used, that is to say, the kind of 'fixative' with which the powdered colour is mixed and which, after application, holds the pigment firmly to the material painted upon, which is called THE SUPPORT.

§1. *DISTEMPER*

A cheap and easy method of painting with water as a solvent or MEDIUM is that in which the powdered colour is simply mixed with ordinary glue. Such colours are widely manufactured under the names of POSTER-COLOURS and OPAQUE WATER-COLOURS, etc. The name which should properly be applied to them is distemper, one of the oldest and simplest methods of painting. Only in use today to any great extent for painting scenery. Artists should at least know the principles, as it is cheap, quick to execute, and for special occasions of all sorts may come in very handy. Well prepared and properly protected it is very permanent.

W. Telbin says in his articles on the subject: 'A splendid material distemper! For atmosphere unequalled, and for strength as powerful as oil, in half an hour you can do with it that which in water or oil would take one or two days!'

Binders

The sort of size you select for painting will largely depend on what you wish to do. You may select one which is (*a*) insoluble in cold water and strongly gelatinizing, or (*b*) a partially soluble and very sticky or adhesive one. The first sort is rather less liable to crack when dry.

The best binders used in distemper painting are:

(*a*) { 1. Size made from parchment clippings.
 { 2. Fish glue.
(*b*) { 3. Gum arabic (which is really Senegal gum).
 { 4. Gum Tragacanth.

The gums may be diluted, as also the glues, with glycerine, honey (or substances derived from it), water, wine, beer, or milk. A good quality of hide glue, such as rabbit-skin glue, can be substituted for parchment clippings.

Purification of Size and Glue

Size and glue should be tested when dissolved in hot water for free acids or alkalis which are often used in their preparation. In the hot water solution they should not redden blue litmus paper, bleach dahlia paper, nor cause tumeric paper to turn brown—all proofs of acidity.[1] If acid they may be neutralized by the addi-

[1] These testing papers can be bought from any chemist (druggist in the U.S.).

tion of a few drops of ammonia; if alkaline by a few drops of vinegar. Sometimes they may be purified by letting them stand in cold water, having first cut or broken them up into small pieces, and then after they have stood for a few hours, or overnight in a cool place, pouring off the cool water before dissolving them in hot. The darker and stickier commercial glues should be avoided, they often contain sulphuric acid. Dahlia and turmeric papers are rarely stocked by druggists, but litmus paper is widely available.

An excellent Binder

This may be made partially from parchment size and partially from the finest fish glue. Two-thirds parchment size to one-third of fish glue is a good proportion.

Preservation of Glue Binders

Glues, sizes, etc., used in distemper painting may be kept by adding a few drops of eugenol (the active principle of oil of cloves). Goupil says that nitrate or chloride of zinc and sugar of lime have the property of opposing the coagulation of the colours. Nitrate or chloride of zinc are also called zinc nitrate and zinc chloride; sugar of lime is calcium acetate.

Riffault, in his edition of 1843, advises the use of absinthe leaves or garlic to be heated with the parchment size, or glue. He says that salt and vinegar should also be mixed with it. Absinthe is also known as wormwood.

In the distemper process the ordinary powder colours, damped down to a thick paste with water, should be mixed with a glue or size solution almost

the fluidity of a fresh cream. The best proportions are about three parts of colour to one of glue. The colour should run easily off the end of the brush. If it does not there is insufficient glue. The actual proportions of your glue to water should be determined by trial and error as there can be no fixed measure, but too much glue will make your colour crack, too little will allow it to be rubbed off as a powder when dry. Powder colours are called dry pigments in the U.S.

The colours mixed with the glue may be kept warm in a muffin tin, over an electric hot-plate or a small gas-ring. This will need a certain amount of experience as they should not boil, which would spell ruin to the adhesive.

The first coat may be applied very hot, the last may be applied cold. Never use more than two or three coats as the colour, if too thick, may scale off.

One of the chief difficulties in distemper is the fact that the colours dry much lighter than they appear when first applied. To remedy this scene-painters use a piece of metal, a sheet of zinc, galvanized iron or aluminium, kept hot by an electric heater or a gas-ring. A small sample of colour placed on this dries at once and gives the finished tone. But in practice the change which takes place may be quite accurately judged by the eye. If the painting is varnished the colours darken again very much.

Distemper may be retouched with tempera, water colours, egg tempera, or oils. Flexibility or retarded drying may be secured with lævulose (the active ingredient for this function in honey), with Aqualenta, Aquarelline, or glycerine which are mixed with the

water in the proportions indicated on the bottle in the case of the commercial preparations and under 'Water-Colour' in this book for the lævulose and honey. Lævulose is also spelled levulose, and Aqualenta is a J. G. Vibert preparation.

When finished distemper may be protected by water-colour fixative, wax, water-colour varnish, or any sort of varnish, if it is first given a coat of fish glue or transparent size. It may also be treated in other ways to render it waterproof.

Distemper Grounds and Painting. (See '*Grounds*'.)

Distemper may be used on any of the grounds recommended in this book which are not oily and which are fairly absorbent, on cardboard or on paper. The ground must be free from any traces of grease and may be rubbed with soap and water, ammonia and water, or gasolene, to make sure of this. The best sorts of paper to use are—Arches, Fabriano, Joynson, Bulle, Ingres, or Lalanne. Any good water-colour paper will do.

Vegetable Glues

Starch preparations of desirable nature are on the market under somewhat fancy names, such as 'vegetable glue'. They should be tested for acid or alkaline reactions and neutralized before using. They can be mixed with powdered colours as a cheap form of water-colour, and are thus used very successfully in Paris primary schools. Commercial distemper colours are preserved with carbolic acid and similar chemical preservatives. They may without exception be used according to the directions furnished by the manufacturers.

§2. *WATER-COLOURS*

Water-colour, in the general sense, means that the pigment has been mixed with gum as a binder. Painting with gum arabic is very ancient, but the old works, except some from China and Japan, are without exceptions those in which the pigments are also mixed with white and used opaquely, known as GOUACHES. Water-colour in the restrained sense of the term is used for the transparent kind of painting, in which the white of the paper furnishes the lights and no white pigment is used for the execution of the picture. This last kind of painting originated, and reached its highest perfection, in England. In France it is known as 'the English method', the French generally using a certain amount of white, and light opaque tints, known as BODY COLOUR. The difference then between Gouache and Water-Colour is simply that the one is used with white and opaquely, the other without white and transparently. The French method is mixed.

The Gums

Gum arabic has always been considered the best gum to hold the pigments in water-colour painting. With so much water-colour being used on every side, it may seem surprising to find that there is little or no genuine gum arabic (from Arabia) to be had today. The gum now sold under that name comes from the same species of acacia tree but growing in Africa, where conditions are very different from those that used to prevail in Arabia. Gum arabic is now really gum senegal and these Senegalese gums may have to be subjected to a heat treatment before they can be

24

used for water-colours. A choice of qualities, however, is on the market, with some adulteration and falsification.

The gum arabic used in water-colour painting is known commercially as Kordofan, Picked Turkey, or White Sennaar. Sometimes, oddly enough, it is called Senegal Gum, although that is where it all comes from.

Gumming

Gumming the colours is a complicated and delicate job as the different pigments take different qualities and quantities of gum. Some are best with gum which has been subjected to heat, and others with it in the natural state. The chromates render the gum soluble as does badly prepared emerald green, in which case dextrine is used. Some colours—as we have all found out—will not keep well in cakes. The water-colours sold prepared for use are seldom equally gummed, and therefore a good idea is to have gummed water ready for use as a medium, making up the deficiency by experience as one sees fit. Sugar, honey and glycerine are often mixed with moist water-colours as sold in tubes, to keep them liquid, often making them so liquid that they will mess up the box in which they are kept. Sugar and honey, of course, attract flies, and these little gourmets may leave their calling cards in the most conspicuous place possible on a picture.

Gum Tragacanth

Tragacanth gum, which is sometimes used in the manufacture of pastels, was supposed by some authorities to have been used by the ancient Egyptians. It

may be used as a binder, but is not very easy to prepare of a uniform consistency.

To Prepare Gum Tragacanth for Use in Painting

Powder the gum or buy it finely powdered Put this powdered gum in a bottle. Moisten it with spirits of wine or pure grain alcohol. Then add the desired amount of water, shaking gently at intervals. Water containing 3 or 4 per cent of gum tragacanth will make a moderately thick mucilage. Spirits of wine are the same as ethyl alcohol.

The use of gum from the cherry tree is advised in an old Byzantine manuscript.

Starch

Starch may be, and to some extent is, used in water-colour painting though not to the extent that its possibilities seem to make desirable. Starch is easy to buy in sufficiently pure forms for purposes of painting. It should, of course, be selected white and may come from rice, wheat, corn or maize, potatoes or arrow-root. Rice starch is probably the best. Starch paintings have a quality similar to that of oil sketches made with plenty of medium.

To Make a Starch Paste for Painting

1. Agitate, by stirring, 50 grammes (a little over one ounce and a half) of powdered starch with enough cold water to make a creamy paste, adding water slowly as needed.

2. Pour this into a receptacle containing about 300 cubic centimetres (a little over half a pint) of pure water (distilled if possible) which should be kept boil-

ing during this operation. All but about 2 per cent of the starch will dissolve into a nearly transparent smooth paste. The quantity of water may be varied according to the thickness of paste desired.

Use of Pigments in Water-Colour

Some pigments, quite permanent in oils, are not permanent in water-colour. In gum they are naturally less protected from the atmosphere. Vermilion blackens in the presence of sulphuretted hydrogen. Artificial ultramarine is affected by sulphurous acid fumes. Cadmium Yellow, Aureolin, Cobalt Green and Emerald Green will not withstand dampness. In water-colours covered by glass, there is often a condensation of moisture on the inside of the glass. Paper will attract moisture, which it absorbs and releases with every change in the atmosphere. This in time affects the adherent quality of the gum. Other colours which are quite permanent when applied pure and in a thick layer, as the madders, are more fugitive in thin washes. Lead White or Flake White is not used in water-colour, Barium White, Zinc White and sometimes chalk whites taking the place. Sulphuretted hydrogen is also known as hydrogen sulphide.

Varnishes

A number of water-colour varnishes and fixatives may be used to protect water-colours against the action of the air. An objection may be that they change the character of the water-colour by altering the quality of the surface to a greater or lesser extent depending upon how thickly they are applied. The objection is therefore one of taste. The best water-colour varnishes

and fixatives are excellent and durable as protection whenever their use is felt to be permissible.

§3. *PAPER*

Paper, at its best, provides a support of great permanence. Some papers still in good condition are 500 years old, other specimens even much older exist.

For Water-Colour Painting

Pure hand-made linen rag paper, which has been water- and sun-bleached without the use of chemicals, is the best. It is rare and expensive. Most paper has been bleached by chemicals such as chlorine. Much contains cotton, wood pulp or other materials. Often it is treated and sized to make it heavy, as paper is sold by weight. The glue or size, to reduce the absorption should be introduced while the paper is being made and be present not only on the surface but throughout the entire thickness. Paper must be kept in a dry place, and when so kept, the longer kept the better. If the storage is damp the glue may be affected, and the colour will be received in spots or patches.

Excellent paper which is manufactured for the British Royal Society of Painters in Water-Colours is probably as near to perfection as any which can be found today. As might be expected, it is not cheap. Should you buy some, hold it up to the light and look carefully for the water-mark R.W.S. and the society's name.

An advantage of pure linen paper is its toughness. It will withstand much abuse in the form of scraping, erasures, etc. Pure rag paper of linen and cotton mixed is next in quality, though nothing like as good as pure linen.

PAPER

Working Qualities of Water-Colour Paper[1]

Rich recommends for the beginner a pure white moderately smooth paper. But if too smooth the paper is much more difficult to work on. The principle surfaces of paper are known as 'hot-pressed', which is very smooth; 'not' (not hot-pressed), which is medium, and 'rough'. The 'not' surface is the best for general use. A good quality paper should be used from the start or discouragement will follow. Don't use made-up sketching blocks. They bubble when wet, and have other disadvantages. 'Not' papers are called 'cold-pressed' papers in the U.S.

Paper is usually priced by size and weight (to the ream). Sizes and approximate weights are:

Demy	20″ × 15½″	25 lb.
Medium	22″ × 17½″	34 lb.
Royal	24″ × 19″	40 to 60 lb.
Imperial	30″ × 22″	70 to 300 lb.
Double Elephant	40″ × 26¾″	130 to 250 lb.
Antiquarian	53″ × 31″	240 lb.

A good medium paper is Imperial, 72 lb., 'not' surface. It must be cut to the required dimensions for stretching.

Imperial paper of over 200 lb. in weight approximates to solid cardboard, and heavy papers of this kind may be used without stretching. Carton d'Arches and Green's Pasteless Boards are solid water-colour sheets of this kind and may be used on both sides, and are of the same material all through.

[1] See Appendix II.

R.W.S. paper, Whatman or Arnold are all good papers to begin on.

Michallet is a beautiful paper but requires careful stretching. David Cox, Creswick, Cartridge, Van Gelder, White Canson and Burlington are all good papers for practical work, but most are a little tricky to use and require practice.

Tinted papers should be considered with caution, they are, of course, only as permanent as the dye used for the basic tint. Turner Paper, for instance, is coloured with indigo, which is not permanent. Papers such as Varley, which contain wood pulp, should be avoided. Sugar paper of any colour, though it gives very pleasant results, is most dangerous. In fact, any paper that is too cheap in price must be looked at with suspicion. Good, cheap paper has not yet been made.

Different substances, such as china-clay, or kaolin, silicate of lime, chalk, whiting, artificial gypsum, etc., are used to dress or 'fill' papers. Blues are used to whiten them as blueing is used in washing clothes. The cheaper the paper, the more of these materials, or 'ash' it is apt to contain. The percentage of adulterants may run up to 12 per cent or over. Silicate of lime is the same thing as lime silicate.

Sizing and Dressing Paper

Size may be introduced into the pulp or applied to the sheet. Gelatin with a little alum, colophony or resin, dissolved in alkalis, followed by treatment with alum or starch and alum are all used. Alum was used by the Chinese, and starch is a durable material in the ancient tradition. Gelatin and starch are the safest sizing materials.

PAPER

If, for one of many reasons, you have no ideal paper at hand, paper which is less ideal may be doctored or filled so that it will take water-colour or gouache paints quite well. This recipe is given by Goupil:

Skin glue or parchment size	1 part
Pure white soap	1 ,,
Powdered Alum	1 ,,

Melt the glue and the grated soap on a slow fire, stirring until well dissolved. Then add the alum which on dissolving will turn the mixture milky; strain and bottle; spread with a soft brush. The mixture may be diluted with water as desired. Should the paper fail to take it well, add to it a little ox-gall or a few drops of ammonia or alcohol. Skin glue is also known as hide glue.

If the Surface of a Paper is Oily or Greasy

This may be overcome by washing the surface with pure water to which a drop or two of ammonia, or ox-gall has been added. Do not use borax. This does not evaporate and leaves an alkaline residue.

Stretching Paper

For straight water-colour one must have a well-sized and filled paper, well stretched and very clean. Your paint, or ink, must be of good quality. A drawing board, an old canvas, a heavy piece of cardboard, a drawing board with stretching frame, a striator (stretching frame with ridges raising the working surface) or a wood panel from an oil sketch box may be used.

A Striator or Stretching Frame

This consists of two frames which fit tightly one into

the other. The smaller is panelled or covered with a fine canvas or cloth. Wet the paper on the reverse side; when well dampened the edges of the sheet are pinched between the two frames. The water evaporates from under the canvas and the paper becomes stretched as tight as a drumhead. If desired the painting may be worked wet by keeping the canvas as damp as necessary, from the back.

To Stretch Paper on a Drawing Board or Cardboard

Lay a clean sheet of paper or cloth on a table, and place the sheet to be stretched upon it. Then take a flat ruler, parallel to each side at about an inch from the edge, turn up the edges to form a shallow tray. These folds along each edge are to receive the paste. Dampen the paper carefully with a sponge and clean water, careful to wet it evenly all over except for the four folded edges, which must be left quite dry. Allow the water to evaporate until no portion of the surface of the paper gleams or reflects the light brilliantly when looked at from an angle, i.e. it must be damp but mat. Turn the paper carefully so that the dry side is uppermost, cover with a large sheet of clean paper to preserve it from a hint of grease, which may cause trouble. Spread the paper on the drawing board or cardboard and rub the surface of the protecting sheet to flatten it to the board, working from the centre towards the edges to drive out the air. Paste your four edges to the board with a little library paste, rubber cement, or gum, and press them down firmly—being careful of pleats. Don't try to rush the drying, or your glue may come loose. Never dry before a radiator, in the sun, or near a fire. Another and simpler way of stretching the

PAPER

paper is to damp it and stretch it on a drawing board of appropriate size, fastening down the edges all around with drawing pins (thumbtacks). Use plenty.

Another method:

1. Wet the water-colour paper.

2. Lay it on the drawing board face up.

3. Fasten it to the board along all edges with gummed strips of paper (the sort which comes in rolls).

4. When dry it will be perfectly smooth and tight.

5. The paper may be dampened slightly again before painting.

A Light Method for Field Work

Use as a board a light wood panel from an oil sketch box. This should have been waterproofed by painting on both sides with oil-paint or varnish. The paper, cut larger than the panel, should be thoroughly dampened and allowed to stretch. Lay the panel on the back of the damp paper, turn the edges over the back of the panel all round and hold with plenty of spring clips. When thoroughly dry the clips may be removed, as the natural toughness of the paper will hold it in place. Two or even three sheets may be simultaneously stretched on one panel, and each removed after it has been used without disturbing the others. For a light wood panel, $\frac{1}{4}$ in. untempered Masonite can be used.

Cennino Ceninni stretched his wet parchment or paper on a plank 'like a drum head'. In the case of parchment he burnished it with a burnisher's stone, either by laying a piece of paper over it and burnishing it on this, or directly on the parchment. He preferred the first method. He usually worked on coloured paper and therefore used gouache.

WATER-COLOUR METHODS

§4. *THE WATER-COLOUR WASH*

One of the most important technical necessities for the water-colour painter is the ability, when desired, to lay a good wash. That is to say to cover a relatively large area of paper with a smooth and evenly transparent tone of diluted colour. For the beginner this is quite difficult and it should be practised seriously.

The quality and texture of the paper, how it is coated or filled, the position in which it is held on the drawing board, whether flat or at an angle, the angle of the brush to the paper, the amount of colour in your brush and the amount of water, and the appropriateness of its size to the area to be filled, your working speed, the heat of the day, or the sun and the wind, which affect evaporation, are all important factors.

To Mix a Wash

The basis of your wash being water you should be sure what action your local water has on the colours. Hard water is not good as it may precipitate or curdle the colouring matter in the paints. The city water in New York is good, in London it can be used, in Paris it is rotten. Rain water may be used with benefit, but the best is to use distilled water whenever possible. It can always be bought at the chemist; that got from the garage round the corner and marked 'distilled water' may or may not be the genuine article. I have seen the bottles filled from the tap. Whenever possible use two glasses, one containing water for mixing the colours and one in which to rinse the brushes. You will change the water less often and get cleaner results.

When starting a wash be sure to have enough tint

34

mixed to cover the intended area. In laying a wash, should your wash run short there will be neither time in which to make up a fresh lot or to get an exact match of colour. Better too much than too little. Be sure that the wash is clear and free from streaks, lumps or granules of undissolved colour. If these are present they may be rubbed out on the bottom of the colour cup with the finger. Some painters and architects make up their washes in little paper funnels, of heavy paper folded to the desired shape.

To Lay a Wash

Practise a wash with two brushes: one with colour and the other with pure water. Begin with a damp brush and pure water on the outside edge of a form working towards the centre, dampening the space one wishes to tint. Then take your brush with your wash and tint it as you like. The dampening will tend to keep your wash smooth, your brush strokes will blend and not show edges or spots.

Also use two brushes or a double-ended brush, one wet for the colour and the other dry, so that excess gobs of colour can be taken care of with the dry one. A good way of learning to lay washes is to start with a small circular space about as big as a tumbler. Damp the area first with a brush and clean water not quite to the edge, leaving a little space of between one-sixteenth and one-thirty-second of an inch all round. Carry your colour all round the circumference and then work from the edge towards the centre. Take off the drop in the centre with your dry brush. No brush strokes should show.

If you want a wash over a big space, like a sky, wet

the paper with a sponge, but do not apply any colour until it is mat. If you are in a hurry, blot the paper firmly with a little ball of dry cloth, a handkerchief for example, tapping it.

Slant your board so that the wet colour of the wash will tend to run down leaving an accumulation of moist colour at the bottom of the space you have covered. Work across this evenly, and when the space is quite covered lift off excess moisture at the bottom, as before, with the dry brush.

Don't slant your board too vertically or a gob of colour may run down the paper where you don't want it. Too much liquid may leave a series of wavy lines where the wet edges have been—especially if the paper is not up to standard—too little will dry before you get a chance to blend it.

Coarse-grained paper will often not take colour without wetting, as the brush does not get down between the grains.

Rough paper will take more water than smooth, and generally speaking, the coarser the grain the more water you can use. For hot-pressed paper, use little water. For smooth Bristol Board, use as little water as possible, working with a damp brush.

Shading a Wash

To get acquainted with the relations of water and the different pigments touch the centre of a large drop of water on the paper with the point of a brush full of colour. Let these blobs dry and they will show clearly the principle of shading by washes.

To shade or gradate a wash is not easy and requires practice. Begin exactly as for a wash, with paper *mat*

damp. Go from dark to light, starting with the full tint all along the dark edge but adding water to the wash as the tint should lighten. Try columns and cylinders starting from the two outer edges with straight brush strokes. Take a circle, start at the circumference and try to get the effect of a sphere. Practice at shading is essential because a gradated wash once laid can never be corrected with benefit.

If you get discouraged, think of the Japanese and their first thirty years of practice—which Hokosai thought were the hardest because he said his stuff was never any good for the first thirty years.

Water-colour has a tendency to dry out a little lighter than when first painted. This is specially true of the darker tones. This drying out must be recognized but practice will soon make the eye allow for the change. If uncertain, a tone can always be got right by trying it on a sample piece of paper.

Never touch a wash once laid until it is thoroughly dry.

Never put a weaker wash over a stronger one.

Never, if you can avoid it, lay more than three washes over one another. The more direct your paint in water-colour the more natural sparkle it will have; more than three coats tend to 'go dry'.

Try out all sorts of paper and choose that which suits you best, but for experience's sake try experiments with poor paper in case some day you find yourself without a chance of getting better.

Sepia and Chinese ink are the easiest colours to handle. Small pictures are easier to paint than large ones.

WATER-COLOUR METHODS

Colours and Palette

Water-colours are made up in cakes, pans and tubes. Cakes are the older form, and give the best washes but are laborious in common use. Pans, which are half-moist colours in china pans are usually provided in colour boxes, but a convenient way of using water-colours is to have a paint box with empty china pans into which sufficient colour for immediate use is squeezed from the tube.

Rich advises a beginner's palette of five colours, viz.:

> Light Red
> Yellow Ochre
> Cyanine Blue
> Ivory Black
> Burnt Sienna

They are all 'permanent', safe, easily mixed and easy to work with. He adds five more as being all that will ever be necessary:

Oxide of Chromium (transparent) Viridian
Raw Sienna
Ultramarine (French Blue, as full pan of genuine
 lapis lazuli would cost a guinea)
Aureolin
Rose Madder

This, however, leaves the palette without a vivid red. Vermilion, Spectrum Red or Cadmium Red are the best provided, but none can be considered as absolutely permanent. Of the three, Cadmium Red is considered to be highly permanent for artists' use.

Cobalt Blue is a permanent colour which makes good washes.

Cerulean Blue is also a permanent blue, difficult to use in washes. Emerald Green is quite permanent but is dangerous to use in mixtures.

The beginner is advised to make as many trial experiments as possible with his colours, testing the results of mixing colours together, the effect of mixing black with the various colours, and also that of mixing colours of some similarity one with another, such as aureolin and raw sienna, ultramarine and viridian and so on. The more that he knows what his colours will do the better he can use them in an emergency.

§5. *BRUSHES*

Water-colour brushes are in sable, fitch, ichneumon or the so-called camels' hair, which are really squirrel, no camels having ever contributed to the Arts. Sable brushes are the best. To choose one: wet it, shake out the excess water and roll on the palm of the hand to form a point. Should the point be thin and sparse, the brush is poor, it will be too flexible and have no 'life' or spring.

Should the brush have too much 'belly' it will pick up too much colour and be hard to handle—when the point is spreading the colour where it is wanted, the 'belly' may spread some where it is not.

Of course, in testing, should any hair come out, it goes without saying that the brush is beyond hope.

Brushes mounted in quills are often better and last longer than those mounted in metal ferrules. The former form a heel less easily. If the quill cracks it may be mended with some adhesive tape and shellac.

Sizes four, eight and twelve should be the first

bought; these may vary somewhat with different makers. A No. 4 brush, the extreme point cut square off (by a safety-razor blade), will be found useful, even larger brushes with the tip cut may be added later.

A useful brush, with a hard centre, some relationship to the Japanese brush, may be made by dipping a No. 8 in a heavy stand-oil and setting it aside for six months till quite hard. The outer oil should then be dissolved away with petrol, leaving a hard centre. This brush will hold plenty of colour, yet is both stiff and soft to work with.

Various effects in water-colour may also be obtained with flat hog-hair brushes as used for oil-paint. The handles should be cut short as are sables. Hog-hair brushes are known as bristle brushes in the U.S.

A Sponge

May be kept in the corner of the box in hot, dry weather to keep the colours from becoming too dry.

Linen Rags and a Piece of White Blotting Paper

Will come in handy.

Mediums

Water is practically the only medium used in working water-colours and gouaches, but a solution to increase the *maniabilité* and adherence of the colours is this given by Guopil:

Gum arabic	3 parts
Rock candy or glycerine	1 part

Melt in warm water to the desired consistency. Add a

little grain alcohol. The bottle should be kept well corked.

Water-Colour Megilp

This may be used with moist water-colours, either mixed with the water or blended with the colours on the palette by the brush.

It is supposed to give brilliance and depth to the colours and somewhat to retard their drying, thus allowing more time for working.

One catalogue advises a dose of 'half a thimbleful of Megilp for each cup of water, when the artist is working in the open air in the summer time'.

Other mediums with patented compositions, such as 'Aquarelline', etc., are used for similar purposes. Glycerine will, to some extent, replace all of them, as will lævulose, the active principle in honey.

India Ink—Mérimée's Advice as to How to Tell Good India Ink or 'Chinese Ink'

Good India Ink in slabs may be recognized by:
A brilliant black fracture.
A fine and perfectly homogeneous grain.
When diluted not the slightest grain is to be felt.
Even with much water, there should be no deposit or precipitate.
In drying, the surface becomes covered with a film of metallic appearance.

The colour should run well from the brush even at low temperatures. Once dry on the paper it must no longer be soluble when passed over with a wet brush. Today India ink, usually purchased ready dissolved in bottles, should always be diluted with distilled water.

§6. *GOUACHE*

Gouache, as has been mentioned, is no more than water-colour used with white. The gouache, which is bought ready prepared in jars or tubes, is sometimes called 'opaque water-colour', a good name, this being exactly what it is. 'Mat Water-Colour', or in the cheaper grades, 'Distemper', or 'Tempera' colour, or 'Poster' colours are also employed, the name being dependent on the type of binder, gum, emulsion, glue, etc.

Grounds

Any ground which is free from grease and oil will take gouache. A glue ground on cardboard, composition board or wood is excellent. Cloth prepared with glue may also be used. Paper should be of good quality and well filled with glue. One with a certain amount of grain is considered preferable and supposed to be easier to work on, but I know painters who successfully use papers with no apparent grain and which are quite unabsorbent. Used on a striator the paper may be dampened from the back as wished, and a raffia-covered or Cornu Patent Palette may be used on which to keep the colours damp. The former has a raffia cloth, the latter a padded cloth which can be kept wet as desired. Hog-hair brushes are useful for certain effects and the slender brushes used by sign writers and called 'liners' or 'writers' often come in handy. The 'Cornu Patent Palette' is described on page 56. As mentioned earlier, hog-hair brushes are known as bristle brushes in the U.S.

Never work with the paper in a vertical position or much inclined as the colours may run together. A flat

position is particularly desirable for the flat tones which may sometimes be 'flooded' on, or put on thickly like a little puddle so that no brush strokes will show. The colours dry considerably lighter, which must be taken into account when mixing the tones. Should you wish to put on a second coat, wait until the first is perfectly dry. If the second coat does not take well, glaze the first with a little ox-gall. A new coat laid on an old one will leave a line of junction, so that a part of an unsuccessful wash cannot be 'corrected', it must be wholly repainted.

As gouache is very easily soiled, always work with your hand on a clean piece of paper, to protect the paper and those parts of your painting already finished. Gouache can also be worked with egg yolk or emulsified wax, and varnished with water-colour varnish.

Ordinary water-colours used with a gouache white, mixed with water, to which a little glue or gum arabic has been added, offer a handy way of working small-sized things.

Gouache may now be purchased in pans similar in appearance to pan water-colours. Gouache, tempera, or designers' colours are normally sold either in tubes or in jars.

§7. *TEMPERA*

As used in this book, 'tempera' means any sort of paint which contains *oil in emulsion*, to be used with water as a medium. In the widest application of the term, the Italian word 'tempera' meant any more or less fluid medium with which pigments could be mixed,

including even oil. In its most restricted sense, it came to mean only colours tempered with the yolks or whites of eggs. The meaning adopted here is now that generally accepted by 'the trade', the qualification 'containing oil in emulsion' being applied to most, if not all of the ready prepared paints sold under the name of Tempera Colours.

An oil emulsion can be made by mixing drying oil with water through the intermediary of gum, yolk of egg or an alkali. Many tempera colours on the market are made from linseed oil and lime water. Of several sorts some are very good, but so many are manufactured that it is no longer necessary for the artist to make his own.

The emulsions made from yolk of egg, a gum or a resin, linseed oil and sometimes a little wax are intimate, mechanical, but not chemical compounds. Two good examples of them found ready prepared in commerce are 'Kervose' prepared from copal and elemi resins, with egg, wax, essence of lavender or spike, linseed oil and water, and 'Sadep', made by Paillard, a similar product. When egg yolk is used—as in the case of the two products mentioned—a somewhat yellowish tinted 'fat' emulsion results. If gum arabic is used, the result is a whitish 'lean' emulsion.

Wax and oil emulsions usually dry with the waterproof character of their non-soluble constituents, at least to some degree. All claims to the contrary notwithstanding, at their best these emulsions provide mediums of an extremely durable character. In fact, it may be said that a good tempera medium is the most permanent known, but great care must be exercised in the manufacture if good results are to be

obtained. C. F. Collin told me that he has seen the expert, Tudor Hart, rub the surface of an emulsion painting energetically with the edge of a coin without doing it any harm.

Casein glue and linseed oil are said to form a splendid emulsion and Toch recommends white of egg with linseed or poppy oil.

The Pastelloid Colours made by Reeves are examples of emulsion-tempera colours. An egg tempera medium is available from Grumbacher.

Egg Tempera

Egg tempera has a tradition behind it centuries older than that of oil-colours as now used. It is a splendid method of painting and the fact that it is rapidly regaining popularity both in England and on the Continent, among painters of all schools, will prove no surprise to those who are acquainted with its great possibilities and advantages. Egg tempera colours may now be purchased in tubes ready for use and the technique of their application is simplicity itself. Egg tempera paint is not available in tubes in the U.S., however.

Egg yolk, as an agglutinant or binder, permits, with the possible exception of wax, a greater colour range than any other vehicle.

Egg tempera has a glorious record as a medium; its very limitations seem to have proved advantageous. One of the most permanent mediums known, it has stood the test of time—showing no fermentations, cracks or bubbles. Furthermore, instead of becoming a possible agent for the destruction of its own support, as oil-paint on canvas sometimes does, it protects the

surface upon which it is painted. Once thoroughly hard, it is unaffected by temperature or humidity.

R. Spencer Stanhope, writing in the *Papers of the Society of Painters in Tempera*, etc. (vol. i, p. 41) sums up some of its advantages and disadvantages, as he sees them, as follows:

'There is no medium of any kind in ordinary use in painting which so little, if at all, affects the colours with which it is mixed.'

It leaves them their soft effect, permanence and brilliance. It dries at once. The work may be completed at once and the colour never changes. It leaves a perfect surface with no brush marks, and the painting may be looked at in any light.

In speaking of its disadvantages, he says: 'Perfect work with yolk of egg medium would mean completing each day's work so that it would require no retouching, but it is rarely possible to reach this point and retouching means the loss of a certain amount of purity and freshness in the work.'

Egg yolk will not keep.

Mould may appear from time to time on the surface of the painting until age has entirely dried up and hardened the medium. A safe remedy for this is rubbing the surface slightly with cotton wool dipped in vinegar. This does not harm the colour in any way and may be used as often as required.

As the surface remains soft for some time, precautions must be taken for its protection.

Yolk of Egg

Egg tempera painting, as practised today, has reduced itself to different methods and ways of employ-

ing the yolk of the egg in combination with water and a little white of egg to increase the transparency, or in emulsions, with the drying oils, glues or resins in the form of different varnishes, etc. The yolk of egg may be bleached with pure grain alcohol and exposure to daylight. It will, of course, not spoil while the alcohol is present. Vinegar was the only antiseptic known to the ancients, and they used it both to neutralize the naturally alkaline properties of the yolk, and also to help in its preservation. White wine may take the place of vinegar; camphor, cloves or essential oil of cloves are other preservatives in current use. I found about half or one per cent of benzoate of soda very successful. Less might do as well. Formalin has been tried but, as it is liable to coagulate the albumen, without great success. Benzoate of soda is also called sodium benzoate.

Effect of Yolk of Egg on Certain Pigments

Egg yolk is supposed to have a deleterious effect on certain pigments. Any to which much vinegar has been added should certainly not be mixed with genuine ultramarine, a colour readily affected by acids, even in dilute solutions. The blues in general are supposed to be affected by the sulphur or some more mysterious ingredient of the egg yolk, and we are therefore advised to temper them separately with a glue emulsion or some other substitute, particularly when they are employed pure. C. F. Collin pays no attention to these warnings and his blues, as far as I can see, have stood up perfectly well in egg yolk without vinegar for five years. All blues may be considered safe with egg yolk, though cobalt does not always disperse well with it.

47

It is safe in practice to use a good brand of tubed Tempera Colours.

Father Paulinus's Recipe as used by the Beuron Monks

The following is the recipe given by Father Paulinus for the tempera as used by the Beuron Monks, a chapter of the Benedictine Order, resident in the little town of Beuron, Austria. These monks have used it, and in fact still do, to paint on well-laid plaster. They used all of the permanent pigments except bone or ivory black, preferring mineral black or lamp black (which are also permanent) in their place.

Medium for fat tempera:

> 4 eggs, to which add
> 1 tablespoonful boiled linseed oil, and
> 1 teaspoonful vinegar

The whites and yolks are shaken up well together. The oil and vinegar must be mixed apart and then added to the egg, the whole being then thoroughly shaken up and passed through muslin to remove the skins. The medium should be kept in a well-corked bottle and mixed with the colours as required. Water is used to thin down to the necessary body.

To Retard the Drying of the Colours

Honey has been used since, at least, the time of a recipe giving its use by Filippo Lippi. A product now on the market, the composition of which is secret, was invented by the chemist, J. G. Vibert. He calls it Aqualenta. The use allows modelling as with oil-paints, retarding the drying of the colours considerably. It may also be used as a preservative.

TEMPERA

Egg and Varnish Tempera

Maxwell Armfield, the English painter in tempera, gives this recipe for egg and varnish tempera which, he says, he 'obtained from a craftsman in Florence' and which he 'believes to be traditional'.

Shake up yolk of an egg with the same volume, or a trifle less, of water. With just enough vinegar emulsify three or four drops of varnish, add also to the emulsion.

The recipe specified 'mastic' varnish, but I am informed that this word signified any kind of varnish in the Middle Ages. Copal is preferable. The mixture must be thoroughly emulsified by shaking and standing for some time until no varnish can be detected. In cold weather a slight warming may help. If kept in a very cold place the varnish tends to separate again, or at least something does, forming a scum. I have not noticed this at any other time. The varnish has the advantage of keeping the egg good for a long while and seems to me better than formalin, which tends to curdle it.

If too much varnish is used, the tempera is unpleasant to handle and dries too quickly for the subsequent films to combine as they should.

The surface is rather more waxy than the ordinary tempera. It varies a great deal with the ground used.

Tudor Hart's Emulsion Recipes

The following is a series of recipes and instructions given by the expert Tudor Hart in a lecture before the Society of Mural Decorators and Painters in Tempera, in 1922. As they have been only printed privately and are therefore not widely accessible, I take the liberty of

49

giving them here with little or no abridging. They are somewhat complicated for ordinary studio practice, but by adding the traditional grain of salt in taking, I believe that they will be found usefully suggestive. Mr. Hart began his lecture by a discussion of pigments and binding materials and a criticism of modern methods.

'. . . As we shall see presently,' he said, 'all pigments are not susceptible to tempering with the same medium. Certain mediums when used for tempering certain pigments render them difficult or impossible for the artist to manipulate with freedom and some pigments lose their colour and their resistance to the action of time when tempered with one medium, although they retain their resistant qualities and even increase their beauty when tempered with another.'

Qualities Sought For in Mediums

'First of all their tractability, which allows the artist to manipulate them and create a work of art without restriction within given limitations. Any medium which, because of its nature, does not allow the artist to achieve exactness and subtlety of blending, permanence of tone and colour, and delicacy of form is obviously improper for use.

'Secondly, their binding quality must be permanent. All liquids or soluble solids which on evaporation to the air and light become hard and binding to any pigment in them, are possible for use as mediums. Their value varies directly with the permanence of their binding quality.

'As far as our knowledge of chemistry and physics can help us in this matter, it shows that this probably belongs to certain essential oils and mucilagenous sub-

stances, mostly found in organic matter in the form of sap or juice of plants, in egg, in hides and the horny substance of animals.

'They can be classified in two distinct categories:

'*Carbohydrates* of vegetable origin are infinite in their variety and though but slight difference may exist in their known chemical composition, they differ greatly in their physical properties. [Let me note that this fact is too often overlooked in 'scientific' treatises on the subject—H.H.]

'*Albumens* or nitrogenous substances are of animal origin and their physical properties vary but slightly.

'To the first series, carbohydrates, belong the mediums for tempera painting such as fig-milk, honey, gum arabic, tragacanth, etc., and also the mediums for oil-painting and varnishes, such as linseed oil, poppy, and other siccative oils, the hard and soft resins, balsams, etc.

'To the second series—the Albumens—belong the mediums for tempera: egg, casein, and the gelatine size glues, parchment, horn, bone, etc.

'It is the siccative property of these substances which is alone the binding element, but there are other constituents found in varying quantities in the nature of solvents and saponifiers which enable the artist to use them in combination with water and other volatile liquids and thus secure sufficient tractability.

'Of all the known ingredients for mediums, by far the most binding are the siccative oils, linseed, poppy, nut and Chinese wood oil (and of these linseed is preferable) but they have the disadvantage of being less tractable than many of the other ingredients for mediums. They also require a lengthy and difficult

process of purification to eliminate properties which darken under the action of light and become cloudy.

'Next in order of binding quality come casein or cheese glue, parchment or horn glue, yolk of egg (which are more tractable than the preceding, but have the disadvantage of changing the tone value of the pigment in drying), fig-juice and balsams come next, and last honey, gum arabic, and white of egg.

'What is essential is that no ingredient should be used in the mixture which destroys the siccative or binding quality of the medium, or retards or accelerates its desiccation, or renders it susceptible to physical alteration by the action of light.'

He proceeds to point out that in practice the very inverse of this is in vogue today in the general use of oil-paint. Turpentine, petroleum and coal naphtha are used to render the oil more tractable and hasten drying, etc. All these solvents tend to destroy its binding quality.

Few painters today would be willing to go to even a fraction of the trouble necessary to the manufacture of the emulsions, the recipe for which follows. Yet the principle involved is interesting, and the fact that some of them may be used in connection with ordinary oil-paints as they come from the tube makes possible some simple experimentation with little-modified materials which may amply repay the effort expended.

Let me advise you, if you do not care to make parchment glue, to substitute for it ordinary skin glue which you may purchase at the first hardware store you come to. Do not be afraid to use any of the emulsions with any colours as they come from the tubes, or even in the form of pigments. Use common sense and no great catastrophe will overtake your work.

TEMPERA

Parchment Size and Linseed Oil Emulsion

Ingredients: Size made from goat and sheep
parchment clippings
Linseed Oil

'The size should be made as described by Cenino
Cennini in Chapter 110, but as this is somewhat vague,
it may be found useful to add the method which I have
evolved of preparing it so as to produce the most satis-
factory result.

'Take one part of the goat parchment to four or five
of sheep parchment. [May the author be allowed to
interrupt at this point and state that it can be made
with sheep parchment, which is the common sort,
alone.] Place them in a wooden tub and wash them
thoroughly in three or four waters, kneeding them and
scrubbing them well. . . . After a final rinsing draw off
the water and wring out the parchment in a linen
cloth. Place them back into the wooden tub with an
equal volume of water to the mass of wet parchment,
and leave them to soak thus for twenty-four hours.
Then place the parchment and the water in which it
has soaked into a large glazed earthenware pot (*pot-au-
feu*) which has not been used for any other purpose
(the smallest trace of grease will ruin the size). Add
boiling water, in the proportion of half the quantity
of water in which they have soaked, making a propor-
tion in all of one part of wet parchment to one and a
half of water. Place over a brisk fire so that the whole
of the rounded bottom of the pot is in direct contact
with the source of heat, but avoiding as far as possible
direct contact with the flames. Stir slowly with a
wooden spoon until the parchment clippings have all

53

curled up, then put a close-fitting lid on the pot and bring to full boiling. The boiling should be continued at intense heat for about two hours, stirring from time to time to prevent the clippings from adhering to the sides and bottom of the pot, which must be kept covered between the stirrings. When the water is reduced to about one-third its volume, strain off through two thicknesses of fine muslin, or better still a thin old linen sheet, and set aside to cool and clarify. By the next day it will have set into a tough jelly and is ready for use. It can be dried and kept for years by running it into flat-bottomed glazed dishes about an inch deep, and when set, cut into slices about a quarter-inch thick which can then be completely dried by placing the slices on metal gauze or a reed matting and fanned in a draft of cold air.'

This somewhat complicated and laborious way of making glue provides a glue of very high quality which may be used for grounds, distemper painting, and the emulsion which follows. If there seems too much work connected with its manufacture, substitute ordinary skin glue for it, for any or all of these uses. The final result will be very similar in every way.

Parchment Size and Linseed Oil Emulsion

'This parchment glue dried [or any similar glue in dry form] should be placed in about seven times its weight of water and left to soak for about twelve hours. Then melted down and stirred, adding a little more water if evaporation occurs, to keep consistency. If freshly made, a few drops of ammonia may be added while it is being stirred over a slow fire. [The author begs to advise a double boiler.] The chill should be

taken off the grinding slab by pouring hot water over it, which is then heated by spreading a cloth steeped in boiling water over it. It may be kept warm by pouring boiling water over it from time to time. Warm size or glue is poured on to the warmed slab from the double boiler and the linseed oil ground in as for the other emulsions, forming a thick alabaster-like cream. Boiling water should be used for grinding pigments into it. Warm water should be used to dilute it for use as a medium. Equal proportions of size and water.'

Pigments ground in this emulsion will keep for a considerable length of time if tubed, but the medium itself will not keep for more than a few days in summer.

Preservatives for Emulsion and Distemper Paints

The foregoing observation is on the part of Tudor Hart, as to the property of the size and oil emulsion for keeping. By the use of preservatives which may be as for egg paint, essential oil of cloves, which has been used since the time of the Egyptians, or any of the more modern preservatives such as Salicylic Acid, Boric Acid and Carbolic Acid may be used. I have found Benzoate of Soda excellent, and very reasonable for most purposes. These preservatives may be used with any of the perishable paint recipes given in this book. A little glycerine not only helps preserve, but prevents too rapid drying in tubes.

Casein Linseed Oil Emulsion

Casein glue (ten parts casein to one part of lime precipitate), prepared as given under Casein Grounds, may be substituted for the parchment size or glue mentioned above, but it slightly desaturates and raises

the tone of the deep-coloured pigments. Of course, neither will it keep nor can it be preserved.

All these emulsions will mix with ordinary oil-ground colours to the extent of:

Emulsion	1 part
Oil-Colour	2 parts

They will then retain all their faculties of flow and smoothness. The proportion may be varied if oil be first removed from the oil-paints by leaving them on blotting paper overnight.

A Summing-up regarding Tempera and Egg Tempera Painting

1. Palette

The palettes used for tempera or egg tempera painting should be of a non-absorbent material, the same as those used for water-colour painting. They may be of porcelain, glass, enamelled metal, celluloid, or specially prepared aluminium. A patented aluminium palette, called the 'Cornu Palette' is fitted with a padded cover which may be moistened and thus keep the colours moist between sessions and while working. Another almost similar is covered with raffia which is kept wet while working. Many artists using egg tempera use no palette, but mix their colours in the little china nested dishes sold for the purpose—ordinary saucers will serve. Aluminium, of course, is known as aluminum in the U.S.

2. Simplified Tempera Painting

The simplest way to paint in tempera is to buy your tempera paints ready for use as provided by the manufacturers. The simplest way to paint in egg tempera is

first to grind your colours in water and mix them with the desired quantity of yolk of egg. To add vinegar or anything else to this yolk of egg is unnecessary, it may simply be used pure. Casein base colours may now be bought already made from J. M. Paillard of Paris. Casein paint is also widely available in tubes.

To Test for Proper Amount of Egg to be Mixed With Colour

Put some colour mixed with egg yolk on the palette and when it dries moisten part of it with water. There should be no difference in the shade of the dry and moistened portions. To test for too much egg, scrape it off with a palette knife. If it comes away in the shape of a greasy, sticky shaving it is about right. If it flakes there is too much egg yolk and more pigment must be added.

3. *Brushes*

Any sort of brushes may be used. They should be washed out in water immediately after use, or if they are allowed to dry, should be then washed in benzine.

4. *Supports and Ground*

Tempera and egg tempera may be applied to any material which is more or less absorbent: paper, cardboard, wood, canvas, etc. If the proper ground is not at hand and the colours do not take on the ground which you have, try rubbing it with a clove of garlic cut in two. On paper, cardboard, wood, and canvas, it is unnecessary to put any priming as your first coat will serve very well as a priming.

In case you wish to work on a priming, for technical reasons, the priming becomes very important in rela-

tion to your way of working. All the gesso and non-oil-primed grounds given in the chapter on primings are excellent for tempera painting. One of the best and simplest for egg tempera is simply a coat of white tempered with egg yolk. If your ground is very absorbent, it will limit your technique in mixing and blending your colours. If not sufficiently absorbent the colour may scale off in time. In any case tempera pictures should not be loaded with too heavy an impasto, which may crack off.

5. *Varnishing*

An egg tempera painting when perfectly dry will take a slight and very beautiful polish if rubbed with a piece of silk. Also when perfectly dry it may be varnished with any sort of good picture varnish, or waxed. Vibert advises that a tempera painting be first given a coat of his 'Water Varnish' before being varnished with another sort, as the diluent of the varnish may decompose the binder in the tempera. I do not believe there is much danger of this if the painting is thoroughly dry and if care is taken in applying the varnish. The composition of his water varnish, which he also suggests using as a retouching varnish in tempera painting, is secret. The water varnish given in this book, under 'Varnishes', may replace it to some extent.

Both Rowney's and Newman's tempera colours are made up with yolk of egg and a little disinfectant.

CHAPTER III

OIL-PAINTING

§1. *OIL-COLOURS*

The oil medium is of primary importance today because it is the medium which offers possibilities for the freest manner of working. It is elastic from a standpoint of the many methods and modifications of methods which it makes possible. Less discipline is necessary in the handling of oil-paints than in any other existing medium.

A few days ago a friend of mine who is a journalist, and who has for some months been amusing himself by drawing and working in gouache and water-colour, came to me and asked what he should do to begin working in oils. He was without schooling of any artistic sort and professed his entire ignorance of even the fundamentals. He did not know what sort of brushes he would need and had an idea that quite a complicated equipment would be necessary. It was not easy to advise him, as I had no idea what sort or style of painting he wished to do. Neither had he. The advice given then, was the same I should give to anyone in a similar position. That is, start with an absolute minimum of equipment: three or four brushes of the sort to which he felt naturally attracted; a small bottle of bleached linseed oil; a little rectified turpentine, or

some pure gasoline; a piece of metal, wood or glass to use as a palette, and five tubes of paint—Black, White, Middle Madder or Deep Cadmium Red, Lemon Cadmium and Cobalt Blue.

He might continue to work the rest of his life with no more outfit, or he may develop a style of working which will necessitate a much more elaborate equipment in every way, but by starting with the minimum and buying only what he feels absolutely necessary, he will be more likely to gain an appreciation and knowledge of each element than if he left his selection to the colourman, who might suggest a catalogue which would make any beginner dizzy with discouragement.

Poppy Oil, Linseed Oil, Walnut Oil, Pale and Dark Drying Oil, Spirits of Turpentine, Quick and Slow Drying Petroleums, Copal, Amber, Dammar and Mastic Varnishes, Megilps of different sorts, Japan Oil Size, Oil of Spike, many 'ready-made mediums', Retouching Varnishes, Courtray, Harlem and Flemish Siccative, Copal Siccative, etc., without counting numerous patent or secret preparations, are but a few of the things which might have been offered him at any well-equipped art store. Some of these things are good; some bad, but few indeed are necessary, unless you have very good and definite reasons for their use and know why and how you must use them.

Oil-paints are ground in linseed oil or poppy oil. In England most colours are ground in linseed oil except white. In France most colours are ground in poppy oil, in other countries the preference varies. Different pigments require different amounts of oil for their grinding. As a rule the densest and heaviest pigments require the least oil. A few need an excess of oil

to protect them from the air, moisture, etc. Some pigments which require large amounts of oil have a tendency to lose opacity when the interpenetration of the oil increases with time. Yellow Ochre and Raw Sienna furnish examples of this. Others are apt to grow 'sour' or acid in the tube and to coagulate into a sort of jelly. This is most noticeable with the madders. Some painters find it good to keep their tubes of vermilion and other heavy pigments in an inverted position, caps downwards, to keep the oil and pigment from separating. Most tube oil paints made by reputable manufacturers today are excellent and dependable.

Paints sold in tubes are quite a recent invention. Commercially, as well as from a labour-saving standpoint, this method has enormous advantages. The introduction of paints put up in this fashion, however, has brought in certain factors which completely revolutionized not only the methods, but the very conception of oil-painting. This statement may sound exaggerated, but on thorough consideration, I do not believe that it is.

The paints manufactured and put into tubes to be sold by the art stores, must contain an excess of oil and other ingredients to make them keep on the shelves. The grades known as Decorator's Colours contain wax to give them body. Further, to keep them from hardening, certain colours contain oil of copaiba, which retards drying. This excess oil is very liable to go acid. Colours also dry very differently, a property of which no account is taken by most manufacturers.

Between the use of these prepared paints and those prepared by the artist himself—who knows exactly

what he wants and why he wants it—there is a great gap. The use of these paints as they come from the tubes itself limits the painter to a certain technique, whether he realizes it or not. Anyone who has tried to copy old pictures of different sorts with modern oil-paints will at once find out what is meant. These facts also account for the existence of the numerous mediums which are supposed to modify in one way or another the behaviour of 'standard' type oil-paints. An understanding of how and why these modifications of behaviour and effects take place is necessary before a choice of technique may be made with any sort of freedom. It can only be gained by studying the ingredients of the paints separately and at some length and by actual working experience.

§2. *THE OILS*

Desalme and Pierron mention somewhat over thirty oils which are or could be used in painting. Generally speaking, as far as the Fine Arts are concerned, only two are used to any great extent. These are linseed oil and poppy oil. As might be supposed there is a great field for experiment left open, for all the thirty oils mentioned are practically possible as substitutes for those at present used.

Nut Oil

Nut oil was formerly used to a great extent, and some painters, though few, still use it. It is very light in colour and almost as good a dryer as linseed oil, but it is very expensive, and, as it is not supposed to possess advantages comparable with its price, its use has been

dropped. A mixture of equal parts of linseed and poppy oils is supposed to have the same properties as nut oil.

Linseed Oil and Poppy Oil

Linseed oil of the best quality should be 'cold drawn' or pressed without heat from the best quality seed, and is available in most art supply stores. The oil comes from the *Linum usitatissimum*, from which it is usually extracted by the aid of heat. There are many methods of purifying but the best and the oldest is that of exposure to air and sunlight. Some oil on the market is really bleached and purified in this way, but not much. Poppy oil is obtained from the seed of the opium-poppy, *Papaver somniferum*. It dries more slowly than linseed oil and when fresh is apt to be much lighter in colour but after a time tends to become even darker.

Chemically the oils are very similar in nature and they may therefore be considered together from this standpoint. They both consist of saturated and non-saturated glycerides. The saturated glycerides, palmitin and stearin, do not change chemically while drying. They are very durable. Glycerides of this sort have been discovered in old Egyptian graves still in good condition. The unsaturated glycerides, olein, linol, and linolein are those which absorb oxygen from the air in drying. They change partially into gaseous substances called aldehydes. What is left of the olein remains syrupy. The linol and linolein solidify. With the palmitin and stearin they form the elastic substance of dried oil which is called linoxyn.

Linseed oil and poppy oil do not really 'dry' in the technical sense of the term, meaning that some liquid

evaporates. They exchange aldehydes for oxygen and possibly absorb some moisture from the air, which might account for the fact that they are heavier when dry than when wet! The drying of oil paint is often called polymerization.

Linseed forms more linoxyn, and less gaseous products, than poppy oil.

The drying process begins naturally at the surface where the oxygen of the air comes into contact with the oil. While the skin is thus forming gases develop and in escaping perforate this oil film—making channels in it. These channels allow further penetration of oxygen into the oil and so the process of absorbing oxygen and giving off gaseous aldehydes continues until the oil is solidified throughout. Siccatives either attract oxygen or furnish it by these means, hastening the solidification of the oil. Certain colours do the same, such as the oxides for instance. That is why they are 'good dryers'.

This generation and escape of gases makes the linoxyn or dried oil layer porous. The more gas, the more and larger pores. Poppy oil, as has been said, gives off more gas than linseed and so is the more porous when dry. A layer of paint put over such a porous surface dries mat as its oil is absorbed by the pores. An oil film, not quite hard, is like a sponge. It expands while sucking up the liquid furnished by the layer of wet paint placed over it. It may extract so much oil that the new layer of paint cracks.

This is why ONE COAT OF PAINT SHOULD NEVER BE LAID OVER ANOTHER ONE UNTIL THE FIRST IS THOROUGHLY DRY. THE LESS OIL IN THE SECOND COAT AND THE MORE IN THE FIRST, THE GREATER THE DANGER

OF CRACKING; HENCE THE RULE: START LEAN AND
FINISH FAT. Which is to say, lay your first coat with
turpentine as a diluent, adding no oil. The succes-
sive coats may contain proportionately more oil.

Linseed oil being more acid and less liable to keep
well in tubes, poppy oil is more frequently used by
colour makers. Linseed oil is more siccative, less porous,
becomes harder when dry, and while perhaps rather
darker to begin with actually darkens less than poppy
oil. To add more poppy oil, as many painters do, while
painting to colours which have already been ground
in an excess of it, is clearly dangerous to the life of the
picture. If oil must be added linseed oil is preferable.
I should be interested to hear the use of poppy oil as
a medium justified.

Even linseed oil, particularly if in excess and if
stored in the dark or in a place poorly illuminated,
tends to darken and thus may affect the colours with
which it is mixed. This tendency has, however, been
much exaggerated. Unless the picture painted with a
great deal of oil has been left a long time in the dark,
the oil will not change colour in a noticeable way.
Even then it will probably not be very noticeable except
in the case of the whites and the pale blues. Further-
more, if a picture with such a darkened oil film is
placed in the sunlight or even in strong daylight, the
film will bleach again no matter how long it has been
in the dark.

A director of Talens and Company during a lecture
delivered in London in 1928, made the following state-
ment regarding this darkening tendency of linseed
oil:

'The property of a linseed oil film to change its

colour when placed from the dark into bright light and vice versa cannot be removed, no matter how the linseed oil is clarified, and from what variety of seed it is pressed. The more linoxyn the oil forms, the greater its durability, but also the more it darkens.'

A Recommendation of Rubens

This tendency of linseed oil to darken has been recognized from a time very soon after its introduction. The Old Masters were preoccupied with bleaching it before using and some of their methods will be next given. In a letter written by Rubens to his friend, the French savant Nicolas Claude de Pierese, and dated London, August 9th, 1629, he wrote:

'If I knew that my portrait was still in Antwerp, I would ask them to hold it, open the box to see whether it had been damaged or if it had darkened. This often happens to fresh colours when they have been packed away in a box and have not been exposed to light and air. Should my picture not look as well as when it was finished, the best remedy would be to put it in the sun and the excess of oil which causes such change will be destroyed. Should it darken again after a while repeat this process, which is the only remedy.'

Purifying and Bleaching Linseed Oil

Many methods are known for bleaching and purifying the drying oils. Exposing the oil to the sun and air is the oldest and perhaps the best method. Other methods may be classified as washing, filtration, and the admixture of ingredients which are either mechanically or chemically purifying. As has been mentioned above, none of them can offer any guarantee of per-

manent efficacy, but it is obvious that the linseed or
other oils used in painting should be employed in as
pure and light-coloured a state as possible.

Washing

The ancient practice of washing oils, like many other
antique practices, seems to have a thoroughly scientific
foundation, for it is recommended by Tripier-Devaux,
who says:

'By thus removing the fermentable particles which
the oil contained, its affinity for oxygen has been re-
duced; a longer duration, a longer resistance to the
atmosphere is secured for it.'

He advises using a glass jar and syphon, washed
and sifted sand and torrefied common salt for studio
practice. Torrified common salt is non-iodized salt.

The oil, salt, water and sand is, in this case, simply
shaken together in a corked jar or bottle. It should
then be allowed to settle. The salt increases the specific
gravity of the water, thus causing an easier separation.
No salt should be used in the final washing, and, as an
extra precaution, three or four rinsings or final wash-
ings in pure water may be also used. Some authorities
recommend stale breadcrumbs as an excellent substi-
tute for the sand and no doubt they are more easily
procurable.

To hasten the process Dessaint advises boiling the
oil with an equal quantity of water for two hours.

Tudor Hart's method, as explained to me by C. F.
Collin, consists in pouring three quarts of oil into a
glass receptacle with nine or ten quarts of pure water.
Stir and beat the mixture violently with a stick or
portable butter churn for as long as your strength

holds out. Allow it to settle and when well settled, the clean oil may be flooded off into a basin by adding more water through a pipe. The scum that remains may be separately washed. The clean oil should be put back with more clean water and the process repeated as many times as is thought necessary. The apparatus should if possible be set in the sunshine during operations. While standing, the receptacle should be covered with a plate of glass, to keep out dust.

To my way of thinking, the METHOD OF PHILIPPE NUNEZ OF LISBON (1615), although some centuries older, seems equally efficient and rather simpler if the proper sort of jar can be procured. An inverted bottle may be used:

'To purify linseed oil for the whites and blues, take a vessel having an orifice at the bottom which may be stopped and unstopped. Throw in the oil mixed with spring water, and after stirring well, let the mixture settle, till the oil remains uppermost: then gently remove the stopper, letting out the water, and as soon as the oil begins to come out, stop the orifice. Do this three or four times and the oil will be very clear and fit for use.'

A Simple Method of Bleaching Oil Promptly

Add five per cent peroxide of hydrogen to oil in a glass bottle and shake the mixture repeatedly from time to time. After a few days have elapsed the linseed oil is entirely bleached and clarified, so that it can be poured off from the peroxide of hydrogen, which has been reduced to oxide of hydrogen, i.e. water, by the process of oxidation. Peroxide of hydrogen is hydrogen peroxide, or just peroxide.

All purified oil, whether prepared by the artist or purchased ready prepared, should be stood in a strong light, or better yet, where the sun will strike it, and kept there until used. Oil bought in tin containers should be at once transferred to clean glass bottles.

To Remove any Water left by Purifying or Washing

Certain ingredients may be added to the washed oil as it is important to remove any moisture that may remain in it. Among these are burnt alum or calcined borax. Calcined white copperas is also one of the best agents for this purpose. Fernback and Pacheco recommend pure grain alcohol or spirits of wine, which have a great appetite for water, to be mixed with the oil to purify and bleach it. Pacheco suggests three ounces of alcohol to each pint of oil. Copperas is ferrous sulphate.

Filtering

Oil or spirits, or any liquid intended for use in painting, should be filtered after purification. Filtering alone will do a great deal in most cases. To make a simple filter for use in the studio, get a good-sized glass funnel, some filter paper, sand if possible—though it is not absolutely necessary—and animal charcoal, which may be bought at any chemist. Put the filter paper, which is already cut to fit, into the funnel. Fill the point for about one inch with animal charcoal (heated before using). Place a disc of blotting paper over this and about an inch of sand. Or better, an 'alcarraza' or disc of porous earthenware or filtering stone upon which you may pour some more animal charcoal, etc., making as many layers in the funnel as you have room for. Even when very badly made and without sand or

discs, these simple filters work very well with only filter paper and animal charcoal. Ordinary house-painter's 'turps' filtered like this comes through as clear as crystal. Turpentine thus filtered costs about a quarter as much as that prepared at an art store although pure gum spirits of turpentine, sold in gallon cans, is sufficiently pure for artists' use.

Boiled Oil

Boiled oil has quite different properties from the uncooked article. In buying it one must be careful indeed; its reputation has suffered from the fact that many boiled oils on the market (including the product known in Germany as 'gekochtes Leinoel') are merely oils which have been boiled slightly with a large amount of dryers. The genuine product, which is very durable, is known as Stand-oil and as prepared in Holland is obtained from linseed oil which has been boiled for six or eight hours at a temperature of 290 degrees Celsius. Boiling in this way removes about 10 per cent of the unsaturated glycerides and poly-merizes the oil, that is, two or more molecules unite and become one. The polymerized part of the oil takes up less oxygen, is less subject to disintegration, and of course dries more slowly. This oil has been used for centuries in the damp and unfavourable climate of Holland by painters and decorators. Quite probably they were already using it when the Van Eycks started to paint pictures with oils and the artists may have merely imitated the decorators.

Slow-Drying Oils

When linseed oil is exposed to the air, as we have

seen, its volume increases as it begins to oxidize. The increase is largest at the surface and so the oil wrinkles or ripples at the top when the layer exposed is too thick. This is the reason why several colours which contain much oil, or are bad dryers, such as ivory black or raw sienna, are apt to wrinkle on the support. As anyone knows, who has attempted to use some old house-paint which has not been kept well corked, linseed oil exposed in a receptacle will show big wrinkles on top in a few days. If it contains 15 per cent of copaiba, or any other slow-drying oil, the film will be perfectly smooth, and this phenomenon is doubtless responsible for the belief that the use of copaiba will reduce the tendency to wrinkle. Tests carried out by some big manufacturers have proved, however, that the action of copaiba in a thin layer of paint is scarcely noticeable. Copaiba, oil of spike, or lavender oil should be used very sparingly. First, because they are often too freely used by the manufacturer to ensure that the colours will not dry up in the tube, and secondly, because they cause the oil to expel more gas than the amount of oxygen absorbed, so that its volume gradually begins to shrink, a shrinking which will continue until the process of oxidation comes to a standstill (under ordinary conditions a period of some two years).

If much slow evaporating oil is still in the paint when the oil begins to shrink, the paint contracts twice as much as should be normal, and, as a result, will crack.

Poppy oil does not wrinkle while drying because there is hardly any difference between the expansion of the upper skin and that of the oil underneath. It dries with a more or less viscous surface, which, with some pigments, may remain viscous for years.

COPAIBA OIL only evaporates to the extent of about one half—the balance oxidizing to a resin. As this resin is poor and exceedingly brittle, this oil should be used sparingly. A mixture of refined kerosene (slow-drying petroleum) and thickly boiled linseed oil may be recommended as a safer substitute.

Oil of Egg

Oil of egg is now sometimes used for grinding colours, and the colours used with it may be employed in the same way as the regulation oil-paints. It works better on absorbent grounds, however, for on the ordinary oil-primed canvas it is apt to dry very slowly. Quick and slow-drying petrols are recommended for use in thinning egg-oil colours. On a non-absorbent palette, these colours will keep indefinitely as they may always be redissolved with the petrols. Tones mixed with them and put into corked pots will keep for months. Mixed with the petrols, they always dry mat. Mixed with oil of egg, they are more transparent.

To varnish, they must be first varnished with a coat of water-varnish, otherwise the vehicle of the oil or spirit varnish might dissolve them. Over this coat of water-varnish, any varnish may be used. These colours are theoretically as permanent as egg tempera painting, and they may be used in the same way as oil-paints without the painter being preoccupied by any of the precautions which oil-paints necessitate.

Colours ground in egg-oil are supposed to have all the advantages of egg tempera colours, and none of the difficulties inherent in the use of that medium. The chief disadvantage in the use of a medium theoretically so nearly ideal is that egg-oil is very expensive. As it is

sometimes employed for dressing leather, it may be bought at a leather supply house.

Paints ground in egg-oil, and egg-oil itself, may be now purchased ready prepared. Probably only the price keeps this excellent if luxurious method from becoming popular. Let us hope for a synthetic egg-oil. Egg oil is not easily available in the U.S.

Painting with Oil

Some painters, and a contemporary example is furnished by Kisling, paint entirely with linseed oil, having no recourse to turpentine, petrol or any other medium. This method is only practicable when the painting can be finished in one séance; or when a very long time, *several months at least,* can be allowed between the first and second coats. A disadvantage is the difficulty encountered in retouching or placing one colour wholly or partially over another.

§3. DILUENTS

In order to dilute the paints ground in oil to the desired consistency, liquids of little body, capable of easy admixture with the oils in which they are ground, are used. They correspond, as solvents, to the water, used as a medium in water-colour, gouache, etc. The diluents in use today are: Turpentine, 'Oil' of Spike, and Refined Petroleum, or more simply, Petrol. Petrol is gasoline or petroleum solvent.

Turpentine

Under the name of Rectified Spirits of Turpentine, this sold by the art stores is supposed to have been

doubly distilled and purified. The product is usually of a good quality and lives up to the claims made for it, but it is unwarrantably expensive. The chemistry of spirits, or oil of turpentine, is complicated. The tendency of turpentine is, upon exposure to air and light, to turn back to the resin from which it comes. This resin is a sort which is worse than useless for any purposes of painting and so this tendency must be avoided if possible. The resin may be noticed at times in the sticky film which collects around the cork and neck of the turpentine bottle. Turpentines vary much in quality and, naturally, the best is the only sort fit for oil-painting.

A Simple Test for the Quality of Turpentine

Drop a little on a clean white blotting paper. In evaporating it should leave no ring or stain on the paper. As turpentine is best fresh, and always oxidizes more or less no matter how well prepared or how purified, it should be purchased in small sealed bottles and promptly used up as soon as opened. Buying turpentine by the quart from a house-painter's supply store may save you about 75 to 80 per cent in cost, depending on your colour dealer. This is how I buy it. Into the quart bottle, in which it is purchased, drop a few small pieces of hard quicklime. These will absorb any moisture produced by oxidation in the bottle, and any acids which may be formed at the same time. Such turpentine, filtered as described on page 69 of this copy, will be as clear as crystal. When quicklime is kept in a well-corked and full bottle there is no necessity for using the small bottles, although it may be filtered into these. Contrary to linseed oil, which should always be kept

in as bright a light as possible, turpentine should be kept in the dark. Most household shops keep a very good quality at a quite reasonable price.

Oil of Spike

If you can't stand the odour of the turpentine, which gives some people headaches, this may be used instead. It dries or evaporates more slowly than turpentine, which is advantageous for certain techniques. It is better than turpentine for painting where wax enters as an ingredient, being a better solvent for the wax.

The Petrols

Supposed to be a modern discovery in connection with oil-painting, but I have every reason to believe that they were used from very ancient times indeed. In any case, petrols have been rediscovered of late, and, as they evaporate completely, are favoured by certain authorities. Turpentine is supposed to leave a resinous residue which, in the long run, yellows and carbonizes, thus affecting the lighter colours, and so certain advantages are claimed for petrols. For ordinary use, good petrol as it comes from the garage is all that can be desired. Aeroplane spirit is the best. But be sure, of course, that it contains no admixture of Ethyl or of Benzole. If it evaporates too quickly to suit your technique, buy some of the special slow-drying kind (really purified petroleum) at an art store. Some painters claim that petrol lacks body.

To Give Petrol Body

Dissolve a little cerusine, or pure white wax, in it. Crusine is ceresin, not often readily available. Paraffin may be substituted for it.

Another disadvantage of petrol is that it may precipitate certain resins which may be in your painting varnish, should you be using one. To find this out you have only to test it. The precipitation takes place quickly. With many resins and varnishes it will work excellently. Generally speaking, petrol is probably the best and safest diluent we have today.

Technique of Working With Diluents

The technique of working with paints much thinned with diluents became popular in the eighteenth century. It gave a mat and somewhat chalky effect. It seems sound enough technically, for the works of Chardin, Hubert-Robert, Fragonard and Joseph Vernet have lasted very well. Gainsborough is supposed to have used it so freely that he had to pour the excess of turpentine off his palette from time to time.

As modern colours contain almost more than ample oil in the tubes, a good modern technique is furnished by the use of petrol with the colours just as they come from the tubes, as water is with moist water-colours. A little wax, dissolved in it to give body, will in no way hurt the durability of the colours; quite the contrary. Good pure kerosene may be used to retard the drying, but care must be used to get it *well rectified*. If it contains any vaseline it will never dry completely. This is one of the easiest and simplest techniques known. Any sort of brushes may be used and great freedom is possible for any style of painting desired, which may be either very thick or very thin. Should you wish to use a palette knife, a little petrol may be mixed with the colours on the palette. Should you wish to paint thinly, dip the brush into the petrol-filled palette cup, taking

as much or as little as needed. Pictures painted this way are mat. The best way to protect them from the atmosphere (most necessary, as the oil film will probably be very thin) is to use a good wax varnish. Theoretically, thus treated they should be exceedingly durable. The ground should be semi-absorbent.

§4. *PAINTING WITH VARNISH AS A MEDIUM*

Painting with varnish as a medium is one of the oldest and most durable methods. It is also, probably, the most difficult of execution, as varnish is apt to be tricky, stringy, and hard stuff to handle. It was, at least in part, the method of the Van Eycks, and may have been used to finish pictures begun in emulsion or tempera.

The Van Eycks' Varnish Medium as reconstituted by Maurice Busset

Oil Copal Varnish	1 part
Spike Oil	1 ,,

The oil copal may be replaced by amber in oil, but the varnish used must be of the best quality and have a hard resin base. If intended to dry more quickly, petrol may be substituted for the oil of spike. Amber in oil is rarely manufactured; copal varnishes and copal concentrate may be substituted for it.

To prepare this medium take a bottle which you have marked dividing it into halves. Pour your diluent slowly into your oil copal, and then shake the bottle violently until the opaque filaments precipitated by

the resin have completely disappeared. The liquid, which is then about the colour of light beer, should be allowed to rest. Harlem siccative may be used in place of this mixture as it does not differ appreciably in composition. It is said to give excellent results.

Rubens' Painting Varnish

Is reconstituted by the same authority:

Oil Copal or Amber	1 part
Poppy Oil	1 ,,
Spike Oil or Petrol	2 parts
(according to the rapidity with which it is wished to dry)	

The Technique for use when Painting with Varnishes

The most important thing in painting with varnishes is that the varnish must be very equally distributed throughout the entire painting. When this is the case it is a very durable method. When not, cracking may result. A good way to assure the proper admixture is to leave the colours which you intend to use on a piece of blotting paper overnight. This will remove the excess oil by absorption. Your varnish medium and the paints may then be mixed carefully and evenly with the palette knife. Failure to do this, and the practice of mixing colours and medium together, hit or miss, from the palette cup has caused doubts about the value of this excellent method, which is *extremely durable* when properly employed. I have used an oil-resin medium for fifteen years, with unexceptionally durable results, but the colours used were ground in the medium. For this method, *the ground should not be too absorbent*; if it is,

too much of the binder may be taken up and cracks may result.

Good Painting Varnish

This should *always* have a hard resin, copal or amber as its base. It may be used, of course, diluted or otherwise.

Japan Oil or Gold Size

This is a very thin sort of oil copal varnish, also used as a painting varnish. It dries very rapidly, usually containing dryers in large proportions. It is *bad stuff* if you want durability.

Megilp

Delightful to paint with, a combination of Pale Drying Oil and Mastic Varnish. Not durable.

So-called Copal Megilp

The same as above with some copal added. Supposed to be somewhat more durable.

Pyne's Megilp

Calcium sulphate ground in poppy oil. Not recommended.

Bell's Medium

This contains no resin so it is not a varnish in the classic sense of the term. It is a mixture of thickened linseed oil dissolved in oil of spike. It is prepared commercially by oxidizing the linseed oil, a current of warm moist air being passed through until the oil is about as thick as honey. It may be prepared in the

79

studio by putting the oil in a wide-mouthed flask which has a wad of cotton batting or cotton wool loosely stuffed into the mouth to prevent dirt and dust getting in while at the same time admitting the air. It must be shaken from time to time (at least once a day) to prevent the formation of the well-known skin.

Purified Linseed Oil for Varnish Medium

Use glass troughs which are filled one-third with water, one-third with oil, the remaining third being left as air space. After about three weeks of exposure to sunlight, the time depending upon the strength of the sun, the oil becomes viscous and very light in colour. It is considered superior to boiled oil for varnishes. Luckily, manufacturers are ready to furnish oil prepared by this tedious process. The oil treated in this way has about the consistency of honey and is too thick to paint with. Thinned with turpentine or oil of spike to the proper consistency, it is also sold under the name of 'Oil Vehicle'. Unthinned, it is known as Sun-thickened Oil.

Robertson's Medium

A substitute for this is provided by mixing warm, strong oil copal varnish, linseed or poppy oil and a trace of white wax.

A Painting Medium used by Gerome

Oil Copal Varnish mixed with Durozier oil 4 parts
Rectified Oil of Spike or Turpentine 3 ,,

Pour the spike or 'turps' on the copal-oil mixture. Mix well by shaking. Girardot said that this medium gave

paintings 'the solidity of flint'. The Durozier oil, prepared by the firm of Durozier of Paris, is now known by the trade name of 'Oliesse'.

Use of Retouching Varnish while Painting

On pictures which have gone flat or 'dead' in drying, retouching varnish, a quick-drying varnish, is sometimes used to bring out parts, so that their original tone may be seen. Many authorities advise filling the pores of the oil film with a good retouching varnish before repainting, advice which is based upon reasons theoretically sound, as may be remembered from the explanation of how the siccative or drying oils dry (see pp. 63, 64). The varnish, thus used, not only restores the brilliancy of the colours, but also reduces the absorbing power of the ground layer of paint and helps to prevent cracking.

Be careful, though, not to use more retouching varnish than is strictly required to fill the pores. A heavy coating of varnish is not a good ground to paint on. The superfluous resin will dissolve in the oil of the superimposed paint, and the latter, having no longer a solid foundation to rest on, will start to drift, form floes, and crack while still wet.

In all discussions on the use of retouching varnishes a difficulty is that their composition is kept rigorously secret. Even Vibert, who makes a great pretence of letting the artist know the ingredients of all his products, only says that his varnish 'is normal resin dissolved in pure petroleum essence'. As far as I am able to find out, 'normal resin' means resin that is fresh and in good condition. This does not tell us much. Soehn's retouching varnish has a shellac base and as shellac is

not soluble in oil, it is supposed to be bad, since it makes proper adherence of the paints impossible.

In using any retouching varnish the best rule is to use it as sparingly as possible. If you know its exact constituents and, therefore, how it acts, it may be used somewhat more freely.

White-of-Egg Varnish

This may be used where a temporary varnish for exhibition purposes is needed and the colours are not dry enough to varnish properly. Afterwards it may easily be removed. Made with white of egg and sugar or rock candy, it can be removed with a wet sponge when you desire to use your final varnish. Half a lump of sugar should be used to the white of each egg. These should be beaten up together and allowed to stand an hour before using. This varnish will not keep and must be made fresh. But its frequent use is slovenly practice and not recommended.

§5. *SICCATIVES AND DRYERS*

These are substances added to the paint to increase the rate of its oxidation, to aid it to absorb oxygen, or to cause it to harden or 'dry'.

Oxides of manganese and of lead are the best known, the strongest and the commonest dryers for linseed oil. *Siccative de Courtrai*, which is known in English by the name of 'strong drying oil', is made of purified linseed oil into which has been introduced the oxides of manganese and lead. It must be used very sparingly indeed and in fact has just as powerful an action in small as in large quantities! A siccative made with manganese

and no lead is preferable to it, but all metallic dryers are very dangerous. Boiled linseed oil and the copal dryers, such as 'siccative of Harlem' and 'Flemish siccative', are copal preparations and are considered preferable to the lead dryers. 'Siccative of Harlem' is composed of copal resin, poppy oil and oil of spike.

All siccatives should be used as little and as sparingly as possible—and very preferably not at all. This is the only and best rule for their use.

To retard the drying of oil-paints, copaiba in small quantities may be used.

§6. *GLAZING*

Glazing is now less used than it was in the past. A glaze consists of a transparent or semi-transparent coat of colour applied over another colour (which must be thoroughly dry) to get certain effects. The modern painter who uses glazes to the extreme possibility is my friend, Francis Picabia. I have seen late pictures of his where as many as three or four glazes were superimposed in certain parts. Sometimes where forms of six different colours met at a common point, a glaze was applied covering portions of all of them and thus giving rise to a very interesting if somewhat complicated *gamme* of combinations.

To explain: suppose that in a wheel with five spokes giving rise to as many divisions, each division was filled with a different colour. Let's say—red, green, yellow, blue and white. The surface adjoining the hub is then glazed with rose madder to a distance about half-way to the circumference. This transparent coating of red at once gives rise to five new colours: over the red, to a

OIL-PAINTING

dark red; over the yellow, to an orange; over the blue, to a violet; over the green, to a dark warm green, over the white, to a pink, etc. The possibilities of glazing may be, therefore, recognized at once as endless. It is a method, and is discussed here only for some purely mechanical technical hints in connection with it.

Of course, the surface to be glazed must be clean, entirely free from dust, and perfectly dry. The glaze may be applied in any medium or mixture of mediums having sufficiently adherent qualities: painting varnishes or pure linseed oil. An objection to glazes is, that they are liable to be removed at some future time when the varnish of the picture must be removed to clean it, but if the picture is properly painted and varnished, the time for this sad event becomes very problematical. In case the glaze does not take, Mérimée advises washing and carefully drying the part to be glazed with a mixture of water and grain alcohol, or mixing a little grain alcohol thoroughly with the glaze. I have never found this necessary. Rudhardt advises rubbing the portion to be glazed with half a raw potato or potato peelings, and rinsing and drying before glazing.

If your Glaze is not successful

And it requires a certain ability to apply a glaze successfully, it must be taken off. Of course, in glazing the canvas is laid flat, and a soft brush is used. The glaze is mixed in a white china saucer (mix too much rather than too little) and applied perfectly evenly and without streaks. Then, if you must take it off, go over it with a brush and some oil and wipe it off with a fine lintless rag, of silk, or old well-washed cheesecloth. Fresh breadcrumbs may then be sprinkled over it,

84

being careful not to get any pieces of the crust mixed in, and they are rubbed around with the palm of the hand. All the oil and colour will be absorbed by the crumbs and come off cleanly.

§7. *A FEW RULES FOR OIL-PAINTING*

Before leaving the subject, a few fundamental rules for the handling of oil-paints, based on simple common sense, may be again mentioned.

1. Always use the *simplest* ingredients possible and see that their quality and purity is beyond doubt. Good linseed oil and turpentine, oil of spike, or petrol are usually all that is needed.

2. Use as little siccative or dryer as possible.

3. Begin a picture 'lean' and finish 'fat'.

The more oil in the first painting and the less in the second painting the greater the danger of cracking. This rule is observed by all ordinary house-painters and is based on sound mechanical reasons. *Little* oil to begin, *more to finish.*

4. *Two* thin coats are usually better than *one* thick one.

5. Be sure that your paint is *perfectly dry* before painting over it, otherwise the under coat will contract as it finishes drying and crack the one over it which, being fresher, has a different rate of change.

6. If the paint does not 'take' well, rub the surface which is too smooth with a little piece of fine sandpaper, some powdered pumice, or water and a stiff brush. In the last case there will probably be enough dust on it to furnish sufficient abrasion.

7. *Never* use any more medium, or diluent for the

colours, or more simply, *any more liquid* than is necessary. The colours, if permanent, will stay fresh and luminous when left alone as much as possible. They are afterwards to be protected by a good final varnish.

CHAPTER IV

SUPPORTS

The paper, canvas, wooden panel or wall, sheet of metal or other material upon which a painting is executed is called the *support*. The materials in most current use today are: for paintings in the water mediums—paper; and for oil-paintings—canvas and cardboard. Paper usually requires little or no preparation, but the other supports are generally coated with a preparation suited to receive the paint which is called the *ground*, or priming. This ground, as will be seen on further consideration, is very important, more important than the support itself, for the life of the picture depends upon it.

Every picture is composed of three distinct elements:

1. The *support*, or material upon which one paints.

2. The *ground*, which covers the support and fits it to receive the paint.

3. The *paint* itself in one or more coats, which is applied to the *ground*.

Of these three elements the support, while certainly indispensable, is the least important. Nevertheless, logically it should be considered first, as it is the foundation upon which the assumed work of art is to be built.

This statement may require some explanation, and it is to be explained readily enough by the fact that restorers are so clever that they are able to remove any

picture which is painted on a proper ground, from its support and place it upon another one at will. Most pictures of any age in the museums have been re-canvased, or rebacked, that is to say, that their supports have been removed, one or several times. The process, no matter how cleverly or carefully carried out, naturally does them no good, and therein lies the reason to study supports as carefully as possible so that this tedious, delicate and costly operation of re-entoilage, or recanvasing, and its attendant risks, may be postponed as long as possible, or, better, made quite unnecessary.

§1. *CANVAS*

The two most popular supports—canvas and wood —are the two least durable. Some authorities say that canvas is the least desirable support, others that wood is. Canvas should take the 'booby prize'. Nevertheless it has several advantages. It may be bought ready pre-pared almost anywhere. It is light and pictures painted upon it may be taken off the chassis and rolled up for shipment. On the other hand, it is fragile and apt to be ripped or to have holes punched through it. It does not properly protect the picture from the back either from shocks or violence, or from dampness or impurities in the air. It is readily affected by moisture, constantly becoming loose and sagging when in the least damp, and getting tight as a drumhead again when it dries out. This elasticity is undoubtedly a great factor in cracking the paint. Chassis is another term for stretchers.

When canvas is primed with oil, if there is not an

impermeable coating of glue between to isolate them, the oil, which becomes acid in time, due to oxidation, eats into the material, drying out the fibres, and thus makes it as fragile as the thinnest paper. Furthermore, as the priming must be very flexible, so that it may be rolled up and take up little space in the art store, it is bound always to contain an excess of oil (usually rancid, and more supple in that state), which takes a very long time to dry thoroughly.

Good canvas should be at least two or three years old before it is used, as too fresh a priming will cause paint applied on it to crack. Rolling the priming between the fingers to see if it is flexible and adherent is not a conclusive test unless you know the age of the canvas.

The underpriming should be of waterproof casein glue, the only sort which has sufficient moisture-resisting qualities to be appropriately employed with another sort of backing. Casein glue is difficult to render flexible and so is very seldom used. Often the oil priming is put directly on the canvas, which absorbs the oil from the white lead, and in that case its life will be short indeed. Absorbent canvases are primed with glue without oil priming, or with but one coat. Though they give a mat surface which is fashionable and sought after by many modern painters, they also take up most of the binding material from the paint which is thus left in a fragile state. Their use is not very favourable to permanence.

Having now discussed some of canvas's advantages and disadvantages, and realizing that some 99 per cent of the people who read this will undoubtedly still go on using it, let us see the possibilities of producing the best results possible.

SUPPORTS

The chassis or stretchers should always be of the sort provided with 'keys', or stretching wedges (on any but the smallest pictures) or considerable trouble may be expected.

The canvas on the market is made of flax linen, linen and cotton mixed, cotton, hemp or jute. The worst of all is linen and cotton mixed, as the tensile strengths of the two materials are different. Cotton is not sufficiently strong or inelastic to be recommended. Pure linen is the best, although some authorities make claims for hemp, especially for larger canvases. One coat of glue as a preparation would be theoretically ideal, as it would be too thin to crack. But as this would not fill the pores sufficiently, more are usually given.

The glue or size, put on to isolate the canvas, should contain as little pigment (or colouring matter) as possible, or even none at all, as pigment makes it brittle. The oil priming may contain a small proportion of some non-drying oil such as almond or olive oil to help keep it supple, but this should never be over *one part* of non-drying to *twenty parts* of drying oil at the maximum. Canvases primed with white lead should have the last coat of priming put on with zinc white as this resists the action of sulphuretted hydrogen in the air and any possible chemical reaction, which lead priming might have in time to colours painted over it.

An old canvas of which the priming has turned yellow may be bleached white again by attaching a piece of blotting paper soaked in peroxide of hydrogen over its face with drawing pins (thumbtacks).

Several grounds, or primings suitable for canvas, will be given later when grounds, or primings, are described, but as few artists can be expected to prime

their own canvases, the best manner of choosing and employing ready primed ones will first be gone into.

1. The canvas should be of pure linen and as thick and heavy as is compatible with your style of painting.

2. If prepared with size only, try and insist on getting casein size.

3. If oil primed, make sure that there is a coating of size or glue under the oil priming. This may be sometimes seen by examining the edges of the canvas where the size or glue ground can be seen, in places where it has not been covered. Rub a bit of it with your finger, moistened with saliva; if it dissolves or softens, it is not casein.

4. If the canvas is oil primed, the priming should be sufficiently dry and hard so that it cannot be scratched with the fingernail.

5. Rolled between the fingers, the priming should not crack.

6. Good canvas, no matter how smooth, has always a slightly gritty feel or *tooth*—an important quality when working on it. If too smooth or soapy, the paint will not take on it properly. This last is also a sign of an excess of oil, bad from any standpoint, as the paint will not adhere and will be more likely to crack.

The ground of a canvas should be perfectly white, as oil-paint darkens on whatever ground it is applied to. Coloured grounds have a way of working up and darkening the whole picture as oil-paint tends to lose some of its covering power or opacity in time.

Stretching

To stretch a canvas on a chassis, or stretching-frame

(stretcher), lay it down flat, the prepared side underneath. Make sure that your chassis is perfectly rectangular and true by testing the inside corners of the chassis with a right-angled drawing triangle, T-square or a bit of string. The diagonals should be exactly equal. Place the chassis on the canvas *squarely* with the *sides parallel* to the *weave* of the canvas.

Special pincers with broad jaws which will grip the canvas without tearing it are necessary for any but the smallest pictures. These are called canvas-pliers and may be bought at any art shop. In testing them be sure that the jaws grip equally at each end. Small tacks are preferable to large ones, especially if you have to get any of them out again.

The generally accepted way of stretching a canvas is the following. For the purpose of explanation imagine that the sides of your chassis are lettered A, B, C and D, clockwise on the back, so that A is opposite C, and B opposite D. Lay your chassis true on the back of the canvas, fold up the edge of the material and tack it to the edge of the wood at the centre of A. Now with the stretchers pull the canvas taut and evenly across to C. Drive in another tack there at the centre edge, opposite the tack at A. If the warp and woof are not parallel to the chassis, undo tack C and try again.

Now pull the canvas to the centre of B. This needs considerable care, as the sideways pull should not be enough to distort the weave of the canvas, but sufficient to set it evenly tight between tacks A, B and C. Pull now to the centre of D. The canvas within the parallelogram of tacks, A, B, C, D, should be taut and even, the stretch between A and C and between B and D equal, and the weave of the cloth undistorted.

CANVAS

With the clippers pull taut the canvas to the right of
tack A and drive in a tack about an inch from the first.
Pull taught to the left of tack B. Drive in a tack one
inch away. Pull taut to the right of tack B, etc. Go on
round and round the edges till the whole is stretched.
When properly done the canvas should be fairly taut,
with no bumps or wrinkles and, seen from the back,
the warp and woof should lie undistorted and square
with the stretchers.

The job, which reads as rather complicated, is not
actually so in practice. It becomes very easy in time
and will be much facilitated if you at once get used to
manipulating the canvas stretchers with the left hand
and the tack hammer with the right. A magnetic ham-
mer is also a great convenience, as small tacks often
lead to bruised finger tips. If the chassis has keys, as of
course it should, a little play should be left at the
extreme corners. These should be tucked in neatly
after the keys have been driven and the canvas
brought to its final tension.

Protection of the Reverse Side of Canvas

Canvas, being hydroscopic or moisture absorbing,
should be protected from the back. Church found that
a piece of canvas only twenty inches long shrunk a
quarter of an inch through changing temperature. If
you do not care to prime your own canvas, buy double
the quantity you need each time. Stretch one piece
first with the primed side toward the back, next to the
stretcher (I am assuming that it is oil primed, if not, it
may be given a coat of paint). Stretch your other piece
with the primed side toward the front ready for paint-
ing. A similar protection may be attained for less

money by buying an oil-primed canvas and stretching it with the primed side toward the back and then priming the other side.

Dr. Wilhelm Ostwald says that two layers of tinfoil should be applied to the back of the canvas, by coating it with shellac and brushing the foil on as gilders do gold leaf when the shellac is partially dry. Then giving another coat of shellac and more tinfoil. He claims that this protection doubles the life of a canvas.

The waxing of the back of the canvas with a good wax varnish should also prove an excellent protection and one very easily applied. Two or three coats should be given.

The reverse sides of canvases are also often painted, as mentioned above. Do not try to do this to a canvas which is already stretched, after it is finished, as unequal tension may take place and the painting may buckle. It must be removed from the stretcher for painting and restretched after the paint is dry. First, it should be given a coat of ordinary glue dissolved in water (see 'Glues'); the solution should have about the consistency of thin cream; or a coating of shellac.

Toch advises the following paint for painting the backs of canvases as being neither too hard nor too soft, and never becoming brittle.

> 1 lb. red lead in oil
> 1 lb. zinc white in oil
> 1 lb. pure white lead in oil

Mix with half a pint of spirits of turpentine and half a pint of raw linseed oil. If the salmon colour of this paint is objectionable, lamp black may be added to produce a more neutral brown.

94

CANVAS

In rolling canvases, always remember to roll them with the *primed and painted side out* so that should cracks appear they will tend to close up again when the canvas is restretched.

Canvas is, of course, only suitable for certain sorts of painting, wherein the paint remains flexible. For egg tempera, wax painting and varnish resin methods, it is not sufficiently rigid or immobile. Those types of painting as well as that in which the paint is applied very thickly or in what the artists call 'impasto' should, of course, never be rolled.

Canvas may be purchased covered with gold leaf, or one may have it so covered by any frame-maker. This is not as expensive a process as might be imagined, except in the case of very large canvases, when 'aluminium' leaf may be substituted.

If you like a smooth surface to paint on, this method is excellent as the brilliant surface of the metal not only lights up the colours used upon it, but leaves little to be desired in the way of protection.

The very best way to treat a canvas is to marouflay (see 'Marouflage') over a panel of composition board, cardboard or wood, in which case it becomes part of a panel, thus obviating all its main disadvantages while retaining some of its advantages. In spite of the fact that museums when renewing supports seem to prefer canvas to panels, the authorities of the Louvre having transferred Raphael's 'Saint-Michel' and the 'Madonne aux Anges' of Rubens from panel to canvas, the disadvantages of canvas may be once more insisted on before leaving the subject.

1. It contracts and expands constantly with changes of moisture and temperature to such an extent as to

practically guarantee some cracking of the paint in the long run, particularly as the warp and the woof (criss-cross threads) do not respond to this phenomenon to the same degree.

2. It allows oxidation and gases to attack and penetrate from the back.

3. The fibre becomes brittle, requiring rebacking or relining.

4. It is mechanically fragile and affords little or no protection to the painting.

Some of these things may be due in part to the fact that as Oudry says: 'We are very neglectful in this respect: the merchant selling the canvas is only looking for profit; sometimes the painter buying it is only looking towards economy.'

When all is said and done, the slight convenience offered by the fact that canvas may be rolled up should not count in the making of such avowedly *de luxe* articles as oil-paintings and the statement of Maxmillian Toch that 'canvas is the least permanent of all foundations, as also claimed by Vibert, Dinet, Church, Ostwald, and most of the best-known experts, must be accepted.'

§2. *WOOD PANELS*

Wooden panels, whether in one single piece or in the form of the modern four-ply veneer, or what scene-painters call profile board, are the next most popular support. Mahogany is usually preferred. Teak, cedar and American or black walnut are recommended by Church, as 'deserving further trial', and he believes that tropical woods of different kinds 'seem very pro-

mising'. These might be investigated without too much trouble as the colonial propaganda offices of those countries possessing colonies as well as certain importers are very accommodating and ready to furnish data concerning their qualities. Veneer and profile board are other terms for plywood.

Good wooden panels are expensive and difficult to procure properly seasoned and treated. The necessary preparation and manufacturing process being difficult, as may be seen from the elaborate directions given by Eastlake and the fact that the Dutch Government some three or four hundred years ago passed a law wherein their manufacture was kept a government monopoly, and which made liable to punishment anyone found guilty of using other than the officially prepared panels. The reasons for this were stated as follows:

'. . . that the genius of an artist is the patrimony of his country, and that the former has the duty of guaranteeing the longest possible duration to the masterpieces to which he may give birth, and that this may be assured equal precautions must be taken in regard to all paintings; as be it understood, that a painter, however celebrated he may become, always begins by being unknown, and that he may happen by chance to be modest; and in consequence ignorant of the later value of the work he may be undertaking, he must not be allowed to compromise its existence by negligence or economy.'

It will be thus seen that the Dutch Government, if sincere, did not consider the first piece of wood which might come to hand as being suitable for a support for painting. Anyone who has worked with wood will at once admit the justice of this view. A well-seasoned

and sound piece of wood of the proper sort is a fairly safe support if thick enough (the thickness of course to vary according to the size of the panel), yet even a fit piece of wood should receive preliminary treatment quite apart from its being sized or primed.

It is generally admitted that after thorough seasoning the wood should be soaked in water of about 50 degrees centigrade, or steamed, or both; then it should be impregnated with some preservative solution such as corrosive sublimate dissolved in wood alcohol, and again seasoned in a warm room or kiln. Corrosive sublimate is mercuric chloride.

The soaking or steaming is intended to extract, at least in part, any surplus resin and to coagulate the albuminoids which are said to be the first cause of decay. The impregnation is against worms.

Properly prepared panels may perhaps be on the market, if so I do not know of them. Georges Malkine used to buy old furniture, which he broke up, using the panels thus secured. They had the advantage, at least, of being well seasoned. Even then they sometimes warped.

I have had in my possession for seven years a sunset, painted on the panel of a door in Brittany by Paul Gauguin, and in spite of the fact that this panel received no special preparation and was in fact simply executed on the grey house-paint with which the door had been painted, the colours seem to me to be more brilliant and transparent than those of any of his canvases which I have seen.

Wood and cardboard are sometimes employed with no preparation. Dinet and other writers on the subject think that this would be preferable if the 'materials

were perfectly sound and pure'. This is doubtful for reasons already mentioned, and furthermore the least trace of resin in the wood would penetrate the painting in the long run. Cardboard is machine made, and often contains (in the cheaper grades at least) impurities, and little particles of iron from the machines. These also may work up, and when there is no ground, play havoc with the painting to an extent that no amount of retouching would properly remedy.

Assuming that you are in possession of a suitable mahogany or oak panel which has been properly treated and seasoned, it should then be strengthened by a cradle, or special framework. Cleats are considered dangerous because they expand or contract at a different rate from the panel. It must then be sandpapered smooth, and the wood filled with a wood filler, which consists of Silex or Silica mixed in a quick-drying varnish, which may be purchased ready prepared. This, thinned with spirits of turpentine, is applied *across* the grain. After ten or fifteen minutes it may be rubbed lightly, and after one or two days the panel may be again sandpapered. It is then coated with any of the grounds given as suitable in this book, and is then ready for painting. Beware of shellac varnish, which readily dissolved in alcohol will make the picture liable to injury by a careless restorer.

Care should be taken in case of knots, as resin always accompanies them. They must be treated with patent 'knotting', shellacked or treated in any of the following manners which are common in use among French house-painters:

1. They may be burned out with a hot iron, a blow torch, or an alcohol lamp.

2. A solution of silicate of potash and water, half and half, with a little zinc white, may be applied to the knots. Silicate of potash is potassium silicate.

3. They may be covered with red lead. (Oxide of lead.)

4. A mixture of lead white, red lead and carpenter's or Le Page's glue may be applied.

For repairing holes or cracks in wood, a preparation called Plastic Wood, bought ready made, is excellent; or:

Thicken an oil varnish with a mixture of equal parts of white lead, red lead and slaked lime.

Make a paste composed of one part of slaked lime, two parts of rye flour and one part of flax flour.

Use shellac mixed to a paste with powdered pumice.

To those who object to the fact that wooden panels offer too smooth a surface, for those used to working on canvas, it may be mentioned that the weave of canvas is easily imitated on the surface of wood, and that the American painter, Gilbert Stuart, had panels prepared to imitate the weave of his favourite canvas, which he used for some of his later work. Furthermore, of course, the ground may be roughened by applying it with a stencil brush, tapping all over the surface, or by padding it with the palm of the hand.

Veneer Ply-Board

The prepared board, called four-ply, profile board, etc., is cheap, light and securable almost anywhere. It may be purchased very light in colour, and many painters paint directly upon it without a ground of any kind. This is most risky as it is very apt to split or warp. An old carpenter in the south of France told me that if

a cross were painted on the back with oil-paint—the lines going from edge to edge—containing plenty of oil, it would not warp. Ridiculous as this appeared, it seemed to work. A friend of mine to whom I recommended it even said that applied to a piece of board already warped, it pulled it back into shape.

Everything depends on the materials and the way the four-ply is manufactured. *It should be glued with casein.* Four-ply wood, while suitable for small pictures, whether prepared or not, must be considered risky at best.

Modern ply-sheets are usually lathe-cut, and the surfaces have a tendency to wrinkle between small cracks towards their natural curved form. However, $\frac{1}{2}$-in. or $\frac{3}{4}$-in. plywood panels are dependable for very small pictures if the plywood has been aged thoroughly for two or more years.

Conclusions in general as to wood cannot be much more optimistic than those connected with canvas. It may be used to back marouflaged canvas, or, when of exceptionable quality and in one piece, for small pictures, if for some reason you are particularly attracted to its physical qualities, and technical possibilities. There is *no possible guarantee* against its warping or splitting, and it can never become sufficiently seasoned so that it will no longer warp. Batons cannot be attached in a safe way to guarantee against its warping. The ancient painters advised boiling it if possible before using it, but even this heroic procedure is no real guarantee. If you must use it, marouflay canvas on the side you are going to paint upon, and prime it coat for coat, back and front. Hot wax may be used as a varnish on the back of wooden panels when the front is

painted with oil-paint. Hard paraffin wax is best for this purpose.

§3. *CARDBOARD*

A great prejudice exists against this common and easily procured material, probably because of its low price. It seems certain that it is superior to both canvas and wood as a support for painting. It may be procured today of excellent quality and in practically any size and thickness desired. Paillot de Montabert, writing over a hundred years ago, says: 'It is very probable that if the ancients had known of rag paper, and consequently cardboard, which is made with old paper, they would have made use of it for their pictures. As a matter of fact, we should consider well-made cardboard as a very proper support for painting. It will not crack, does not work under the effects of dampness or dryness, and consequently does not warp. It can easily be preserved from destruction by worms.' It may be primed and protected from damp in the same manner as wood and, of course, canvas may be marouflayed to it.

The back of cardboard may be protected by treating with hot paraffin wax and resin preparations, by a coat of nitro-cellulose lacquer, or by any of the preparations used to protect the back of canvas, or any good damp-proofing solution-shellac dissolved in petrol, etc.

For small works first-class water-colour paper treated and grounded like canvas provides one of the best supports possible.

CARDBOARD

Composition Boards

Millboard, which is usually made of wood pulp, oakum and straw pulp, and many patent composition boards, such as Masonite, Tempered Masonite, Carnell Board, Prestwood, Eternite, etc., are on the market today. Most of them should be *excellent supports for painting* although, of course, the materials will not last longer than the substances out of which they are made. Thus, cheap straw-board made from soft woods will perish far more rapidly than panels made from compressed hardwoods.

Dark hardboards such as Masonite and Prestwood are bound in a water-resistant resin, and should not be sized, since water-glues will not penetrate. They should be primed with Hardboard Primer or an Oil Primer directly on the surface. Tempered Masonite should not be coated with glue size, but it can be painted on directly, or after applying an oil ground to it. Untempered Masonite should be treated in this way: Give its smooth surface an alcohol wash, dry it off, then apply the glue size and the ground.

§4. *METAL SUPPORTS*

Metal supports have been used in painting for years, particularly by the Dutch, who used copper. The surface of any metal to be painted upon needs no other preparation than being rubbed with coarse sand or emery-paper to give the paint better adherence. My friend Collin suggests that it should be sand-blasted, and J. B. Corneille advised rubbing it with a half a head of garlic, that is to say, with the flat side of a garlic cut in two.

Copper and zinc were much used in the past, but aluminium seems to be an ideal modern material. It is light, not very expensive and may be procured in practically any size or thickness. The manufacturers of nitro-cellulose motor-car enamels sell prepared grounds, having a great adherence to metal which, as they contain a little oil, are most suitable for painting upon with oil-paint. Good motor-car bodies are all made of aluminium, and we have doubtless all seen accidents which sufficiently prove the adherence which paint may attain on this metal. Processes which stand the extremes of temperature, moistness and dryness to which motor-cars are constantly subjected, need not excite much doubt. Few paintings would ever be put to such a test. Dr. William Ostwald, of Munich, says: 'Aluminium offers a more appropriate painting ground than copper. When exposed to the atmosphere it forms on its surface a transparent and imperceptible film of oxide which retains oil-colours very firmly. Even on unprepared surfaces of aluminium it is possible to paint very easily, for it possesses a peculiar tooth so that one can readily lay on successive coats of paint, stroke by stroke. . . .'

It should be in any case both suitable and safe if primed with one of the prepared products mentioned, and should provide as near to an ideal support as we possess today.

§5. CONCLUSION

To sum up regarding supports is very simple as there is no subject connected with the materials of painting which should excite less controversy nor about which there is less doubt.

If you can help it:

CONCLUSION

DON'T USE—

Canvas or Wooden Panels.

USE—

First-class Water-Colour Paper.
Heavy Cardboard of a good quality.
Good Millboard.
Exploded and recompressed Hardwood Fibre Boards.

(In which case get into touch with the manufacturers, explain to them the use you wish to make of their products and follow the advice they are ready and willing to give.)

Aluminium in sheets of suitable thickness (the thicker the better).

CHAPTER V

GROUNDS

In the case of any sort of support, except canvas, to paint directly upon it is possible, and often desirable, without any special preparation to receive the colour, but there are also disadvantages so that it is seldom done. In the first place, except in the case of aluminium, which has been rubbed with emery cloth or powdered emery, the materials are usually too absorbent and do not offer a pleasing surface for the application of the colour. In the case of oil-paint, remembering the tendency to darken and become transparent with the passage of time, it is always preferable to have a pure white surface underneath to neutralize this defect. Paintings executed on coloured grounds—a proceeding which was very popular in the seventeenth century—furnish a striking example of what usually happens in such a case, as they are, almost without exception, now dark and heavy looking. Because dark surfaces are harder to cover there is little labour-saving involved by omitting the ground and, in general, a suitable and carefully chosen ground should be used, and it should *without exception be pure white*.

Different mediums require different grounds as do different methods of working. Every ground has peculiar and distinctive qualities of its own. Absorbent grounds require one method and non-absorbent ones

GROUNDS

another. Grounds for distemper or egg tempera are usually mixed with water; those for oil-painting more often, though not necessarily, with oil. As canvas is the support in commonest use and oil-paint the more current medium, grounds suited by their flexibility for use on canvas will be first considered. There are several recommended ready prepared grounds on the market, and those of us who would rather save time, or who have not the facilities for preparing grounds in the studio, have only to buy one of these.

The usual disadvantages of ready prepared canvas have been mentioned, and, of course, must be avoided when the painter prepares his ground for himself. Grounds for canvas are the most difficult to make, as, added to the necessary qualities of *whiteness*, *resistance to moisture*, *freedom from chemical reaction* on the canvas and on the paint, and *great durability*, they must be *elastic* so that they may move with the canvas as it contracts and expands and can be rolled up with no fear of cracking. We have seen that linseed oil oxidizes or 'burns' canvas, which should always be treated with a neutral glue before applying an oil ground to stop this from happening. Furthermore, a ground should be rot-proof, worm-proof, microbe-proof, absorbent enough, but not too absorbent, and imperishable as well as impermeable. This is no small order.

Oil primings are used by the dealers because they are convenient for shipping, rolling up and keeping; they are also cheap and easily prepared but do not fill the bill. Oil takes years to dry and, contracting as it dries, constantly becomes less elastic. It is often too 'fat' to give good adherence to the paint.

I had with a fair measure of success used a certain

quality of canvas prepared in Belgium for a number of years. Suddenly the quality changed. It cracked while I was stretching it. One day my stretcher slipped while I was driving in a key, and the mere contact with the corner of the stretcher was sufficient to rip a hole in the canvas. The foreman in the factory had either been taken ill or lost his job and this brand of canvas has never been of the slightest use since. It is irritating to be dependent on circumstances entirely out of one's control.

The formerly used organic grounds are being replaced by a number of newer compounds. The pigment component is typically Titanium White plus Calcium, Magnesium, and Aluminium Carbonates and Silicates. The base is apt to be an Acrylic Polymer Latex. Such grounds may be used with the newer 'Quick Drying Underpainting Whites' which dry in two to four hours. These Whites would be used for a wide variety of textural effects.

§1. *THE GROUND COAT OR UNDER-PAINTING*

Before going into the subject of grounds, it might be well to mention in passing their effect upon painting in relation to what the French call the *ébauche*, which may be translated as under-painting. In the cases where the painting is finished in one sitting, this coat is the whole work, or this is only another way of saying that the under-painting forms the painting, or that the painting consists of one coat only. From a technical standpoint, this method leaves nothing to be desired, but for most painters, it is too limited to be practical.

GROUND COAT OR UNDER-PAINTING

When more than one coat of paint is applied, the under-painting is supposed to have special qualities and functions of its own. For certain mediums there were—and perhaps still are—conventionally stipulated colours used in this under-painting, arrived at by a common experience and agreed upon as being the least likely to cause future trouble. The under-painting should always be 'lean', that is to say, poor in oil, or made with diluents—a rule observed by all house-painters, so the coat or coats to follow may be sufficiently absorbed to have proper adherence.

It is not within the scope of this book, or the desire of the writer, to go into *method*, as every painter should find or adopt one suited to his individuality, but methods of under-painting are inseparable from technique, and a few ideas of painters and writers on the subject may at least give a notion of the mechanical principles involved. Technically also, the under-painting may be considered as it has so often been in the past, particularly in the Middle Ages, as appertaining directly to or really a part of the ground.

Cennini's Method

Cennini, after giving full instructions for building up and finishing a glue and plaster ground (which will be given later), writes as follows about the manner of beginning work (see C. J. Herringham's *Translations*, 3rd Edition, page 101):

'When the plaster is as smooth and polished as ivory, the first thing that you should do is to draw on this panel or board with willow charcoal, which I have heretofore taught you to make. But this charcoal should be bound to a little cane or stick, so that it should be

as long as the face, thou wilt thus find it more agreeable to compose with.' (The place of this stick is now usually taken by a crayon holder.) He then mentions rubbing with a feather for corrections, as the little pieces of chamois skin are now used, and advises you to lay aside the drawing a few days if it is of any importance, so that you can make your corrections in a more leisured manner, thus showing that his ideas differed from those of many modern instructors as to working 'in the hot fever of inspiration'—a state in which he apparently had little faith. He goes on to advise the copying of the 'great masters' when there is an opportunity for doing so and then: 'take the said feather, rubbing little by little on your drawing until thou hast made it almost entirely disappear, but not enough so that thou losest entirely trace of the lines. Take a vase half full of clear water with a drop of ink, and with a little pointed brush of miniver strengthen thy drawing everywhere. Then with a bunch of feathers brush off all the dust of the charcoal, then with a wash of said ink and a little soft squirrel brush shade the pleats and the shadows of the face; thus there will remain a vaporous drawing which will render everyone to love thy work.' He goes on to give precise directions as to the laying of the ground coat, which in his time was done as was usual with the entire picture, in egg tempera, advising us to work from dark to light, and always with the same precision. The precision necessary from medieval practice often made necessary the use of cartoons and tracings, and the reasons for all this care in the under-painting seem to have been about as follows:

1. To avoid the necessity for alterations and repaint-

ings which might tend to destroy the luminous quality of the white grounds.

2. To avoid the necessity for loading the opaque colours which considerations also led to the mixing of as many tints as possible before the actual painting was begun. What an amusing contrast to the modern method of using the canvas or panel as a palette.

Eighteenth-Century Methods

In the eighteenth century many painters made the under-painting an integral part of the priming by giving it a coat of colour suitable to the subject they were to execute. This under-painting was usually tempered with the same ingredients used in the priming. This method has certain advantages and there is no objection to it if the colour used is very light, otherwise it is apt to work up in time and affect the colours of the painting.

Under-Painting in Different Mediums

Often the under-painting was carried out with the pigments tempered with glue (distemper), or according to Vibert, in pigments tempered with gum, that is to say, a sort of gouache or water-colour. In still other cases, the painting was begun in egg tempera and finished in oils.

Vibert advises beginning the painting with 'ordinary water-colours' and then varnishing this under-painting with painting varnish which will be partially absorbed by the water-colour and can be painted upon even before it is dry. He gives another method by which the oil-painting is done on paper, and, as this might come in very handy for work while travelling, I will repeat

it here. His method of painting on paper is to simply begin your work in water-colour, carrying it as far as you wish in that medium, and then coating it with one or two coats of water-colour fixative, depending on how absorbent the paper is. His water-colour fixative is a secret preparation, which dries at once, and the work may thus be continued in oil without loss of time. The water-colour fixative has a highly characteristic odour, body, viscosity and volatility. It may be quite safely assumed that it is nothing more or less than what is commonly known as 'banana oil' or 'banana solution', which is in common use as a vehicle for the application of gilt bronze powders. This 'banana solution', so called because of this highly characteristic odour suggestive of bananas, consists of:

Water-Colour Fixative—Banana Solution

Equal parts Amyl Acetate, Acetone and Benzine in which is dissolved just enough Pyroxyline to give desired body. The liquid should have the consistency of a rather thin syrup. As it is very volatile, it should always be kept well corked. It is highly recommended by Vibert in the form of his somewhat expensive 'water-colour fixative' to be used as a priming for cardboard, wood or canvas, either alone or as a vehicle for zinc white in powder. I have *not* found it ideal for this purpose as its manipulation is difficult, because it dries so quickly, but it might be used for this very reason if a ground or priming was needed in a hurry. Pyroxyline is nitro-cellulose. Collodion can be used.

Methods of Da Vinci, Fra Bartolommeo, Titian, Correggio and Paul Veronese

Vibert claims that the method of beginning in water-

colour and finishing in oil was the one employed by Paul Veronese, but Mérimée differs from him when he says: 'One may see in Florence a picture by Leonardo da Vinci, and another by Fra Bartolommeo, which are only laid in, they are drawn in outline with a brush, and then washed and shaded like a sepia drawing, with a brown colour, which one may recognize as bitumen.

'The method of under-painting by a sort of wash in a single colour was doubtless that of Van Eyck, it was constantly followed by the chiefs of the Roman and Florentine schools.'

Titian, and those who followed him, did their under-painting thickly; they doubtless found that they arrived at the same result of transparency by terminating with glazes. Moreover, this method procured them the advantages of making such changes in the under-painting as might come to mind. Correggio, and the painters of his school, under-painted thickly and often in cameo (one colour and white). Paul Veronese, like Titian, under-painted thickly, and very often, on canvases primed with distemper—he under-painted in colours with a water medium (distemper).

In any case, it must be remembered as far as oil-colours are concerned that as the painter David said— and as Guy Pène Dubois rightly insists—that *to paint over mistakes without thoroughly scraping out what is underneath makes for bad work*. The mistakes will certainly come through and show themselves most undesirably in time. This accounts for the six-legged horse by Velasquez in the Prado.

Method of Van Eyck, Dürer, Van Leyden and Breughel

Another method of under-painting which I have

found personally very useful is described by Van Mander, who tells how his predecessors (naming Van Eyck, Albert Dürer, Lucas Van Leyden and Peter Breughel) laid their white or flesh-coloured grounds, their use of cartoons, etc., and the outlines once drawn 'they then delicately spread over the outlines a thin (oil) priming through which every form was seen, the operation being calculated accordingly'. This priming may have been flesh-coloured, because of the use of sandarac resin, which is reddish in colour.

§2. COMPOSITION AND MATERIALS FOR PRIMINGS

Before going into the actual recipes for grounds and primings, or discussing their respective advantages and disadvantages, I should like to note a few general hints which were found invaluable to remember while manipulating the ingredients.

Whenever possible use your priming as thin as is compatible with the result you are after—one coat—if this proves sufficient. A thin ground is much less likely to crack.

If using a glue pot, have it with a sufficiently wide mouth to take a very wide, flat brush. You may wish to do some big canvases or walls sometime.

Don't be a plumber on your own time. Laying a ground is sometimes a somewhat complicated operation. Plan the work, make a list of everything you will need and check it before starting operations. Go over the job in your imagination, taking account of everything which will be needed. If you are forced to run out every few minutes, the glue may get cold.

MATERIALS FOR PRIMING

A rough surface is much *easier* to paint on with oil-paints; it allows easier and quicker brush work, and the time gained may make it possible to finish in one sitting. If you want a panel rough, tap the ground with the end of a blunt stencil brush while the priming is still soft, or touch it all over with the palm of the hand while it is half dry. If this leaves it too rough it may be smoothed a bit with sandpaper. Or use a rough-grained canvas (marouflayed, see page 157, or not) and coat it thinly. A rough ground may be somewhat more absorbent than a smooth one, as the adherence is always better.

Tooth

Tooth may be given to a ground by mixing pumice powder, sifted sand, ground glass, marble dust, or similar substances in with the priming. The ready prepared priming 'Case Arti' has quite a rough grain as it comes from the box. I had to sift it as I wanted my grounds smooth.

If you want your grounds smooth, be sure and have the brush you apply them with perfectly clean, otherwise there are apt to be lumps appearing aggravatingly from it in quite an astonishing number.

In priming a canvas on a chassis, do not have it tightly stretched before applying a priming of hot glue. It may shrink to such an extent as to break a strong stretcher or split even a tough canvas. Again, chassis is another term for stretchers.

A glue priming will deform even a thick panel in drying. Be sure to prime both sides at the same time.

If you wish to prime a canvas with a glue priming,

wax it on the back to keep out moisture—or prime the 'reverse side' of an oil-primed canvas.

In priming cardboard get it under pressure as soon as the glue or size will permit and keep it flat until thoroughly dry. It is easier to stop cardboard from warping than to flatten it afterwards.

Primings and Grounds Discussed Generally

Primings and grounds are, of course, made up on the exact principle which is used in making paints. There is a binder and a powder, or pigment, used, and a ground or priming is really no more than a preparatory coat of paint which is applied to isolate and protect the support and to furnish a pleasing and appropriate surface for the assumed work of art which is applied to it. The binders, as in the case of paints, are usually organic substances, animal or vegetable in origin; the pigments inorganic. The commonest binders are animal glues made from skins, hoofs, horns and bones, casein glue made from milk or vegetable glues such as starch paste, gum arabic, etc. The frequency of use of sugar, honey, glycerine, eggs, milk and cheese makes the reading of some of the ancient manuals quite appetizing and more than faintly reminiscent of cookery books.

The simplest and handiest, but not the safest, way of isolating a panel from an oil priming is to apply one or more coats of shellac. A thin coating of shellac may even be used for the same purpose on canvas.

Shellac

Orange Shellac	2 pounds
Denatured Alcohol	¾ of a gallon

Or in proportion—i.e. two pounds to three quarts, etc.
The canvas or panel may then be coated with a good,
lean house-paint. This is one of the simplest and quickest
methods known, but not by any means the best. Firstly,
the house-paint must be allowed to dry for a very long
while (six months at least) before being painted on. It
should be sandpapered before use to assure adherence.
Many ready prepared canvases are done in this way—
sandpaper them lightly before using. This method of
priming has two great disadvantages beside the fact
that one is forced to keep them in the studio for months.
The first is that should alcohol ever be used by a
restorer, a very common use, the shellac is soluble in
it and the result may be imagined. The second is that
the house-paint or oil priming will certainly crack in
time.

§3. GLUE GROUNDS

Parchment Glue

Parchment glue is generally considered the best
animal glue. It is mentioned and recommended by
Theophilus, Cennini and Watin, who was 'Varnisher
to his Majesty King Louis the Fifteenth'. C. F. Collin
uses it exclusively and successfully. He follows Cen-
nini's instructions. The ancients were not quite as sure
of its superiority as our contemporaries are, for Cennini
says it is the best 'if thou hast no joiner's glue'. Theo-
philus remarks, after giving a recipe for casein glue,
and one paralleling those used for our ordinary strong
glue, 'that made from parchment (vellum) scraps is
also good'. Parchment glue is chiefly useful for grounds
in tempera painting, which is what Cennini used it for,

GROUNDS

but it should also prove excellent for isolating any sort of wood or canvas support. Hide or rabbit-skin glue may be substituted for parchment glue.

Preparation of Parchment Glue or Size (see 'Distemper Painting').

Other Animal Glues

The preparation of this parchment glue is not altogether simple. Unless dried, it will not keep over a few days. The parchment scraps must be thoroughly washed, and the cooking carefully performed with attention paid to the temperature, which must not get too high. Its use cannot be expected to appeal to many readers in these hurried times.

The best ordinary glues are made in France and Scotland, but excellent qualities are now manufactured in the United States and may be bought ready prepared and substituted for the parchment glue above described. Any *good quality* of glue will do. Fish glue is excellent and has centuries of tradition behind its use. A good substitute in France is the ordinary 'colle de peau' or 'Totin' which may be had at any colour shop. Ruassi Cement or Le Page's glue may be used with all confidence. Gelatine is recommended by almost all the authorities as being equally good as a first priming. Personal experience has prejudiced me against it. Except when used very thinly, I believe it to be dangerous; it contains too little chondrin (a substance obtained from cartilage). Also if it gets at all damp it may attract microbic disease and moulds. Glue may be purchased in hard sheets in which case:

GLUE GROUNDS

To Prepare Glue

Put a pound of glue to soak overnight in a quart of cold water.

Place over fire in *double boiler* and add more water until the solution has the consistency of thin cream. It should be no thicker. Better let it cool before application to the support.

To be sure that the glue used is properly neutral, it should be tested with dahlia and litmus paper for acid or alkaline reaction. It should not turn blue litmus paper red, bleach dahlia paper, nor turn tumeric paper brown. If acid or alkaline, it may be neutralized; when acid, by carefully adding the necessary amount of ammonia while testing from time to time; if alkaline, by the addition of vinegar. Litmus papers are sold in drugstores in the U.S.

Several methods exist for making glues hard, elastic or waterproof. Many interesting experiments are possible.

To Render Glue Supple

Puscher, of Berlin, recommends the addition of glycerine to glues to prevent their becoming too brittle. It is preferable to the honey, sugar or similar substances used by the ancients for this purpose, because of its antiseptic qualities, this being less perishable and less attractive to insects. A safe rule is to add a little glycerine to every glue solution that you use. The exact amount should be determined by experiment, depending upon how flexible you desire the glue, but a tablespoonful to a pint is generally about enough.

C. F. Collin makes his grounds following Cennini's

method. It requires some patience. He buys fine dental plaster which is soaked:

1 part plaster to 10 parts water.

The plaster is poured into the water and stirred immediately and almost uninterruptedly for an hour to prevent its setting. Do not be deceived by the apparent thinness of the mixture. The receptacle is then covered to keep out dust and allowed to slake for three weeks, stirring a few minutes every day. If the water grows foul it is poured off from the top and fresh water is added. The more frequently the water is changed the better. At the end of three weeks the plaster, as much water as possible having been poured off, is made into little cakes somewhat resembling fish balls, and dried, being kept for use as needed.

There is no doubt about the excellence of this ground for priming wood or composition panels. It has stood the test of time and has a beauty of its own, but its preparation may be considered by some of us to be somewhat onerous. Furthermore, it is so absorbent that it could not be used by all painters even for painting in egg tempera. For painting on in oils, I advise a thin coat of mixed lead and zinc white, thinned with turpentine or prepared petrol, applied before painting upon it.

There are several grounds which may be more easily prepared if a priming of this nature is desired. Here is one recommended by the painter Carlos Merida:

For half a square yard of canvas bring 2½ glasses of water to a boil, add:

Glycerine	35 drops
Honey	20 ,,

GLUE GROUNDS

Whiting	6 handfuls
'Fishtail'	7 sheets

The fishtail is a prepared glue sold in the United States under that name.

Goupil uses a ground composed of:

Gelatine	1 part
Glue	1 ,,

dissolved in skimmed milk in proportions so that it will be thin but slightly syrupy. Whiting or zinc white in powder is then mixed in; the first coat is given thinly and the second rather thicker. Not over three coats should be used for fear of cracking.

Louis Hess gives the following recipe for priming:

4 oz. fine slaked dental plaster.
1 teaspoonful parchment glue.
1 teaspoonful cold unboiled milk.

Grind together. Then grind in one teaspoonful of long oil varnish (boiled linseed oil).

If the paste is too thick, add a teaspoonful of water and the varnish afterwards. Then add four or five drops of ammonia to eliminate possible acids.

By substituting whiting for the plaster, and ordinary glue for the parchment glue, this ground becomes quite simple to make.

Gesso

Gilder's whiting	12 oz.
Gilder's parchment size	9 ,,
Cold-drawn (cold-pressed) linseed oil	3 drops

Melt the size in warm—not hot—water in a clean

basin. Sift the finely ground whiting into this, mixing it in a warmed mortar. Add oil. Pour off into the basin and stand in a cool place twenty-four hours before using. To thin the size add water; to thin the gesso add size. In applying ornaments to a gesso ground, after every third coat give the modelling one thin coat of orange shellac. Keep the gesso at blood heat while using it. If the brush clogs, wash it out in warm water.

J. E. Southall in *Papers of the Society of British Tempera Painters* (vol. 1, 1901–7, 2nd Edition, page 4) says, in discussing gesso:

Whiting versus Zinc White

'For our ordinary work, whether panel or canvas, what more do we desire than gesso! It is intensely white and has the enormous advantage of having successfully emerged from the test of time, the only thoroughly exhaustive test.

'The first requisite in a ground for tempera [allow me to add: or oils for that matter] is surely that it should have an intense power of reflecting light, and that that power shall be permanent. Can we say that either white lead or zinc white are sure not to become less opaque in time?' He adds in a footnote that a little zinc white is to be recommended for its antiseptic qualities, 'for where oxide of zinc is, there fungus will not grow'.

M. Lanchester in the same publication (vol. 2, page 117) thinks that whiting is better than slaked plaster as it has more body. This belief has other reasons to support it for chalk is always used by builders for foundations, sewers, and in fact any place where dampness must be withstood, in the place of plaster.

GLUE GROUNDS

A writer signing himself 'M.S.F.' has the following remarks to make anent Gesso Duro:

'Personally, I avoid a *gesso grosso* (unslaked plaster) or a *gesso sottile* (slaked plaster) ground as having too quick a suction to allow time for "premier coup" manipulation [he considers these grounds too absorbent]. I have found one possessing this quality of slower absorption in a modified form of the *gesso duro* of the Italians, the base of which is very similar to the frame-maker's "composition".'

A Gesso Duro Ground for Tempera Painting

Raw linseed oil	1 part by measure
Best Scotch glue	1 " "
Powdered resin	¼ part by measure
Whiting	From 3 to 4 parts

when moistened with parchment size. Best Scotch glue is a fine hide glue.

Strain the oil through muslin to remove impurities. Measure. Soak glue overnight in clean, soft water and measure the swollen pieces without liquid. Melt in glue pot. Powder resin in a mortar and strain through fine muslin; measure. Soak whiting to a stiff paste with parchment size.

Heat oil in a double boiler, add resin little by little, sifting it into the oil and stirring continually till the two are completely amalgamated. Into this thickened liquid pour the measure of melted glue and stir thoroughly till the whole is a stiffish liquid. Take another earthenware pot and mix equal quantities of this hot liquid and of the soaked whiting; keep this pot warm while stirring the ingredients into a smooth

cream. This constitutes *gesso duro*. An excellent, brilliantly white gesso ground suitable for painting is made in London under the name of Crossland's flexible gesso. Sold mounted on boards and backed with silver paper it is an ideal ground.

The grounds given up to this point all have animal glue for a base, which is not considered ideal by most authorities. It is difficult to handle, as if the glue is too 'strong', that is to say too thick, it will crack. If a thick ground is wanted, it should be applied in a number of thin coats. The first coats should be thin enough to penetrate well into the support, the later coats may be somewhat thicker. Animal glue is also hydroscopic, an obvious disadvantage. Its advantages are cheapness and ease of its preparation. Also it dries and hardens quite promptly. Glue may be affected favourably and some of its disadvantages partially overcome by the additions of certain ingredients. Thus in certain recipes linseed oil, cooked or raw is added. Its presence toughens the glue and aids it to resist damp, as do the resins or varnishes mentioned in other recipes. Shellac, either in alcoholic solution or dissolved in water, is also added to harden and strengthen the glue.

To Dissolve Shellac in Water

Shellac in scales	$3\frac{1}{2}$ oz.
Borax	2 drachms
Distilled water	1 pint

(2 drachms = $\frac{1}{4}$ oz.)

Must be boiled a very long while and may then be passed through filter-paper giving a syrupy liquid. It may be bleached by adding peroxide of hydrogen in

quite a large proportion and then allowed to re-thicken by evaporation. White shellac is much harder to dissolve than the orange shellac. Orange shellac will dissolve in ammonia at room temperature in about five weeks; white takes two or three months. Picture varnish and linseed oil added to glue are said to furnish a very tough ground which is kept elastic by the addition of glycerine. The possibilities for experiment are almost endless.

To Make Glue Grounds Less Absorbent

Glue grounds which are to be painted upon without an oil priming may be rendered less absorbent by:

1. Giving them a coat of clear size.

2. Giving them a coat of milk, buttermilk, or thinned evaporated milk diluted with water.

3. A coat of Van den Velden's ground manufactured by the Weimar Paint Co.

4. A coat of zinc white tempered with yolk of egg.

5. C. F. Collin gave me the following method as practised by the English expert on technique—G. Tudor Hart—which is also applicable, as are most of these methods, to a casein ground, in which case it should be used while the ground is still damp.

A coat of half zinc white and half lead white in oil and egg emulsion, to which has been added half its volume of water. Let this dry in mat (it takes from twenty minutes to two hours) then lay on a second coating of the same medium, brushing in opposite direction but adding no water. Let this dry several days and you will have a fine semi-absorbent ground excellent for oil or Venetian method painting. Pumice lightly and rinse off with a damp cloth before using.

All of these glue grounds should be wiped off with a damp cloth before being painted on.

An excellent all-round Ground which is simple and quick to do

This is made by mixing zinc white with yolk of egg and water. The longer it is allowed to dry before being used the better, but it may be employed as soon as it is sufficiently hard. It becomes practically waterproof and is particularly good if applied to the reverse side of an oil-primed canvas. It may be used on any support except metal, and dries so quickly that the required number of coats may be applied one after the other almost at once. It may be painted on with any medium.

§4. *CASEIN GROUNDS*

Casein is a substance obtained from milk. It resembles albumen in its general properties. Formerly the name 'casein' was given both to the precipitated substances now known by that name and to the corresponding substance as it exists in solution in the milk; but at the present time the latter is usually distinguished as 'casein-ogen'. Casein is insoluble in water, but dissolves easily in alkaline solutions. When freshly prepared it is soluble in a strong solution of borax, and in this form is used as an adhesive under the name of 'casein glue'.

It is considered by most authorities as an ideal ground, and its only disadvantages are that it is somewhat difficult to manipulate and I have found it apt to be brittle in any but the very thinnest of coats. It has years of tradition behind its use showing that when properly used it is of extreme durability and perma-

nence. The very best and purest casein must always be employed and samples vary greatly as to quality and strength, making the giving of exact formulae somewhat difficult.

Any good frame-maker will lay grounds for you and there is old precedent for this as in the archives of the Duomo at Treviso, dated March 1520 and published by Federigi (*Mémoire Trevigiane*, Venezia, 1803). The note dated '7 Marzo 1520' says: 'To Mistro Lio, who made the panel, to buy cheese to make the glue for fastening the planks of the same, 1 soldo——' and on the 13th October 1521, 'To Mistro Zan, the gilder [part of his account], for having laid the gesso ground on the altar-piece, 3 soldi.' The panel in question was afterwards painted by Fra Marco Pensabene, who, fitly to his name, had the good sense, since he could apparently afford it, of leaving his dirty ground-laying to 'Mistro Zan Indorador'. Casein is a tricky thing to get right and Uccello knew more about it than he cared about if the story, told by Vasari, in his *Vita de Paolo Uccello* is true. According to this, he quit a convent where he was at work, because the brothers fed him on nothing but cheese. He fled if he saw his employers in the streets, but being at last caught by two friars, who outran him, and being questioned as to the cause of his deserting them, he confessed that he was tired of their diet, adding that he was afraid of being metamorphosed into cement.

§5. *VEGETABLE GLUES*

The French chemist, Mérimée, had occasion to examine and analyse a piece of the ground on which a

picture by Titian was painted and he found plaster and starch, but no gelatine, which of course led him to the conclusion that the plaster was tempered with some starch paste which he supposes to have been made from flour. The canvases of Paul Veronese, he states, were prepared in a similar manner. Vegetable glues may be used in place of the animal ones, discussed above.

Starch Paste

Sir Arthur Church gives this recipe for making starch paste: ' . . . For the limited uses to which it is put in artistic practice, uncoloured or white starch should be selected. The starch from rice, wheat, maize or potatoes may be employed indifferently. Arrowroot may also be used. The preparation of starch paste does, however, require some care. The best plan is to thoroughly agitate 50 grammes of the dry powdered starch with enough *cold* water to produce a liquid of creamy consistence, and then pour this mixture slowly into a vessel in which about 300 cubic centimetres of distilled water is kept in steady ebullition. [300 cubic centimetres is three-fifths of a pint.] All but 2 per cent of the starch will dissolve into a nearly transparent homogeneous paste; the quantity of starch must be reduced, if a thinner liquid is desired.' (50 grammes = $1\frac{3}{4}$ oz.)

Similar methods were employed in the past. I have seen old books where rye flour was highly recommended. Dessaint recommends rice flour or rice starch as being by far the best and speaks of its common use in the Far East. When a white ground is wanted some or any of the white pigments described with the animal glue recipes may be used, with the starch paste, plaster, whiting, zinc white in powder, etc.

OIL PRIMINGS

§6. *OIL PRIMINGS*

The support treated with one or two thin coats of any of the above preparations may be primed with an oil priming if oil-paints are to be used. The oil priming is not necessary but it is generally used. This is a matter of personal taste and preference. Church advises a priming of white lead, copal varnish and linseed oil (with borate or oxalate of manganese added to it as a dryer). The coats of oil priming should be brushed on, one at right angles to the preceding one, and each coat should be sandpapered so that the next 'takes' well. In the case of canvas, to insure flexibility, one part of a non-drying oil, such as olive oil or almond oil may be added to each twenty parts of drying oil. The rather lean priming in general use by house-painters is good if flexibility is not needed. I have found it excellent. It consists of:

Zinc white, ground in oil	2 lb.
Whiting	3½ oz.
Powdered dryer	1½ „

Turpentine or petrol to thin to the desired consistency.

Holman Hunt used a priming which was worked over while wet, and a similar one is recommended and described by Harold Speed at some length. Oxalate of manganese is manganese oxalate.

Why Oil Primings must be thoroughly Dry

A member of the firm of Talen's explains the reasons why oil primings should be thoroughly dry before being used. 'When a linoxyn layer, or drying linseed oil, has dried hard throughout,' he says, 'its absorbing

power is considerably reduced. Its power to expand and increase its volume like a sponge is then gone, and owing to shrinking of the film, the pores are much more minute than at the beginning of the drying process. This is why an old canvas, or panel, prepared with an oil priming is so much safer to paint upon than a fresh one. The "Old Masters" were well acquainted with this fact. If compelled for some reason to paint on a fresh ground, they first pumiced it, thus rubbing off the upper part of the oil film and consequently reducing the absorbing power of the ground. At the same time they obtained a rougher surface or better "tooth" which helped hold the paint and made cracks less likely—or at least less large if they did appear. A rough ground counteracts "sliding" due to the tension of the paint.' A good idea is to pumice or sandpaper any ready prepared canvas before using it.

Grounds for Metal Supports

May be purchased at any paint store ready mixed. They are the ones used by motor-car painters before applying nitro-cellulose paints. There are special abrasive papers made to smooth them which are employed wet. I have found these grounds excellent for any rigid support and they can be made as smooth as glass. They dry extremely hard, and may be painted upon within twenty-four hours.

In closing, it may be remarked that casein when of the best quality is the best priming for canvas or in fact any organic support. It is somewhat tricky to handle and apt to be brittle. Many good ready prepared grounds are on the market.

CHAPTER VI

VARNISHES

A considerable documentation, some of which may be almost dignified by the name of literature, concerns varnishes. Within arm's reach I have literally hundreds of formulae for the manufacture of varnishes, and I will give a few of them, more to let the reader 'see how the wheels go round' than for their practical value, for I believe that there are only two or three formulae which are either necessary or desirable for the varnishing of pictures meant to last over a considerable period of time.

Most varnishes are made from dissolved resins which are combined with some liquid vehicle either by being dissolved chemically or by means of heat. These may be roughly divided into three general types:

> Oil or Hard Resin Varnishes.
> Spirit or Soft Resin Varnishes.
> Mixed Varnishes.

Hardly a subject connected with painting rouses more discussion and reaches less agreement on the part of 'experts' than this subject of varnishing.

Until a very few years ago, the chemistry of resins was apparently little understood or studied; now synthetic resins of very fine quality are manufactured and used for every purpose for which varnishes are employed, even for the manufacture of fine quality picture varnish. They are highly recommended by the

firms who use them (if the fact of synthetic resins is mentioned at all) and are apparently in no way inferior to the natural product.

The discussion and arguments as to the virtues of different sorts of varnish may be arbitrarily divided by the sorts of varnish each camp recommends, with their reasons and principles given briefly.

§1. *HARD RESIN VARNISHES*

One school believes that the hard resins, dissolved in oil, are the best and in fact the only sort of varnish fit for varnishing oil-paintings. Their reason is that such 'long oil and hard resin varnishes' are the most durable. Copal and amber, the hardest and most lasting known, are the resins used in their manufacture and, as the proportion of oil is high, they are not likely to crack, provided that the painting to which they are applied is thoroughly dry when the job is done. The following is a typical presentation of the case for this type of varnish, as presented by a large firm of colour manufacturers of international reputation:

'We therefore strongly advocate applying for the first time a good varnish containing some stand-oil (and a hard resin). Such a varnish will never have to be looked after again in a lifetime, probably not in centuries, if the picture is not exposed to abnormal conditions and the varnishing is not done before the picture is thoroughly dry to the ground.'

This contention is certainly not without an element of truth and such a durable varnish might be considered as ideal under some circumstances *but not under every one.*

HARD RESIN VARNISHES

For instance, copal varnish being very acid may affect zinc white and certain other pigments. Amber is very difficult to dissolve, usually requiring the application of so much heat for its solution that the product obtained is dark and the original qualities of the amber possibly much altered. Such oil varnishes are too dark and too apt to become yellow to make their use desirable in pictures painted in a high or delicate key.

If for any reason such varnishes have to be removed the job is a very difficult and delicate task of which only a few men alive are capable. Chiefly for this last reason numerous exponents of the soft resin-spirit varnishes are so heartily against the use of the hard resins. Furthermore, the terms 'copal varnish' and 'amber varnish' are used very elastically in the trade and you have small means of knowing whether the copal you are getting is a hard or soft variety of copal, what is its quality, or whether it will last for very long or not. Amber varnish is even more vague. The best amber varnish made only contains 5 per cent of amber, a maximum quantity, and this varnish must be very much thinned before use. Amber varnishes are apt to contain almost anything else but amber.

If you use Hard Resin Oil Varnishes

Take every precaution to be sure that your picture is absolutely dry.

Thin your varnish with turpentine and lay as thin a coat as possible. You may use two coats on the dark portions of the picture should they need it.

Be sure that you get what you think you are buying by purchasing the product from the best and oldest established firm possible. Follow their instructions to

the letter, no one knows better how to handle their product than they do.

If you care to go to the trouble of making your own copal varnish, be sure to get the very finest quality of resin.

A Modern Recipe for Making Copal Varnish

Furnished by Tudor Hart:

Dissolve hard copal resin in tetra-chlor-ethan, mixing the resin with half its volume of raw linseed oil. Then completely evaporate the tetra-chlor-ethan without boiling. Tetra-chlor-ethan is also spelled tetra-chlorethane.

The opinion of this authority is that 'ordinary copal varnish which is made with litharge and boiled oil is extremely dangerous and improper for use'.

These hard resins are otherwise very difficult to dissolve and so the making of varnishes from them had better be left to specialists. Their solution by heat and other methods will not be discussed here.

Picture Varnishes as Sold Commercially

The following are some formulae from authoritative sources for the making of picture varnishes as they are presented on the market. It will be noticed that most of them contain some cheap and perishable resin, which is incidentally never mentioned on the label.

§2. SOFT RESIN VARNISHES

Romain's Picture Varnish

Choice mastic	375 grammes
Camphor	15 ,,

134

Alcohol	500 grammes
Venice turpentine	45 ,,
Essence of turpentine	210 ,,

(Essence of turpentine is spirits of turpentine, or turpentine.)

Held's Picture Varnish

This is of similar composition to Romain's, both are remarkably translucent. The Venice turpentine comes from the larch. It has a sweet smell, is white and clouded in appearance. The ordinary Venice turpentine sold in commerce is often of a brownish tint due to impurities which render it unsuitable for the needs of the artist as it may darken. Venice turpentine will dissolve in ordinary turpentine especially when warmed.

Winckler's Picture Varnish

| Elemi resin | ½ pound |
| Benzine | 1½ quarts |

and

Winckler's Chloroform Picture Varnish

| Choice mastic | 1 pound |
| Chloroform | 1 qt. |

A Typical 'Copal' Varnish

Copal	2¾ pounds
Dammar resin	1¼ ,,
Mastic	1 pound

Dissolved in ethylated hydrocarbon 2¼ gallons.

(Ethylated hydrocarbon can be any of several alcohols.)

VARNISHES

A Dutch quick-drying Picture Varnish

To be pulverized together:

Mastic	¼ pound
Sandarac	¼ ,,
Venice turpentine	2 oz.

to be mixed with:

Oil of spike	3½ oz.

To be dissolved in a double-boiler; filtered after the complete dissolution of the ingredients above, and mixed with:

Long oil varnish	2 quarts

A long oil varnish is any resin varnish containing a high percentage of oil.

The above formulae are simply given to show the number of ingredients and a few typical methods by which commercial varnishes are made. They are mostly soft resin varnishes. Vibert is a great partisan of soft resin varnishes because they may be easily removed without injuring the picture . . . much. His well-known 'Vibert's picture varnish' is made of what he calls 'normal resin' dissolved in petrol. As he keeps the sort of resin this 'normal resin' is secret, he keeps his varnish pretty secret too.

Vibert's Picture Varnish

Is made from a resin which will dissolve cold in petrol and as there are not so many sorts which will do this, it is not so secret after all. Sandarac is not used for the varnish is colourless. None of the cheaper tur-

pentine or colophony resins are used (or at least I hope not) as being not suitable for a fine arts product. This elimination leaves Dammar and Mastic resins as the most probable sorts, and of these two mastic seems preferable.

Hiler's Petrol Picture Varnish

Which I modestly so label is simple to make, and, in tests made with Ross Sanders, similar to those which we used for the permanence of colours, it stood up better than any similar varnish which we tried. To make it, get some choice mastic resin, light in colour, brilliant and transparent. Fill a bottle of the desired size about one-fourth full. The resin may be in 'tears' as it comes from the tree, or powdered. Fill the remaining space in the bottle with filtered petrol and in a few days, the length of time depending on the temperature of the room in which the bottle is kept, the mastic will have dissolved. The process is hastened if the bottle is shaken from time to time. Filter and use. Petrol is petroleum solvent or gasoline.

This petrol varnish which many of us suppose to be of recent invention, and which is one of the best soft mastic varnishes one can use, has a very ancient tradition behind it.

Armenini's Picture Varnish

Armenini says that his essential oil varnish was used by Correggio and Parmigiano, stating that he received his information from their immediate scholars. He describes its manufacture as follows:

'Some took clear fir turpentine [resin] and dissolved it in a pipkin on a very moderate fire; when it was

dissolved they added an equal quantity of (*oglio de sasso*) naphtha or petroleum, throwing it in immediately on removing the liquified turpentine. Then stirring the composition with the hand, they spread it while warm over the picture, which had been previously placed in the sun and was somewhat warmed. They were thus enabled to spread the varnish over every part of the surface equally. This varnish is considered the thinnest and (at the same time) the most glossy that is made.'

The turpentine resin which he mentions is a product of the silver fir (*Abies pectinata* or *taxifolia*). An excellent quality, perfectly clear and colourless, is obtained on the Italian side of the Tyrolese Alps. It is thus distinguished from the Venice turpentine, which is produced from the larch, but which may be purified by the usual methods.

C. Verri took the trouble to duplicate, as nearly as he could, Armenini's formula, procuring 'Olio d'Abezzo' through the services of a friend and having some petroleum rectified by a chemist, which doubtless procured him a liquid similar to the rectified petroleum which is on the market today. With these ingredients he succeeded in making a varnish with which he was highly pleased as it had 'just the right gloss' and showed no change or discoloration after a period of thirty years. He does not give the exact proportions used, but says that they may be determined by experience, and that generally speaking, very little resin should be used as thus the varnish may be spread very thinly and this is always easily repeated if necessary. The resin in question for this varnish of Armenini's and Verri's is now called Strasbourg turpentine. The picture should be first warmed and the varnish applied

warm—very little heat is needed to liquefy the resin. This at least seems to settle the question of what sort of resin was used in 1587.

§3. *WAX VARNISHES*

Beside the hard and soft resin oil or spirit varnishes, which exist in dozens of forms and under as many names, wax varnishes may be used when it is not necessary to have a shiny or brilliant surface. They bring out the colours pleasingly and may be polished when dry, which usually takes place between twenty-four and forty-eight hours after their application, depending on the weather.

A simple Wax Varnish

May be prepared by dissolving pure white wax (bleached beeswax or even paraffin wax) in petrol or essence of turpentine. This is applied with a stiff brush as evenly as possible over the surface of the picture, allowed to dry and polished with a soft flat brush like a clothes' brush, or an old silk stocking. The picture must of course be scrupulously clean before its application and the brushes used should be immaculate.

Dinet's Wax Varnish

Consists of Dammar or mastic resin, with wax and essence of turpentine, 'or better, oil of spike or lavender, which dissolves the wax more completely'.

Dessaint's Wax Varnish

Is made from:

White wax	1 pound

Essence of turpentine $1\frac{1}{2}$ pints
Subacetate of lead ground in 5 grammes
 turpentine

(Subacetate of lead is basic lead acetate; 5 grammes =
nearly $\frac{1}{5}$ oz.)

Mix well and strain.

The ready prepared wax varnish 'Ceronis' provides
an excellent wax varnish ready to use.

The claims made for wax varnish make it nearest to
the ideal where brilliance is not wanted. It protects the
picture from the atmosphere better than resin varnish.
It may always be easily removed with petrol and care,
no matter how fresh or old it is. It protects the picture
against retouching, which will not 'take' on it. Finally,
any brilliant varnish may be waxed and is much pro-
tected by the process.

For those wishing a mat effect who, for some reason
or other, do not want to use wax, there are mat drying
preparations on the market in the form of copal,
dammar, or mastic varnishes which contain about ten
per cent palmitate or stearate of aluminium. I cannot
see what advantage they have over wax. Stearate of
aluminium is aluminum stearate.

§4. *NITRO-CELLULOSE VARNISH*

Of the sort exemplified by 'duco' which is used for
motor-cars is not really old enough. Its real possi-
bilities of permanence are not yet sure. The way it
stands up on motor-cars under most unfavourable
conditions augurs in its favour. It may be used on
gouaches and water-colours. In order to use it on oil-

paint, which it affects unfavourably, the oil-paint, which must be thoroughly dry, should be given one or two coats of a good shellac-base varnish such as Soehne's. It may then be varnished with any nitro-cellulose varnish, preferably with an air-brush. The American painter, Paul Eugene Ulmann, made this experiment some twenty years ago, and the paintings I have seen varnished in this way are still in perfect condition. A number of the newer varnishes are made with colloidal and other synthetic resins or 'plastics' in solution. It is difficult to ascertain the ingredients of these varnishes as they are usually not divulged by the manufacturer. Some of them are water clear and it is claimed 'that there is no tendency toward after-yellowing upon ageing, nor the development of a "blush" or "bloom" in the presence of moisture'.

§5. RULES FOR VARNISHING

To do a good job of varnishing with resin varnishes is not easy. If you feel that you are unable to do it well and care much for the picture which is to be treated, better leave the work to a good specialist if you can afford to pay him. I have seen painters of many years experience do almost irreparable harm to their pictures by bad jobs of varnishing. In using resin varnishes, the following rules *must* be observed in order to get the best results.

1. Never varnish on a damp day. Dampness causes varnish to bloom, or become white and opaque.

2. Varnish must be kept clean and dry in well-corked receptacles. It must be poured only into clean, dry vessels, and if it has been in contact with the brush,

never from these back into the main receptacle in which it is kept. Use for varnishing only perfectly clean, dry brushes which are not moist with turpentine, linseed oil, or varnish.

3. Have a brush which is just right. This is of primary importance. A brush which still holds the split points of the bristles never varnishes clear; they are rubbed off easily and spoil the varnished work. A brush which has never been used does not produce clean work; it should be tried several times, and when it is found that the varnishing accomplished with it is neat and satisfactory it should be kept very carefully.

4. Stir and work up varnish well before applying.

5. Have your varnish warm and your diluent warm if you wish to dilute it. If you are diluting with turpentine, be sure of the nature of your varnish before doing so, or it may behave badly or bloom. Genuine mastic varnish does not bloom as a result of dilution with turpentine.

6. The picture to be varnished must be scrupulously clean. Rudhardt advises rubbing the surface with half a raw potato and then carefully rinsing with tepid water. It must then be allowed to dry thoroughly and should be gently warmed before a source of heat, or in the sun to make sure that it is absolutely dry. It may then be coated with purified petrol and varnished immediately afterwards if you are sure that the petrol will have no bad effect on the resin you are using. Petrol is petroleum solvent or gasoline.

7. Always apply in thin coats as evenly as possible. Spirit varnish should be applied quickly and daringly without going over. Oil varnish, on the contrary, can be worked up and smoothed out, which only improves

it. When you lay an oil varnish with a flat varnish brush, brush from left to right and from right to left; from top to bottom and from bottom to top; cross everywhere and rapidly work out any bubbles. This, of course, should be done with the picture lying flat.

8. Like oil-paint coatings, every coat of varnish must be thoroughly dry before a new one is put on; otherwise cracks may ensue.

9. Never expose modern varnishes to the sunlight to dry.

10. The varnish must be dried in a warm place and the surface varnish thoroughly protected from dust. A spare room which is used for nothing else is ideal to leave pictures in to let them dry. If this is not possible, turn the painting face downwards over a very clean and freshly oiled or waxed portion of the floor. It may be supported on two chairs, saw-horses, boxes, etc., cover the whole thing with an old bed sheet or other clean cloth which should of course fall to the floor.

§6. *HOW TO PRESERVE VARNISH BRUSH*

The preservation of the brush is accomplished thus: first of all, do not leave it in oil or varnish, as this will form a skin, parts of which would adhere, rendering the varnished surface dirty and grainy. As well as this skin, other particles accumulate in the corners and cannot be removed by dusting off; these may also injure the work. In order to keep the brush properly, insert it in a glass of suitable size through a cork in the middle of which a hole has been bored exactly fitting the handle. Into the glass pour a mixture of equal parts of alcohol and turpentine, allow only the point of the

brush to touch the mixture, if you allow it to touch it at all. If the cork is airtight, the brush cannot dry in the vapour of oil and turpentine spirit. From time to time the liquids in the glass should be replenished.

§7. CONCLUSIONS AS TO THE VARNISHING OF OIL-PAINTINGS

From the foregoing explanations some simple conclusions may be drawn concerning the best ways of varnishing oil-paintings or paintings in kindred mediums (emulsion, wax, wax-resin, etc.).

1. After consulting the considerable documentation on the subject, the mass of authoritative opinion seems to be against the use of copal and amber oil varnishes as final picture varnishes, because of the quasi-impossibility of removing them when this becomes necessary without damage to the picture they are supposed to protect.

2. Therefore, the kinds of varnish which may be recommended as safe are reduced to two:

(a) Where a brilliant surface is desired, use a good soft resin spirit varnish—either mastic or dammar. Of these the former is preferable.

(b) If a mat surface is possible use a wax varnish. This is the best.

§8. OTHER VARNISHES

A Varnish for Drawings

Recommended by Dessaint consists of:

Canada balsam	2 parts
Essence of turpentine	4 ,,

Mix well and apply with a soft brush. If the paper is not sized, give it a light coat of thinned fish glue and water before application of the varnish.

Water-Colour Varnish

Which, as its name implies, is used to varnish and protect water-colours, is given by Riffault under the following formulae:

1.	Sandarac	185	grammes
	Mastic in tears	16	,,
	Pure alcohole	375	,,
	Venice turpentine	65	,,
2.	Sandarac	268	grammes
	Mastic in tears	24	,,
	Elemi resin	7	,,
	Venice turpentine	97	,,
	Pure alcohol	604	,,

Goupil's Water-Colour Varnish

Is made of fish glue softened in water and then dissolved in alcohol. As fish glue in its solid state is not soluble in alcohol below the boiling point, this varnish may be cleaned with alcohol when dry.

FOR GOUACHES, TEMPERA, ETC.

Crystal Varnish

Which is used for gouache and tempera, drawings, maps, etc. is a solution of Gum Dammar in essence of turpentine.

Chinese Varnish

Is a stronger variety of the same.

VARNISHES

For Egg Tempera

J. E. Southall says: 'I have two panels painted in tempera on gold leaf and then varnished with shellac varnish, in perfect condition after twenty-seven years. They have never been under glass.'

CHAPTER VII

WAX PAINTING

A very practical and beautiful branch of painting, most useful for mural painting and any decorative work, because the surface of the picture is always perfectly dull or mat, is furnished by WAX PAINTING.

Ready prepared preparations on the market such as the Feigenmilch (fig milk) medium, manufactured by the Weimar Paint Company, make this sort of painting very simple, particularly as special colours are sold to be used in conjunction with these mediums.

If the artist wishes to make his own mediums or employ any of the current methods, no great difficulties are in the way. They have been in use for years in France and Germany. Van Gogh used a good deal of wax in many of his paintings.

Van Gogh was not a stranger to the method which is in current use in one form or another in France and Germany. In Germany, Taubenheim made experiments in which wax was incorporated with oil by heating. In France, his method with that of Paillot de Montabert, has been studied and made commercially practicable by Duroziez, and the firm of that name now sells ready prepared most of the products mentioned in the following paragraphs. Wax painting is somewhat more difficult to do than oil painting, but it is usually much higher in tone and there is little chance of the colours getting muddy.

WAX PAINTING

Beeswax

Bleached beeswax melts at about the temperature of 144 F. In painting its purity is important, the commercial variety being often adulterated with fat, tallow and other substances. Art supply stores and most drugstores sell pure beeswax in small cakes.

To Test Beeswax

Heat to boiling point with a solution of:

Caustic potash	1 part
Grain alcohol	3 parts

Place test tube in a bath of hot water to stop contents from solidifying. If the wax is pure it will remain clear. If an oily coloured residue comes to the top it contains cerosin. If white flakes appear they indicate stearic acid. Beeswax is also adulterated with yellow ochre, sawdust, flowers of sulphur, and animal or mineral waxes.

If when treated with dilute muratic acid it bubbles chalk is present. If it dissolves without bubbles but leaving a residue there is plaster of Paris. A slight but continued effervescence indicates calcinated bone. If the acid does not act on the wax there is sulphate of baryta or some other sulphate present. Good wax should also dissolve completely in spirits of turpentine, leaving no residue.

To Bleach Beeswax

Dessaint advises the following method.

Melt the wax. Add to each quart, 20 grammes of nitrate of soda and 40 grammes of sulphuric acid diluted with ten times its volume of water. Stir con-

stantly, taking care that the wax is always hot. Stand for a few minutes. Fill the receptacle with very hot water and allow to cool off. Wash well and rinse to eliminate any traces of nitric acid, which would make the wax turn yellow. Nitrate of soda is sodium nitrate.

The bleached wax, after thorough washing and drying, is remelted. Its hardness and its melting point are improved by the process.

§1. *OIL AND WAX PAINTING*

Oil-colours which have had the excess of oil removed by standing on blotting paper, although this is not necessary, may be used. They are then mixed with bleached beeswax, dissolved in essence of aspic or turpentine to the consistency of a jelly or paste. If too much of this dissolved wax is used it will not cover well. If too little, the paint will not become mat, will dry badly and fail to get the peculiar qualities which are considered appropriate. Essence of aspic is oil of spike lavender.

Wax Oil of Spike Medium

A fine medium to use with oil-paints which gives them the appearance of tempera in that they dry perfectly mat, is made as follows:

1.		
	Water	10 parts
	Pure White Wax	1 part
	Ammonia	

When the water is boiling violently, shave the wax into it in fine slivers and when the wax has melted add the ammonia drop by drop until the water turns

milky, the wax being emulsified. Allow this emulsion to cool and preferably to stand overnight, when the wax will be seen to have separated and come to the top in a cake having the form of the receptacle. Pour off the water.

2. Pour enough oil of spike over the wax to cover it, and allow it to dissolve and soften in a warm place for a few days.

3. Add enough rectified turpentine so that the mixture is about the consistency of cream. Bottle, but do not cork for several days so as to allow any excess of ammonia a chance to evaporate. During these operations, while the ingredients are amalgamating, stand, if possible, in a warm place.

This medium is splendid for under-painting, or laying on the first coat. Turpentine or petrol may be used to dilute it while working. For mural painting, it is very useful as the colours dry perfectly mat, with much the appearance of fresco. If the ingredients separate out on standing, shake before using and warm a little by placing the bottle in hot water.

Used on paper which has been prepared to receive oil-paint by a coating of glue, shellac, casein or a ready prepared ground purchased from the colour shop, it gives exactly the effect of gouache. The advantages over gouache are that it is not fragile, is waterproof when dry, and the colours do not change tone much in drying. It took me three years to perfect this apparently simple composition, and I consider it an important and very useful formula. Its use allows one to do entirely without gouache or tempera colours. It may be used freely with ordinary oil-paints with no difficulty.

OIL AND WAX PAINTING

As a ground I find that a *white sanding under-coat,* or priming coat, such as is used to prepare motor-cars to receive the lacquer with which they are painted, is excellent. It may be purchased from any large paint dealer in tins. Good supports are Masonite, Prestwood or any good Mill board or Wall board. The ready prepared priming coat or 'under-coat' should be applied according to the directions printed on the tin. If you do not care to prepare your own ground use any ready prepared semi-absorbent canvas or board. Do not use a non-absorbent ground as the colours may peel off.

Paint on these supports with ordinary oil-paints as they come from the tube, using *Feigenmilch* as sold by the Weimar Paint Company, or my Oil of Spike medium as described, pure or diluted with rectified turpentine. The work will have a very beautiful tonal quality. It will dry quite mat and, for this reason, slightly lighter than when applied. You should encounter no difficulties of any kind in the execution.

When the work is thoroughly dry, which will be after a few months (and two or three months should be considered as a minimum length of time for drying any picture except a water-colour), a good wax varnish should be applied, 'Ceronis', one of those described in this book, or any ready prepared mat picture varnish. It will be unnecessary to apply heat.

I am executing some large murals in this way at the time of writing, and all that is necessary to become quite expert is a little experience. Not much of the wax medium need be mixed with the colours.

Winsor and Newton's waterproof 'Ceroline' colours are made up with wax and an oil medium, as also are

Newman's 'Fresco' colours, of which the name is purely misleading.

§2. *WAX-RESIN VEHICLES*

The above are clearly short cuts to wax painting. A process in which little or no oil enters is that employing specially prepared colours, ground in a wax-resin vehicle.

The supposition that wax was dissolved by the ancients in an essential oil is supported by Fabbroni, who found that the colours of a mummy cloth showed that they had been mixed with pure wax. He concluded that a volatile oil, probably naphtha, had held it in solution. Naphtha was known to the ancients as it occurs in the writings of antique authors. It would be easy and interesting to reconstruct such a method today with our quick and slow-drying petrols, which will dissolve both mineral and animal waxes and resins as well.

Elemi Resin

The resin most used with wax for painting, as prac-tised today, is elemi resin. When genuine it is a white, supple and transparent resin which is not supposed to change colour. It comes from a wild olive tree, *anyris-elemifera* and has a certain analogy with wax, as the tree producing it is similar to the one which produces wax.

If pure it should have a strong and penetrating odour somewhat like that of pepper, in no way re-sembling turpentine. It dissolves easily in oils and essences with the aid of a very little heat.

WAX-RESIN VEHICLES

Elemi Gluten

This forms the vehicle in which the colours are ground. It is made from the elemi resin dissolved with wax in oil of spike. It may also be used during work to dilute the colours ground in it.

The proportion of wax may be increased by the addition of pure wax dissolved in a spirit, the proportion of resin by elemi resin dissolved likewise. Copal dissolved in a spirit may also be used if a brilliant finish is desired. Essence of aspic may be used if very fluid colours are desired. Colours ground in essence of aspic or turpentine may also be used with this Elemi Gluten. Essence of aspic is also known as spike lavender.

Taubenheim's Gluten

Or Taubenheim's medium, is made of wax dissolved in linseed oil by heating. It is said to make oil-colours unalterable by giving them the quality of wax colours. It may be used with oil-colours, or with colours ground in wax and resin.

Wax-Spirit Solution

Pure wax dissolved in turpentine, petrol or oil of spike. It can be used to varnish, with the aid of heat, to prepare grounds, or to mix with the colours.

Elemi Spirit Solution

The same as the wax spirit solution except that the wax is replaced by elemi resin. It may be used in combination with copal solutions if these contain *no oil*.

§3. VARNISHING OR FINISHING WAX PAINTINGS

Wax paintings may be varnished with any picture varnish and this is undoubtedly the simplest and worst way to varnish them. One reason is that one of the great advantages of wax painting is that it may be left absolutely mat, and therefore seen in any light. Any good wax varnish or wax-resin varnish may also be used, and driven in by heat or not as desired. A coat of wax in spirit, or emulsified wax, may be applied and driven in by heat.

For Finishing by the Application of Heat

A plumber's blow-torch equipped with a metal shield so that the heat may be more evenly distributed is often used. In these days of electricity, it is easier to use an electric iron, made very hot and moved about over the surface of the painting very near it but of course not touching it. When heat is applied, by torch or by heat lamp, to melt wax colours, the term 'encaustic' is applied to the process. See page 171.

A Good Wax Varnish

Which has great qualities of permanence and resistance to the atmosphere consists of:

Pure white cerisine	1 oz.
Toluol	4 fluid oz.

(Ceresine is also spelled ceresin, and is a natural white wax, similar to paraffin.)

This varnish was suggested and used by Noel Heaton in the following manner:

'Warm the painting. Apply with flat brush. Leave overnight. Heat the surface with a hot flat sheet of metal held near it.' Noel Heaton's apparatus for applying the heat is described under 'Murals'.

§4. *PAINTING IN SOLID WAX*

Some authorities object to wax as a material for painting in the belief that if ever subjected to heat it will run and mutilate the painting on which it has been used. This theory, which is little more than a superstition, is fostered by the fact that wax has been abused and misused in the past. A few rules for solid wax-painting are:

The wax should be used in conjunction with a gum or resin, as this gives a harder surface with a higher melting point.

It must be pure and free from fat or tallow, with which it is usually adulterated in commerce.

If used pure it should be subjected to heat.

The ground must be specially prepared and quite absorbent.

If these rules are followed a wax-painting may be subjected to *a degree of heat* which would *ruin* any oil-painting. See the description of encaustic painting on page 171.

CHAPTER VIII

MURALS

§1. *MURALS ON PANELS OR CANVAS*

These need little particular technical discussion. They are large pictures or designs subject, of course, to peculiar æsthetic limitations and functions which may not be discussed here.

They should, of course, be mat so that they may be seen from any position. If in oil, they may be executed on sheets of aluminium which are simply roughened to receive the paint, and varnished with a mat varnish, or waxed. Composition board, backed by aluminium or tinfoil and primed with an appropriate ground may be used to work on in any appropriate medium; wax, egg tempera, emulsion tempera, distemper, etc. Canvas, of course, may also be used, in which case it is usually glued to the wall or marouflayed. This process removes the chief advantages, the canvas being of course, difficult or sometimes impossible to remove once well glued in place.

Wood panels must be protected on the back with red lead or foil from various forms of rot. Recently, a church mural on ½-inch panel was destroyed beyond rescue by fungus within a year of its placing on the wall. Wood panels can be protected from fungus attacks by treating the back and edges with fungicide (Dow

chemical and other companies manufacture many kinds), as well as by applying a finish of moisture-resistant coating, such as wax or silicone varnish.

Marouflage

As the different methods of glueing the canvas to the wall are called, was very popular throughout the nineteenth century. Most modern European wall decorations were executed by this method. The canvas is, of course, painted according to the personal ideas of the artist and is then glued to the wall as follows.

Formerly, a paste of rye flour to which two or three heads of garlic were added was the commonest way of marouflaying on the Continent. The paste was made rather thick. Later this method was replaced by white lead ground to a thick paste in oil, a preparation known in France as *céreuse*.

Noel Heaton advises that the wall should be prepared with a stiff paste of white lead and gold size (the gold size being a quick-drying varnish prepared by dissolving a hard resin such as copal in the minimum quantity of oil and a large proportion of dryers, and diluting it with spirits of turpentine).

In all the methods of marouflaying the canvas is pressed on the prepared wall with rollers, working from the centre outwards to avoid bubbles. This is difficult to do. When accidents happen they are almost impossible to remedy. The work of attaching the canvas should therefore be confided only to specialists in whom every confidence can be placed. Many workmen, however, have more self-confidence and nerve than skill, so that the artist should have a working idea of how this process of glueing is performed.

The wall must in every case be perfectly dry. If it is of cement it should first be treated with a solution of hydrochloric acid diluted in water, and, after a few days, rinsed and allowed to dry, or painted with two coats of fresh-beaten blood—beef or pork.

It should then be varnished with two coats of good varnish, the first coat to be well thinned with turpentine. Dessaint then advises the following glue:

> 20 pounds of white lead ground in oil.
> 1 pint of liquid dryer.
> 1 quart of flatting varnish.

When these ingredients have been well mixed add 20 pounds of whiting or pulverized chalk. If the paste is too thick it may be thinned with boiled linseed oil.

The canvas is applied to the wall, previously prepared and covered with this mixture, and is flattened out with rollers as advised above, from the centre outwards.

§2. *TRUE FRESCO OR BUON' FRESCO*

In true fresco or Buon' fresco the pigments are applied to a freshly laid coat of wet plaster before it has had time to absorb much carbonic acid from the air. The painting ground is saturated with hydrate of lime mixed with a lot of water in which a large reserve of this compound remains undissolved. When the wet pigment is applied to this surface, the lime water in the ground accepts the wet pigment, soaks it through, and at the same time gradually absorbs carbonic acid from the air. This produces carbonate of lime which acts as a binder. Wetting the plaster ground or painted

surface dissolves more of the reserve of hydrate of lime present, reinforcing the binding material. When even stronger binding material is required baryta water, which contains about sixty times as much hydrate of baryta, as the lime water contains hydrate of lime, is used. Hydrate of baryta is barium hydroxide.

Sometimes hydrate of lime is also mixed with the pigments used. Silicate of lime may be also present in the case of certain plasters and sands which, as also certain ochrous pigments, contain soluble silica. Silicate of lime is a more permanent binding material even than carbonate of lime.

True fresco is a very ancient process and the literature on this somewhat complicated and controversial subject is considerable. To go into the chemistry and general technique of it here would require more time and space than I have at my command, particularly as the process is of very doubtful permanence in any but the driest climates. The classic ingredients used were pure slaked lime and clean white sharp siliceous sand. The wall to which these ingredients are to be applied must have been thoroughly rinsed and free from soluble salts, etc. It should not be too porous. The plaster is applied in two or more coats, the coarsest and thickest first. The slaked lime is very important as an ingredient. Its preparation is complicated and delicate and it should be kept as long as possible before use. Ingredients containing soluble silica are now usually added to increase the natural binding power. The final coat of plaster put on to receive the pigments is called the *intonaco*. It is of very fine quality plaster and in modern usage is only about an eighth of an inch thick. The plastering which must be carried out by experts,

is done in a particular manner. No more *intonaco* is laid than can be covered by the artist in a day as it *must* be worked on while *wet*. For a discussion of the chemistry and detailed methods of true fresco, the reader is referred to Church and other authorities.

The catalogue of the Diego Rivera exhibition, at the Museum of Modern Art, January 1932, contained a note on the technique of true fresco painting. As it is not likely that the reader will be in a position to get hold of one of these catalogues, excerpts are here given as a condensed explanation of a current fresco technique.

'In the present exhibition it was necessary to meet the problem of a portable fresco. For this reason, the frescoes are done on plaster applied to a base of steel netting supported on a steel framework rigidly braced. This method allows the fresco to be set into the wall in sections giving the appearance of being in situ, or to be moved from one place to another. The frames are carefully made to guard against any possibility of bending and, if steel is not used, a heavily galvanized iron must be substituted so that rust will not work through the damp plaster to contaminate the surface of the fresco.'

This method of building up a fresco with units of matched steel frame, if the area be very large, is an important one in the development of a modern method of fresco painting, for it permits the use of this medium in buildings which are relatively of short life, since the destruction of the building, the fresco being movable, does not necessarily mean the destruction of the fresco.

The first step in fresco painting is the preparation of the plaster. The sand which is used in the plaster must

be absolutely free from salt, as salt ruins the colour. Furthermore, it must be free from fungus of any kind which, unless this care is observed, sometimes breaks out in a growth on the surface of the finished work.

Equal care must be exercised in the selection of the lime. Lime which has been coal-burned cannot be used as the sulphur from the coal may contaminate the lime and cause discoloration of the fresco. The best lime for the purpose is wood-burned lime which has been slaked for at least three months. No trace of activity must remain in the lime, as this will have a disastrous effect upon the colour.

The plaster is applied to the wall or, in this case, to the frame. A minimum of three coats of plaster is necessary. There are two basic coats. The first coat is the rough coat. The second coat is called the 'brown coat'. The third coat is the thin finishing coat. Graduation from the rough first coat to the smooth finishing coat may be made, however, through as many as eight successive stages. The finishing coat in the frescoes shown in the Rivera exhibition was composed of lime and marble dust, the latter being used in place of fine sand. Marble dust gives a white, pearly texture to the surface.

Rivera in these frescoes has followed his latest practice of making only small studies for the design. He has done this to allow a freer change in design upon enlargement. The small sketch is first enlarged to scale on paper on the size of the section to be covered by the fresco. The paper is then pierced with fine holes along the lines of the drawing. The pierced paper is then placed over the surface of the 'brown coat' and the outline of the design is dusted on to the plaster by the

use of coloured chalk, which sifts through the small perforations in the design, leaving on the 'brown coat' the enlarged drawing. This operation is called 'pouncing'.

The artist then freely corrects or modifies this transferred drawing, seeing it for the first time in relation to surrounding detail and in relation to the limits of the particular section of the fresco. When the design on the 'brown coat' has been corrected and enlivened to his satisfaction, a careful tracing of this finished drawing is made on tracing paper.

The artist is now ready for the final stage of the plastering. Since he can work upon the plaster only while it contains a certain amount of moisture, only that section of the design on the 'brown coat' is covered with plaster which he can complete during the day. This area depends in part upon the rapidity with which the plaster dries. It also depends upon a factor of design, the necessity of bringing the day's work to completion at a place where the new plaster of the following day can be pieced on without this joint appearing in the fresco.

In other words, the design itself must be so thought out that certain lines in it can be used as boundary lines in plastering. The units of these finishing coats of plaster must so join together that their joints do not cut plain painted surfaces and thus become conspicuous divisions in the finished work.

A section, then, of the design on the 'brown coat' is covered with the thin finishing coat of wet plaster. Since this plaster covers the design, the drawing is retraced upon the wet plaster from the tracing which has previously been made. This retracing is done with

a sharp point which grooves the wet plaster lightly along the lines of the drawing. The surface is now ready to paint upon. It is needless to state that the degree of moisture in the plaster must be carefully judged before the painting starts.

Rivera in the frescoes which are here exhibited follows the practice of blocking in the drawing and modelling the high-lights first in blacks and greys. When these accents have been carried to the proper point the colour is applied.

The palette of the fresco painter is of necessity limited. In the main it must consist of earth colours, of oxides of iron and manganese. These colours are *ground* on a marble slab for purposes of immersion with a small amount of water to form a paste. They are then applied with a brush moistened in water, much as water-colours are applied.

The palette which Rivera has used in these frescoes consists of the following colours:

Vine black. (Calcined seeds of grapes.)
Ultramarine.
Cobalt blue.
Emerald green.
Burnt sienna.
Almagre Morado, a Mexican earth; a red oxide of iron.
Pozzuoli, an Italian red natural cement.
Dark ochre.
Raw sienna.
Yellow ochre.

There are numerous modifications and 'improvements' in connection with true fresco painting which

may be best studied in works by specialists on the subject. I cannot recommend it.

Saponified Wax used with true Fresco

Miss Lanchester has demonstrated 'that the addition of weak solution of saponified beeswax to the plaster retards the settings, so that it can be worked on for two or three days, thus obviating the necessity for preparing the final coat daily and the consequent joints'. The process remains essentially that of true fresco and some ancient frescoes may have been executed in this way as the quantity of wax is so minute that it could scarcely be determined by analysis.

The mass of evidence in any case points to the fact that true fresco and ordinary fresco secco (see page 166) are not very permanent in any but the driest climates. Some frescoes, which have apparently stood up well in England, have been treated to a coat of wax varnish by the Royal Arts Commission, which accounts for their apparent durability. In modern cities, with their impure air, the process is not to be recommended, which is a shame, as artistically its limitations make it a very fine medium. Many of the old frescoes were freely retouched with egg and distemper colours, and this accounts for the presence of organic colours such as the madders which would not have stood up if used on the wet plaster. Victor Mottez was an expert and careful fresco painter who worked in France in the nineteenth century.

Auguste Renoir in speaking of the frescoes executed by Mottez, at Saint-Germain-l'Auxerrois, says: 'His beautiful frescoes . . . which have now disappeared, irremediably destroyed, in so few years, by dampness.'

And Guerlin writing on the same subject states that: '. . . There is an object lesson in the comparison of the work of Victor Mottez and Hippolyte Flandrin. Mottez, a fresco enthusiast, executed his work in the medium of buon' fresco . . . it is already but a memory. . . . The contemporary creations of Flandrin done in wax look as fresh as though they were finished yesterday.'

J. D. Crace, in a paper read at Painter's Hall, 29th November 1912, said, in comparing the durability of true fresco with tempera:

'But I do not think that we can find much evidence that it [true fresco] was in use north of the Alps [where] the vehicle was for centuries some form of tempera when applied to wall surfaces; and there is no doubt that under favourable conditions, even in such climates as our own "tempera" is very permanent when properly used.

'Many tempera paintings of the twelfth, thirteenth, fourteenth and fifteenth centuries exist to-day in England in fair condition; where they have been inaccessible to direct injury by the hand of man, they are not less perfect than the true fresco would have been. . . .'

(The contrary is more likely to be the case. The frescoes in the Gallery Henri II, at Fontainebleau, were disappearing at a great rate at the beginning of the nineteenth century, when they were restored in wax by Alaux, though they were not as old as most of the tempera paintings mentioned by Crace. Rivera's frescoes in Mexico City were, when I last saw them, in lamentable condition.)

§3. *FRESCO SECCO*

This is a process similar in principle to that of true fresco except that the plaster is allowed to dry. It is described by Theophilus in the Schedula (ca. 1100 A.D.). The plaster is thoroughly drenched with lime or baryta water the night before the painting is to take place and this is repeated in the morning. The method of transferring the design, etc., to the wall, the pigments and the manner of painting are the same as for **true** fresco. The colours are mixed with a little lime or baryta water or slaked lime. It is certainly easier and simpler of execution than real fresco and requires much less work and complications. It is less permanent than real fresco and much less beautiful. Fresco secco might be sprayed with several coats of emulsified wax when finished and these driven in by successive applications of heat. I have never had a chance to perform such an experiment but theoretically it should provide a simple, practical and permanent process. Baryta water is barium hydroxide solution.

§4. *TEMPERA WALL PAINTING*

This is probably the most ancient technique of all. For egg tempera, it is of similar technique to that used on panels. The walls should have a special gesso ground applied to them before beginning work, or simply be washed with distilled water and given a thin coating of size. The Beuron medium as described under egg tempera painting, was much used for mural decoration by the monks.

For distemper painting which has been successfully

practised since the time of the Egyptians the process is even simpler. A good modern example of the process is given by Reginald Hallward, an English painter who has used it extensively. He uses weak parchment size so diluted that when it is cold it will just set without being very tough or solid. 'Having my colours already mixed in water,' he says, 'my habit is to add just so much size as will prevent the surface rubbing off. One gets to know instinctively too little rather than too much should be used. Size is easily warmed up again if it sets, and reheating helps to prevent it becoming unpleasant. One or two cloves put into it will keep it fresh over a longer period.' He prefers painting directly on an unsized wall and rubbing the paint well into the plaster. He never uses it thick. He makes a frequent use of moist water-colours both for painting and retouching. If he did not, the size painting might be rendered waterproof by a spraying with a tannin solution. Tannin solution is a solution of tannic acid.

A Quick and Simple Method of Wall Decoration

Is mentioned by Hammerton, who made experiments with charcoal drawing on plaster, which convinced him that 'valuable results might be attained in that direction without any great cost of labour'; but as charcoal by itself is cold it might be used in conjunction with pastel or coloured chalks or crayons and then fixed with a good casein or other fixative. In fixing any large wall decorations, a hand atomizer with a fine and even spray, with the air furnished by a sort of bicycle pump arrangement comes in very handy. There are models (paint-pistols) which work very well now on the market, which are made for use with nitro-cellulose lacquers. They are

quite inexpensive. Paint pistols are paint sprayers, or sprayguns.

§5. *OIL-PAINTING ON WALLS*

As has been mentioned is usually executed on canvas and marouflayed to the wall. If the wall is to be painted on directly, it must receive a special preparation as was proved by the disasters to 'The Last Supper' by Leonardo, at Milan. The use of oil on walls is very old, and ancient manuscripts describe methods of using it and how it was laboriously dried with artificial heat when so placed that the sun could not get at it. The ground is often prepared by simply giving several coats of well-thinned white oil-paint. A damp-proofing solution used in France consists of:

Gutta percha	4 parts
Resin	2 ,,
Wax	$\frac{1}{2}$ part
Shellac in scales	1 ,,
Turpentine	4 parts

French house-painters give the plaster as many coats of boiling hot linseed oil as it will absorb before laying the ground coat of white lead ground in oil and thinned with turpentine. A mixture of zinc white and white lead fifty-fifty or titanium white might be an improvement.

§6. *WAX FRESCO*

The Gambier Parry Spirit Fresco Process

Has the following advantages claimed for it by its inventor:

1. 'Durability (the principle ingredients being all but imperishable).

2. Power to resist external damp and changes of temperature.

3. Luminous effect.

4. A dead mat surface.

5. Freedom from all chemical action on colours.'

The *intonaco* should be left with its natural porous surface. All cements should be avoided. When perfectly dry the surface of the wall should be saturated with the medium which consists of:

Pure white wax	4 oz. by weight	
Elemi resin	2 „	„

dissolved in:

Rectified turpentine	2 oz.
Oil of spike lavender	8 „
Copal varnish, by measure	20 „

These ingredients are melted and boiled together until incorporated and when in use the medium is diluted with about half its bulk of rectified turpentine. The wall is well soaked with this diluted solution and allowed to evaporate for several days. Then equal quantities of pure white lead in powder and gilder's whitening is mixed in the medium diluted with about a third of turpentine and the surface is painted thickly, 'and when sufficiently evaporated to bear a second coat, add it as thickly as the brush can lay it'. This must be allowed to dry for two or three weeks and leaves a white absorbent surface.

The pigments which are the same as those used for oil-painting are ground in the undiluted medium and

may be kept in tubes. Solid painting with a good deal of body is recommended and oil of spike is freely used as a painting medium. This oil of spike 'is the common solvent for all the materials'. It may also be washed over the ground before painting 'to melt the surface and prepare it to receive the colours painted *into* it', hence the name 'Spirit Fresco'. The surface opens to receive the colours and on the rapid evaporation of the spike oil it closes them in, and thus the work is done.

Church's Suggestions for Improvements

Professor Church has suggested that the medium would be improved by the elimination of the 'doubtful constituents', elemi resin and beeswax, paraffin wax and non-resinifiable oil of turpentine being substituted for them. These should be mixed, as before, with the copal varnish and used in the same way as the regular Gambier Parry medium. He gives full directions for its preparation in his book, *Chemistry of Paints and Painting*.

The Gambier Parry process is nothing more than a modification of Paillot de Montabert's and Taubenheim's wax resin processes and for this good reason is seldom, if ever, used (under that name) outside of England.

Andreas Muller's Medium

In which he executed his murals, which are in the National Gallery in Berlin, is similar to Gambier Parry's though much simpler in composition. It is made as follows:

Virgin wax	1 part
Essence of Turpentine	2 parts

(I should suggest oil of spike as a better solvent)
A few drops of linseed oil.

The pigments are ground in boiled linseed oil with the addition of his wax-turpentine medium.

The Plaster Ground

Is soaked with boiled linseed oil, hot, diluted with an equal quantity of turpentine. It is then primed with several coats of white oil-paint put on lean, and smoothed with pumice stone. The painting may be executed either thinly or with a full-bodied technique. It is supposed to dry somewhat lighter than when wet, and of course with a mat surface.

Encaustic Mural Painting

Is a process which employs wax in conjunction with heat. Noel Heaton has used a combination of encaustic and tempera painting for walls, when he heated his wax varnish made with cerisine dissolved in toluol by using a Bunsen burner equipped with a shield and rollers. Such a service might be more conveniently and safely performed by one of the numerous little electrical contrivances now so popular. A little ingenuity employed to adapt it to this new function should be all that is needed.

To Prepare the Walls for Encaustic Painting

The holes and cracks are first stopped up by means of a putty knife with a putty made from wax dissolved in turpentine, elemi resin, and whiting worked up to the proper consistency. Then the whole wall is treated with several coats of pure wax dissolved in petrol or turpentine, driven in by heat.

MURALS

The Materials used for Encaustic Painting

These have been described under 'Wax Painting'. They may be varied as to the proportions of wax and resin and oil of spike used according to the preferences of the artist but it is of course of primary importance that the proportion of wax and resin should be very evenly distributed throughout the colours used. Elemi Gluten is used as a medium. A good practice is to apply heat after each coat of colour and later after each of the several coats of wax varnish. If the work is given a final coat or two of paraffin varnish it should prove as nearly imperishable as any sort of painting we are capable of executing today. I consider encaustic the ideal medium for modern murals. Its technical possibilities are almost limitless.

§7. STEREOCHROMY OR WATER-GLASS PAINTING

Is a process in which the fixative employed is an alkaline silicate dissolved in water. Open to considerable discussion because of the chemical factors involved, the materials of this comparatively new method of mural decoration have been changed several times in the last few years.

Those interested are referred to works specializing on this subject.

CHAPTER IX

TOOLS

§1. *THE BRUSHES OF THE OLD MASTERS*

The brushes of the Old Masters were not the same in form as those we use now. They were without exception round, as may be seen from documents left us by Breughel, Van Ostade, and others, as well as by Cennini's instructions for making them.

He says that the sort of brush made of white hog-hair bristles should be first made into a big brush to be used in house-painting and white-washing until the bristles become soft. Then it may be taken apart and made into the smaller brushes, set in quills, which an artist needs. He advises making blunt-ended brushes and pointed ones in this way.

Nor is Cennini's advice as archaic and quaint as it sounds, for hand-made brushes mounted in quills are in current use today. A good idea is to save the handles of all worn-out brushes for mounting these quill-mounted brushes which are sometimes sold without handles. They are at best of very fine quality and may be found rather in professional sign-painters' stores than in the artists' supply stores. I will say nothing of them here except warmly to recommend their use. To one who has never used them, their excellence

must be surprising. *Wet the quill before you try to put the handle in or it will probably split.*

§2. *MODERN BRUSHES*

The brushes in commonest use are hog-hair brushes which are made from hogs' bristles. They come in four shapes, Flat, Brights, Filbert and Round. Brights and Filberts are both brushes of flat section with rounded tips. The length of the bristles varies but no round modern brushes that I have ever seen possess bristles as long as those used by the Old Masters.

The best brushes are made with white Ardennes or Russian bristles as these are softer than the grey variety used for house-painters' brushes. These large brushes should all be first tested in water, as they are often faked having *whale* hair or *horse* hair worked in to give them bulk. Any brush which, when wet, does not at once take a symmetrical and uniform shape is no good. Hog-hair brushes should be made from raw bristles which are set in such a way that the natural curve of the bristle forms the shape of the brush. Thus made, they hold their shape. The cheaper sorts are boiled so that the bristles straighten out. Artists should never use cheap brushes as no money can be saved in this way. Hog-hair brushes are called bristle brushes in U.S.

Hammerton says that that 'unclean animal, the hog, renders unceasing service to the fine arts by supplying the kind of brush which has done more than anything to encourage a manly style in oil. The use of this or that kind of hair in brushes has more to do with executive style in art than the most ingenious reasonings about the beautiful.'

A good bristle brush charged with colour and held horizontally should not allow the colour to run down the handle. It holds it too well. Brushes may with advantage be soaked in water before using, when possible in a deep receptacle so that the handle should be down and the bristles up. The water should only come above the base of the brush by between a quarter and half an inch.

Some Qualities of the Different Sorts of Brushes

A short round brush gives firm coats but empties easily. A long flat brush is supple, holds more colour, puts it on thinner. Thin colour and a long brush lay down a thin coat of paint which the French call a 'frottis'. This kind of brush is sensitive to the slightest pressure.

With a good flat brush you can experiment for the angles of the handle to the canvas, holding it vertically, slanting, almost horizontally, etc. In this way you will find out about your touch.

A brush should be held firmly but never tightly. Squeezed, it will form ridges where they are not wanted.

Rudhart says that the average length of bristles for all-round use is about a half-inch for the small brushes and from one to one and a quarter inches for the bigger ones. The width may vary from quarter-inch to over an inch, but in all cases the largest brush possible should be used for the work in hand—or at least this seems to be the advice of every writer on the subject.

The round brushes may be used for lines and certain methods of stippling, or even for laying the paint

with a rolling motion; they are ordinarily chosen smaller than the flat ones. Sable brushes, if well taken care of, should improve with age.

Besides the hog, the hairs of the badger, the pole-cat, the marten, the calf, the squirrel (camel hair), red and grey, the sable, etc., are used. The Japanese use a rat's-hair brush for lacquer.

The quality of brushes varies unbelievably and all sorts of frauds are practised in their sale and labelling. Brush-makers also have the tradition that the handle of a brush should vary in its size and length according to the size of the brush. They certainly exaggerate this principle as the size of the human hand remains always the same. We all have the habit of holding pens and pencils, and if the handles of brushes were modified a little nearer to an average 'normal' handy size, no harm would be done. Hand-made brushes require highly skilled labour. You can't tell a book by its cover, nor a brush by its handle or finish. The only way to learn to pick out a good brush is by experience.

Every sort of brush has its peculiarities and uses. R. Topfer (1799–1846) said: 'One brush, no good for washes is excellent for little touches: another admirable for foliage is deceiving for skies. From which it follows that there is no such thing as an absolutely good brush or an absolutely bad one. Without mentioning the fact that the same brush because of its caprice is neither always excellent nor always detestable, one may nevertheless say that the principal conditions which may characterize a good brush, are its elasticity, which makes it straighten itself out naturally, a fine but soft point, a large enough "belly" to contain water, strong enough to hold it suspended so that the weight of its

drop keeps the point wet. These qualities can only be obtained in brushes of medium size, and this is important—a little brush is bad for washes in chinese ink, for it produces work dry and without daring.'

Flat sable brushes will lay the paint very smoothly.

Round sable brushes for oil-painting should have no 'belly'. The ones with short hair are best for delicate touches. Those with long hair, which are known as riggers, liners, and writers, are best for lines.

A badger-hair softener or blender will take out brush strokes. The existence of these brushes has been almost forgotten by most of us. They are made in several forms. The face of a good badger-hair softener should be slightly convex. It should be supple and fine. They are best used in a circular motion of 'interlaced rings' held perpendicularly to the picture and very lightly touching it. Keep clean by frequently rubbing them on a white absorbent cloth, stretched flat on a board, over the thigh, or in an embroidery ring.

Trimming Brushes

Sign-painters and some artists trim their brushes. Sometimes flat brushes, which have only two or three rows of bristles, are trimmed down to about a third of their length with scissors held a little slanting so as to fringe the end of the brush. Thus prepared they are used for blending, especially where the paint is applied thickly. They are supposed to produce a very crisp effect.

Fan-shaped brushes, whether they are fringed or not, do the same work. They are a comparatively recent invention. Round brushes can be cut down in the same fashion, in such a way as to make them into

flat ones. When this is done, they offer a new form, different from anything on the market.

Cleansing and Care of Brushes—Hog Hair

An excellent way to clean brushes is first to rinse them in petrol and then have a fairly large receptacle full of a strong soap solution. In this method they are rolled around between the palms of the hands as house-painters do, without letting them touch the bottom of the receptacle. Naphtha soap is a good sort to use. About three-quarters of a pound to two quarts of water is a good strength. When this solution loses its bite, add a little carbonate of potash, washing soda, ammonia, or other alkali. Rinse in warm water.

Paillot de Montabert says that 'Volatile oils employed alone to clean brushes make the fine points curl up. When the brush is thickened by viscous materials, it should be washed in soap. The soap should be softened into a sort of cream with water. Having wiped off as much of the oil as possible, one takes some of this soap with the point of the brush, and rubs it on a rough unplaned plank or board, working up a lather. It is rinsed in tepid water and the operation repeated as necessary. Then what may be left of the colour is carefully scraped with a finger-nail, the brush being held against the palm of the hand,

and the brush is again worked about on the plank and rinsed.

The ferrules of brushes should be kept clean, as bits of hardened paint or skin may otherwise develop. Handles should be cut off short if desired. They are often more bother than help.

If any alkali or soap is left in brushes after washing, it is apt to interfere with the drying of colours, particularly certain pigments. Soft brushes, such as sable brushes and others of that type, seldom, if ever, need to be washed with soap and water, and will last the longer for it. Petrol is better to clean brushes in than turpentine, as turpentine burns the hair. After such a rinsing they may be placed in a flat dish; the points covered with olive oil, which is rinsed out again before they are used. This saves work and keeps them in excellent condition. Olive oil, or salad oil, never dries.

Be sure that no colour stays in the base of the brush. Roll the brush carefully but thoroughly between the thumb and forefinger. If you do not thoroughly get rid of colour at the base of the brush, it will soon form a heel and the brush will lose its elasticity and become worthless.

Brushes which have stiffened or hardened up and which are dried or caked with old colour should be rolled around in strong ammonia as above illustrated. They may be allowed to stand in the ammonia about an hour before cleaning them. They should then be washed with soap and water. Oil of creosote may be substituted for the ammonia, or they may be rinsed several times in turpentine and then worked up in hot linseed oil. Pull out or cut off all loose bristles, or

leave them to soak in linseed oil for forty-eight hours, then rinse them in benzine and they will regain their elasticity.

If the bristles curl, clean the brushes and wash them in hot water. They will straighten out.

To Restore Elasticity

To restore elasticity to brushes, they may be put into oil and then brushed several times over a hot iron in such a manner that the hairs touch the iron from each side, then dipped quickly into cold water.

Keep brushes in a cool place.

Sable and Water-colour Brushes

Suck your sable brushes to shape before putting them away and letting them dry. Be careful that they are perfectly clean before doing so—as many colours are poisonous. Saliva has a lightly cohesive quality excellent for the purpose. If this does not appeal to you, shake them violently in one direction while they are wet. They will then take shape while drying.

Sable brushes must be protected from moths with moth balls, tobacco, naphthalene or paradichloro-benzine which is used in big brush stores. A very little of this goes as long as its name. They may also be dipped in camphorated alcohol, which evaporates, leaving a fine coating of camphor. Sables should be kept closed up when not used every day.

French artisans grease their sable brushes with tallow or a tallow candle if they have to leave them unused for any length of time.

Never leave your water-colour brushes in the water, especially touching the bottom of the receptacle.

MODERN BRUSHES

Sable brushes which have got badly out of shape may be reset by dipping them in stand-oil, allowing the oil to set a little, moulding them into shape, leaving for a few days and then dissolving out the oil with petrol. After which they should be washed before using for water-colours.

How to Choose a Water-colour Brush, see Water-colours

Priming Brushes

A flat nail brush or scrubbing brush is excellent for applying the first coat on porous material or canvas. It is stiff enough to work the glue well into the fabric. For succeeding coats a flat brush with not very many rows of bristles, and with these bristles not too long, is very handy. A house-painter's smoothing knife is good to smooth grounds on any rigid support. Their use saves much time as the priming may be handled much thicker. Any house-painter will show you how to use one. When purchased the edges are usually too angular and may be ground down on a whetstone. Never use good brushes for casein, it burns the bristles.

Brushes which have been Used for Glues

Should be washed with strong soap, well rinsed, and hung up to dry—point down.

New Varnish Brushes

Should be well worked up in the palm of the hand and all loose hairs removed. They should then be suspended in poppy oil overnight and rinsed in turpentine or petrol. New ones are not so good as those well broken in.

Cleansing Varnish Brushes

Brushes used for Japan varnish should be allowed to soak between sessions in half varnish and half turpentine. They must, of course, be suspended in some manner so that they do not touch the bottom of the receptacle in which they are kept.

See also Varnishes.

In size, brushes roughly run to the following measurements taken in fractions of an inch across the hairs at the ferrule.

No. 00	one-sixteenth
1	one-tenth
4	one-eighth
9	one-quarter
13	three-eighths
16	one-half
18	five-eighths
21	seven-eighths
24	one and a quarter

The sizes between can be reckoned relatively.

§3. *PALETTE KNIVES*

Palette knives are sold in a multitude of forms and shapes which everyone must choose for himself. Horn, bone, ivory or hard rubber knives are good to use for grinding when handling pigments and for use with certain colours, such as Naples Yellow and Cobalt Violet, which are affected by the contact of steel.

Palette knives may be filed down or ground down if desired.

The trowel-shaped palette knife was invented by

Courbet. One such and a straight knife are almost indispensable. The trowel-shaped one may be used to remove passages which you wish to change—if for no other reason.

For this purpose also a short, sharp-edged, leaf-shaped scraper may be used. Care should be taken not to scrape away too much of the ground so that the canvas itself is exposed to the action of the linseed oil.

§4. *PALETTES*

Wooden palettes are only to be used when necessary for reasons of portability. Glass or porcelain are much better in the studio, being non-absorbent and easier to keep clean. When in wood, mahogany is considered the best.

Walnut, pear or apple are the most usual. *The thumb hole should be big* enough, but seldom is when the palette is purchased. Little space should be left between the hole and the edge of the palette—otherwise you'll suffer. Correct the size of the hole for your thumb with a round file and sandpaper.

Never buy a varnished palette, the varnish is worse than useless. Before using any new wooden palette, let it absorb as much linseed or nut oil as it can by soaking. This will take two or three days. Clean it each day that you use it with a cloth, but *not* by scraping with a palette knife. Rub it frequently with oil.

If you want to keep oil-colours from drying take them off the palette, put them on a narrow piece of glass and place them under water.

Should you ever need to use sandpaper or pumice on your palette, use oil in conjunction with them.

Some painters counterweight their palettes if the balance does not suit them. A natural balance is much better if you can find it. Aluminium palettes prepared for oil-painting are also on the market.

In laying out the palette the lighter colours are usually placed nearest the thumb.

In the old days, shells were usually used to hold the colours, or sometimes they were even placed in little cups hanging from a belt around the artist's waist. Vasari ridicules this habit of Aspertini of Bologna. The first palettes were certainly very small as is shown by old pictures.

The old painters were afraid of diluting their colours unequally, and probably this fear was not foolish. They mixed them up before using. This practice is recommended by Harold Speed when he says that he used patty or biscuit tins in which to mix his colours when working on large things.

I use a palette which I designed myself, made of a zinc tray with a close-fitting cover. Along one side of it I keep a strip of white glass about seven inches wide and as long as the tray, which is somewhat over two feet. When I am through for the day I put a wet sponge in the tray and put the cover on. This not only keeps out all dust but considerably retards the drying of any colours which are left on the glass (see illus. p. 236).

André Salmon, writing in *Gringoire* of the 24th of April 1931, speaks of the palette used by the Hungarian painter, Farkas: 'A sort of all-white surgical table, on which the painter Farkas spreads his colours which he makes himself. Étienne Farkas claims that the brown wooden palette is an error and an anachronism. According to him this brown palette suited

painters before impressionism and is of no value for the moderns, whom it can only lead into error necessitating needless corrections. Why? Because the painters of the day before yesterday began by preparing their canvases in brown—today we paint on canvases prepared in white. For white canvas a white palette.'

For gouache a regular white china plate or platter may be used. If this is covered with another and slightly larger one which is in turn covered by a towel or napkin tied round it and dampened, the colours will keep damp until the following day.

§5. *EASELS*

The choice of an easel depends largely on what you can afford. For the portrait painter who must to some extent impress his client by the luxurious quality of his apparatus the most monumental easel on the market may not be a bad investment and for this he may pay some £25 or even more. But for the average studio worker a light, studio easel is sufficient. It should be rigid, and must have some apparatus by which the canvas may be tilted forwards at the top, otherwise much annoyance will be caused on account of reflections from the wet paint. A great saving of energy and sometimes temper will also be made by having a screw for raising or lowering the canvas. At the back of the easel tin receptacles for holding spare or dirty brushes may be set with advantage.

If the artist cannot afford a regular, screw-frame studio easel, what is known as the Radial or Pillar Easel is the cheapest and most convenient. It consists of a central pillar on tripod struts and, for moderately

sized pictures, is quite rigid enough. It also folds up into a conveniently small space when not required.

For field work the easel should be as rigid as possible compatible with lightness. It also should have an apparatus for tilting the canvas forward.

For water-colour sketching out-of-doors the only satisfactory easel is the table easel. This is a light flat tripod with an adjustable head to which the drawing-board or paper-stretcher can be attached. It can then be set at any convenient angle needed, from quite perpendicular to flat as a table. The angle may also be altered at will during the course of the work.

§6. *THE CAMERA LUCIDA*

For enlarging or reducing from a drawing to a picture or vice versa, the ordinary method is by squaring off. This consists in dividing the drawing into a series of equal squares like a chess board and dividing the canvas into a *similar number* of squares, which are of course in relative proportion. The drawing can then be copied from square to square.

An apparatus which does the same work is known as the Camera Lucida. This consists of a small, total-reflecting prism on an adjustable arm. The peculiarity of the prism is that while by looking at its edge a clear image of the work that you may wish to copy can be seen reflected on, say, a blank paper set at right angles to the original, at the same time the point of your pencil is also visible. Thus you have only to follow with the point of the pencil the image thrown on the blank paper to produce an accurate copy, enlarge-

ment or diminishment as desired, the two last depending on the relative distances between the original, the copy and the prism.

THE CAMERA LUCIDA

ment or enlargement as desired, the two focusings depend on the relative distance between the original, the copy and the paper.

CHAPTER X

PIGMENTS

§1. *THE MANUFACTURE OF PIGMENTS*

Pigments are the colouring materials, usually in the form of powders, which are mixed with the liquids called vehicles to form paint.

They may be divided into two main groups, according to the source of their origin, as *Mineral* and *Organic*. The groups may be subdivided as follows:

Mineral Pigments

NATURAL. The earths (yellow ochre, terre verte, lapis, or natural ultramarine, etc.).

ARTIFICIAL. Cobalt blue, viridian, aureolin, cadmiums, etc.

Organic Pigments

ANIMAL. Indian yellow, carmine, sepia, etc.

VEGETABLE. The madders, indigo, sap green, gamboge, etc.

ARTIFICIAL—as Prussian blue.

There are other means of classifying pigments, for instance, chemically as: elements, compounds and mixtures, and further into groups according to their nature regarded chemically as: oxides, sulphides, hydrates, carbonates, silicates, etc. A minimum of chemis-

try will be offered in this chapter, as the ground has already been satisfactorily covered by Church, Fischer and others, and because having no pretentions to chemical knowledge—except the most elementary—I am totally unfitted to deal with it.

From personal experience, I believe that the most useful thing for practising painters is a list of pigments divided, as well as possible, according to colours and discussed exclusively in their relations to the material technique of painting. Thus a painter who wished to see the greens available for a particular problem could easily find those recommendable, and so on with any colour, of which he might feel in need for a temporary or permanent enlargement of his palette.

Another thing of interest to the painter is to establish, as far as is practicable, the nature and qualities of the pigments sold under literally hundreds of different names, by different manufacturers in a distressingly confused and undesirable fashion. The reasons for such a huge, vague vocabulary are entirely commercial. Sometimes the names are quite frequently changed, which makes things even worse, and it may be supposed in such cases that they are changed merely in order to be deceptive, for instance, an analine red which gained a bad name through its coy manner of disappearing too promptly when it was called 'Geranium Lake' is withdrawn from the market, and the stock on hand relabelled 'Permanent Thibetan Red' or something even more euphonius. This may fool 'some of the people all of the time', but the red remains as coy as ever, and so forth. Certainly reputable firms are less and less given to this sort of nonsense, and an excellent rule to follow is to buy only colours which are

honestly labelled with their classic names, so that their composition, at least according to their label, may be trustingly assumed to be something like what is advertised.

A list of pigments pretending to completeness would require a thick volume, a sort of dictionary of pigments It would be practically impossible to keep it up to date, because of the new colours, or at least, new names, which are constantly appearing. But by showing the absurdity of the great number of unnecessary tints on the market, it might do much for the desired standardization of nomenclature, and help to hasten the honest and simple labelling which fortunately seems at last to be coming into vogue.

Properties of Pigments in General

Secrets connected with the making of pigments have always existed, some of them were lost for centuries. Even in the preparation of the natural earths, which were formerly washed and ground by the artist in his workshop, there were tricks and processes in the comparatively simple operations involved. These things can hardly be of practical concern to us here.

When the manufacture of artificial pigments became important, during the last hundred years or so, and the methods of manufacture relatively complex, some manufacturers discovered special methods of preparation which made their products clearly superior to others. These secrets defy analytic chemistry. They are almost as mysterious as those which were known in connection with the making of fine violins. Specialization naturally followed and certain European manufacturers are so highly specialized that they only make

one or two colours; these materials may be sold to several firms of paint makers to be made into paint. The best Naples yellow was long the secret of a house in Marseilles. Spooner's process for the manufacture of a very superior grade of chrome yellow was purchased from the inventor by a big firm of French colour manufacturers. And partially for reasons of this sort we have the endless discussions as to the permanence of the cadmiums, etc. Actually they may be permanent in some cases and less so in others. The same situation applies also to Prussian blue; so much depends on the method of manufacture.

Methods of Making Artificial Pigments

Artificial pigments are prepared by two main methods which may be defined as the WET and DRY methods respectively. Sometimes the same pigment may be made in either way. The dry method consists chiefly in the application of heat; the wet by precipitation from aqueous solutions.

The Dry Process is used in the manufacture of Vermilions, Cadmiums, Artificial Ultramarine, the best grade of Prussian Blue, Cobalt, Smalt, Venetian Red, Burnt Ochre, Burnt Sienna, etc. Pigments made by the dry process are as a rule more permanent than those made the wet way.

The Wet Process is used in the manufacture of the Chrome Yellows, Lemon Yellow, Pure Scarlet, Aureolin, Emerald Green, White Lead, etc. The particles of the pigments made in this way are often crystalline in structure and some of them are very difficult to grind.

When a pigment may be made in either way, the dry way is usually preferable.

PIGMENTS

§2. *THE PROPERTIES OF PIGMENTS*

Classified first as *physical* or *chemical* these may be listed as follows:

Physical	Chemical
Colour	Permanence
Transparency	Crispness and setting-up
Opacity	Drying power
Specific gravity	
Working quality	
Fineness of texture	
Body	

If a pigment is not permanent, the other properties need not matter much to an artist, at least not to anyone who is working for anything other than a temporary reputation.

Colour

Each tiny particle of a pigment may be regarded as a transparent body which colours light by selective absorption. Even the most opaque pigments may be composed of transparent particles, for a cloud made up of transparent water globules is opaque. This property of transparence or opacity of course depends on the thickness of the coating in which the pigment is applied. With the thicker coats we get decreased luminosity and also an appreciable change of hue. A pigment may be either delicate, pure and brilliant, or deep, rich and intense. *As these qualities can scarcely exist together in the same pigments, some painters use two pigments of each colour, one for delicacy, the other for richness and depth.*

THE PROPERTIES OF PIGMENTS

The same applies to pigments of similar hue, one of which is transparent and the other opaque.

Transparency

The light is reflected back through the pigment from the white ground. Its chief usefulness makes itself felt in glazes or shadows.

Opacity

Its opposite. The light reflects more or less directly from the surface of the pigment. It should not be confused with—

Body

Which really means tingeing power. The body or tingeing power of a pigment may be established by mixing a given quantity of it with a given and much larger quantity of white. Tingeing is another term for tinting.

Specific Gravity

Is too well known to need definition. There is usually a direct relation between specific gravity and opacity.

Working Property

Must be a matter of the painter's individual experience. The vehicle and medium have much to do with it. Some of the best pigments are the most difficult to manage. Fineness of texture and body are the chief factors in working property.

Fineness of Texture

Is produced by careful grinding and the elimination of coarse particles.

PIGMENTS

Crispness and Setting-Up

Are the qualities which enable a pigment to keep its place on the support. Some pigments (vermilions, umbers, Harrison red) can only be kept in place by the use of special mediums or vehicles.

Drying Power

Depends largely on whether or not the pigment aids the vehicle, especially in the case of an oil vehicle, to take up oxygen from the atmosphere. Sometimes *dryers* must be used. Dirty brushes which contain a little alkali left from the soap through lack of proper rinsing may interfere with the drying.

Permanence

The most important quality will be treated in connection with each colour as it is discussed. Generally speaking, it is a relative affair. Manufacturers use it in a very relative sense indeed, and it is naturally to their advantage to name as many pigments as being 'permanent' as possible. Discussion to one side, it is interesting to note that WINSOR AND NEWTON in their classification of permanent colours—Catalogue 1936—consider only the following colours as absolutely inflexible under all ordinary conditions in the oil medium.

List of Absolutely Permanent Oil-Colours

I have taken the liberty of rearranging the list to some extent so that the limitations of a palette possible to compose from it can be more readily seen.

Whites. Permanent White (a special preparation of Oxide of Zinc prepared for oil-painting), Titanium White.

Yellows. Ochres, 'Aurora Yellow' (a special preparation of sulphide of cadmium), Mars Yellow.

Reds. Indian Red, Light Red, Mars Red, Venetian Red, Terra Rosa.

Blues. Cerulean Blue, Cobalt Blue, Genuine Ultramarine, Ultramarine Ash. (The last two susceptible to the action of Sulphurous Acid, which might be present in the air.)

Greens. Emerald Oxide of Chromium, or Viridian (in France called Vert Emeraude), the Cobalt Greens, dark and light (which are not, however, proof against damp), Veronese or Emerald Green, Terra Verte.

Violets. The Cobalt Violets, dark and light, Mars Violet.

Browns. The Umbers, the Brown Ochres, Burnt Lake, Burnt Sienna Cappagh Brown, Cyprus Umber, Mars Brown, Prussian Brown, Raw Sienna, Verona Brown.

Orange. Mars Orange.

Black. Black Lead, Blue Black, Ivory Black, Lamp Black, Cork Black.

Greys. Charcoal Grey, Davy's Grey, Mineral Grey, Payne's Grey, Neutral Tint, Ultramarine Ash (Grey).

It will be readily seen that this really permanent palette is a most limited one. The chief lack is in the reds. There is apparently no brilliant red which is absolutely permanent although I have lately received strong claims to the contrary for a new variety of red cadmium. None of the madders are permanent in the full sense of the term. Pale yellows are also lacking. In the discussion of colours which follows, it will be thus understood that many of them which may be referred to as 'permanent' are meant to be reasonably so under

any ordinary conditions to which works of art may be expected to be exposed—that is to say, that they will last indefinitely when protected by a good varnish and in the diffused light of an ordinarily well-lit room.

Maximilian Toch says that 'All in all, one German catalogue contains five hundred and seventy-nine varieties of colours.' Get a number of these manufacturers' catalogues and familiarize yourself with the names. Real knowledge of the qualities of different oil-colours can only come from specialized study and long practice.

The Permanence of Pigments

The permanence of pigments may be affected by the following factors.

1. Action of light.

2. Action of the atmosphere or impurities which it may contain.

3. Action of the vehicle or medium.

4. Interaction of pigments which have been mixed together.

1. *Action of Light*

The action of light makes itself most felt on pigments of organic origin, and the more unstable inorganic ones. Aniline pigments, as everyone knows, are almost —but not quite—without exception soon changed by light. Of course, a great difference may be remarked between the action of direct sunlight and that of the diffused light of the average room. Anyone who has ever had some experience with photography will understand this, at least in part. The colours usually considered as 'permanent' by most manufacturers will

be reasonably permanent in practice as was rather comfortingly proved to me by an experiment which I recently carried out in conjunction with my friend, Ross Saunders. He has a house on the Côte d'Azur, in the south of France, which on one side is almost constantly exposed to the direct rays of the hot Riviera sun all the year round. It is in the country, the atmosphere is pure, so that the tests carried out can only be said to apply to the effect of light, but this sunlight is so strong and the sun shines so much of the time that the colours which were exposed to it for about a year, having shown no appreciable change during that time, under such unfavourable conditions, may be considered permanent as regards to light for all practical purposes where ordinary conditions are concerned.

The experiment is simple and may be easily performed by anyone having doubts as to the amount of resistance a given colour may offer to light. We simply took several wide boards, which had been treated with my neutral whiting-glue and milk ground, and applied the colours to them in two-inch wide horizontal stripes. Some colours were applied pure; some in mixtures. None of them was varnished or otherwise protected. When the colours were dry, the boards were sawed in two vertically; one half was kept in the house in a dark corner; the other nailed to the sunny side of the house. By putting the two halves together, from time to time, comparison between the colours on the exposed half and the colours on the sheltered half could be easily made. Colours of several qualities, made by French, German, Dutch and English firms were used. They were applied pure, as they came from the tubes when possible. When too thick they were thinned with a

little petrol. Some fifty-six colours and mixtures were tried. The results in general were very heartening. A cadmium red darkened a little on three months' exposure. A cadmium green faded somewhat in the same period of time, a lead white affected slightly an artificial ultramarine with which it had been mixed in equal proportions; and the oils, with which the whites were ground, turned somewhat darker in the shade, but generally speaking the colours stood up very well indeed—even Prussian blues and madders and the cadmiums behaving well under the circumstances, and all fully living up to the claims made by the manufacturers for them.

The conclusion to be drawn from the experiment is that in general the sensibility of modern prepared pigments to sunlight has been much exaggerated, and that the claims of most reputable colour makers may be fairly trusted.

2. *Action of the Atmosphere*

A normal atmosphere contains oxygen, nitrogen and a small but constant quantity of carbonic acid; also a certain quantity of water-vapour or moisture which varies enormously with the temperature. The nitrogen and carbonic acid may be considered as having no action. In towns there may be present a varying quantity of sulphureous and sulphuric acids due to the combustion of coal, and sulphuretted hydrogen from drains or sewers.

Oxygen

Especially in the form of 'ozone' and in combination with sunlight or moisture may have a strong oxidizing

effect on some pigments, particularly when these are not protected by an oil or resin film as is the case on unvarnished water-colours.

Moisture

Water dissolves twice as much oxygen as nitrogen. It is supposed to soften the film of gum which covers water-colour pigments and allow of quicker action by any constituents in the atmosphere present. It affects the cobalt greens.

Sulphuretted Hydrogen

Forms dark-coloured and stable sulphides with some metals. Some colours such as white lead may be affected by it if insufficiently protected by varnish. In the atmosphere it becomes slowly oxidized into sulphureous, and finally into sulphuric acid. These would have a very injurious effect on pictures. A shower clears them away. Sulpheretted hydrogen is hydrogen sulphide.

The Medium

In the case of oils, absorbs quite a lot of oxygen in drying. This may be taken partially from the atmosphere and partially from the pigment. The chromates, for this reason, are apt to turn green in oil. When *metallic oxiaes* are used *as dryers*, their effect is *likely to be disastrous*. It is better to avoid all of them, although those of manganese are considered the least injurious. In water-colour there is, of course, little or no chemical change; but, on the other hand, the pigments are less protected from possible action of the atmosphere.

PIGMENTS

§3. *MIXING OF PIGMENTS*

Solids do not interact chemically. If a pigment is soluble in a vehicle or medium, this is, of course, a different affair. Insolubility is, therefore, a primary quality to be sought for in a pigment.

Few of them are absolutely insoluble. Mixtures should be avoided where possible. *The lead and iron base colours are particularly dangerous in admixtures.* True Naples Yellow and the Cobalt Violets should not be touched with metal. Any but the best cadmiums are not supposed to be mixed with white lead. Madders are 'eaten' by white lead. Emerald Green should not be mixed with the Cadmiums or Vermilions; or for that matter with any colours when this can be avoided. The Alizarin Lakes should not be mixed with the Ultramarines; Prussian Blue with the Cadmiums or Vermilions; lead whites with Artificial Ultramarines. All this may be forgotten if the palette is confined not only to permanent but to chemically neutral colours. This is quite possible *theoretically and practically* today. I have found, in practice, that the danger of mixtures in permanent pigments has been much exaggerated.

The Common Causes for Colours Changing

These are, according to Dinet

1. The use of the lakes. (Madders, Alizarins, etc.)
2. The use of aniline colours.
3. The use of vermilions.
4. The use of the chromes.
5. Emerald green or Vert Veronese in mixtures, particularly with the vermilions or cadmiums.

MIXING OF PIGMENTS

Sometimes colours are supposed to have changed when in reality the medium or vehicle has darkened. This is particularly apparent with the whites and the blues, but it may be noticed even with such a colour as Burnt Sienna. Exposure to sunlight will usually bleach the oil film to its original colour.

Some Simple Tests

Expose the colours to sunlight, as described above, or place the colours on a piece of white paper. The commonest adulteration of colours today is that accomplished by mixing brilliant aniline dyes with them. This is particularly practised with expensive pigments such as the cobalt violets. If there is any doubt, they may be simply placed on a piece of white paper. The oil in which the colours are ground should not be stained. If it is, and thus stains the paper, there is probably an aniline adulterant present. Aniline dissolves at once in alcohol and thus provides a sure means of testing powdered colours, water-colours or gouaches as alcohol added to them should not take colour.

Manufacturers' Tests

Are often carried out under special artificially produced conditions. Mercury arc lamps, or violet carbon or other special lamps are used twenty-four hours a day in rooms where humidity, changes in temperature and large amounts of chemical vapours are maintained in the atmosphere. The manufacturers at least have the advantage of knowing what they are testing when the trained chemists employed on their staffs take the trouble to investigate the raw materials.

Washing

Washing pigments to cleanse them of all the impurities possible before grinding is an operation which is as simple in principle as it is complicated in practice. Volumes might very easily be written about it. Cennini says little or nothing about it even when writing of yellow ochre, which is one of the pigments which may be most advantageously purified in this way. Most pigments are simply washed by stirring for varying lengths of time in several clean waters. The scum or sediment formed, sometimes one, sometimes the other, and sometimes both, are thrown away. Proper washing is as difficult as it is important. Filtering must be used in connection with it for some colours, as in the case of the Madders and Prussian Blue. To assure the fineness of texture of pigments they are, in modern usage, also sifted through fine wire sieves. House-painters indicate the fineness of a colour by giving the number of wires per square inch in the sieve which it will pass through, as 240, etc. Insufficient washing is a common defect of manufacture, even in some of the finest brands of colours.

§4. *GRINDING*

To grind the powdered colours in the studio before using them is advantageous for certain sorts of painting. For egg tempera, for instance, the colours must be ground very fine. Prepared colours are now usually ground by machine, though several European makers still grind them exclusively by hand, or, in any case, finish the grinding in this way. Modern grinding machines have been brought to a very high state of

development and there is no reason to believe that hand-ground colours are superior to those ground on a carefully tended modern machine. On the contrary, some authorities agree with Ludovic that machine-ground colours are apt to be more even and fine than the hand-ground product.

A practical substitute for a grinding stone, which is too heavy and ponderous to be used by most painters in their studios, is simply a thick piece of ground glass. These pieces of glass, and glass mullers of different sizes to be used on them, may be bought from any artist's supply shop. If you find yourself without your glass plaque and have only your muller, you can grind emery powder on any piece of glass and soon get enough tooth on it to grind your pigments. I have ground house-painters' pigments into quite acceptable shape with no other apparatus. On a piece of ground glass about a foot and a half square, which is approximately the usual size they are sold, about as much pigment may be ground at a time as will go on a six-pence. The muller is moved with a circular motion in a gradually widening circle. When the outside edge of this circle gets near the edge of the ground glass, the colour is scraped again into the middle with a palette knife, which should be preferably of horn, bone or ivory, as steel affects some of the pigments, particularly when they are not yet in their oil vehicle. You will know when the pigment is sufficiently ground by its smooth and creamy texture and its freedom from all lumps and grit. It may be necessary to add a little water from time to time as the water will be absorbed by the dry pigment or evaporate.

The ground glass or stone must be cleaned immedi-

ately after each session of grinding as, of course, if any colour of a strong staining power is left in the pores, it may ruin your next batch of colour. In grinding, an ounce of experience is worth a ton of theory. It is a simple operation and a little practice can make it quite a pleasurable one. Enough colour may be ground in a day or so to last for months.

Cleaning the 'Stone'

To clean the stone, or ground glass:

If you have been grinding with water, soap, water and a stiff brush usually suffice. Be sure to rinse well. When grinding with oil or wax mediums, use petrol or turpentine. If you have the hard luck to leave some dried-up colour on the stone, grind it off with a strong solution of potash-water or ammonia and water. Sifted fine sand, pumice powder or a good cleaning powder, such as Gold Dust, or Old Dutch Cleanser, etc., or pumice stone and borax may be ground over the stone. Fresh bread is best for cleaning the stone when it becomes stained with a fine pigment. Grind the crumbs over it.

Advantages of Grinding your own Pigments

For certain mediums, such as egg tempera, it is almost a necessity to grind your own pigments. With any medium it is quite advantageous. In the first place, many colours require different amounts of grinding to fit them really for use, and an artist grinding his own will soon find out just how he likes them.

The manufacturers, being chiefly interested in their power of keeping without drying upon the shelves of the colour supply shop, usually put in from 25

to 40 per cent more oil than is either necessary or desirable. This is practical *and* economical for them. A large part of this excess oil will come out if the colours are left on a piece of blotting paper overnight, but even this process does not remove the wax or other substance which has been probably added to them to give them 'body'. Home-ground colours prove these points by covering surprisingly well. An artist who has ground his own colours knows all about them; their purity and the nature and peculiarities of each. Tubes may be purchased almost anywhere, and as most of the powdered colours are pretty well ground before you buy them, the job of grinding them is not too long to repay the trouble. Such colours are also very economical when their quality is considered.

Characteristics of the Different Pigments

A number of good—and some quite thick—treatises exist on the composition, fabrication, qualities, properties and chemistry of pigments. When it is realized that the substances used to make colours vary from dead insects, urine, the sap of plants, etc., to the most complex products of modern inorganic chemistry, it may be admitted that the subject is sufficiently complex to provide a liberal field for research.

§5. CONCLUSION

I discuss some 460 names of colours in my book, *Notes on the Technique of Painting*. Their qualities having been very frankly treated, the list from one standpoint at least, will be found to be the shortest of its kind ever compiled. What I mean is that the list of 'permanent'

colours, as will be noticed by any experienced eye which has the persistence to peruse it, is very short indeed. Over 50 per cent of the colours claimed as 'permanent' by the manufacturers have been here listed as 'durable'. With all the important discoveries of modern chemistry in this domain, extravagant claims of colour-makers notwithstanding, it is still practically impossible to make up a palette of absolutely permanent colours of any but the most limited nature. If the list here given is considered by experts as being rather pessimistic, I must retort that the lists by manufacturers are, almost without exception, rather too optimistic. If 'permanent' colours are lacking (particularly in the domain of brilliant and permanent reds) durable ones are not. Never, in the history of painting, has the painter had at his disposal so many fine and lasting pigments. Some new or less current colours may be mentioned here, as a general demand, even if not very widespread would make them easily obtained, and they are all interesting, if not absolutely necessary, for there is every reason to believe them superior to the colours they are meant to replace:

New Colours

TITANIUM WHITE to replace LEAD AND ZINC WHITE.

MONASTRAL BLUE or BLUE LAKE to replace PRUSSIAN BLUE.

MONASTRAL or 'THALO' GREEN to replace EMERALD and other GREENS. Monastral and thalo blues and greens are phthalocyanine pigments.

The Quinacridone or 'Acra' or 'Astra' run of pigments, made with the famous Dupont Monastral pigments, termed 'exceedingly permanent' yield a new

CONCLUSION

run of Reds, Crimsons, and Purple-violets. Messrs. Rowney now produce a range of colours such as Red Violet (Quinacridone) and Indanthrene Blue, which are being used by many major paint manufacturers, and are assumed to be permanent. A purer, brighter hue than any of the madders is provided by the Rhodamine-Rubine pigments which also furnish a brilliant Violet. Another Violet, on the Blue side, is made from Dioxamine Carbasole. It is said to be 'extremely dependable'.

Vermilion may now be very advantageously replaced by the newer Cadmium-Mercury Sulfide Reds which are replacing the traditional Cadmium-Selenide Reds. They are stronger and more brilliant and their permanency is of the same order.

Several new blacks are worthy of investigation. Mars Black is an outstanding example.

Palettes of some 'Old Masters'

Jean Van Eyck (La Vierge du Chancelier Rollin)
1. Brown, *verdaccio* 5. Terre Verte
2. Madder 6. Orpiment
3. Lapis-lazuli or 7. Sinopis—Red Ochre
 genuine Ultramarine 8. Peach Black
4. Yellow Ochre

Titian used to say, according to the information furnished us by his pupil, Giacomo Palma, that a great painter needed only three colours, and he applied his own precept by working with a very small palette.

Colours Used by Titian
1. Lead White 2. Genuine Ultramarine

3. Madder Lake
4. Burnt Sienna
5. Malachite Green
6. Yellow Ochre
7. Red Ochre

8. Orpiment (rarely used alone but usually in mixing greens)
9. Ivory Black

Titian apparently did not, like his predecessors, mix his tones in advance in little pots, but placed them on a palette as we do today, mixing them in the course of painting.

Palette of Rubens

1. Lead White
2. Orpiment
3. Yellow Ochre
4. Yellow Lake
5. Madder
6. Vermilion
7. Red Ochre
8. Genuine Ultramarine
9. Azur d'Allemagne (cobalt)
10. Terre Verte
11. Vert Azur (oxide of cobalt)
12. Malachite Green
13. Burnt Sienna
14. Ivory Black

There is a trunk in the Museum at Antwerp which contains the powdered colours used by Rubens. The lead white, the ultramarine, the madders, and the earth colours are in a good state of preservation, but the yellow lake, the vermilion, and the vegetable greens are faded almost entirely away. Rubens' pictures have been retouched to an almost unbelievable extent.

From Rubens, onward for two hundred or more years, the palettes hardly warrant discussion here. Dark primings, all sorts of doubtful colours, culminating in the famous Bitumen, appear and are discussed with fitting heat. Courbet used cheap colours very carelessly; his canvases sometimes show it, sometimes

CONCLUSION

they *seem* to have stood up well in spite of it. The Impressionists with their prismatic palette which contained few earths and no black, could be more fittingly treated of in a book on æsthetic theory, which this one tries hard to avoid. Gauguin was careful of his mixtures, but I believe that his colours have faded appreciably. He was often forced to use those he could get, rather than those he might have chosen. Van Gogh was a very careful technician. He used wax in his impastos or when he applied the paint thickly. Modern speculation on the part of the dealers has made the attempt to judge by the conservation of the canvases naïve to the point of folly. Having heard some choice conversation from the Rues de la Boëtie and de la Seine—I refrain. Nobody knows what is done to the paintings we see today. A few months back I was asked to retouch a Modigliani 'in a hurry'. It had just been restretched and some of the paint had cracked off. I'll willingly bet that it looks fresh and fine now! The dealer found a retoucher within fifteen minutes after I had declined the job.

A Contemporary Chemist Specializing in Pigment Chemistry
* —Maximilian Toch*

Gives the following as a 'restricted simple permanent palette'.

1. Venetian Red or *Plus*	6. Raw Sienna
Light Red	7. Burnt Umber
2. Medium Cadmium	8. Chromium Oxide
3. Ultramarine	(opaque)
4. Lamp Black	9. Chromium (trans.)
5. Zinc White	10. Madder Lake

PIGMENTS

The Madder Lake is not to be mixed with Raw Sienna or Yellow Ochre.

Advantages of a Small Palette

Certainly a beginner can learn a great deal by confining himself to a small palette, the smaller the better. Not only is it easier to keep the colour harmonies in hand, but the number of colours which may be mixed with a few basic ones, and the things which can be done with them is little short of unbelievable.

A good Five-Colour Palette (*rather low in chroma*)

Might be made up with:

1. Titanium White
2. Yellow Ochre (pale and brilliant as possible)
3. Light Red
4. Cobalt Blue
5. Ivory Black

or (*higher in chroma*)

1. White (any sort you like)
2. Lemon Cadmium
3. Ultramarine
4. Cadmium Red (deep)
5. Lamp Black

A Basic Nine-Colour Palette

Was established by Hammerton and reported by him in *The Portfolio* (1876, page 132), it consisted of:

1. Flake White (advantageously replaced by Titanium White)

CONCLUSION

2. Pale Cadmium
3. Yellow Ochre
4. Vermilion
5. Rose Madder
6. Ultramarine
7. Emerald Oxide of Chromium
8. Vandyke Brown
9. Black

(I should suggest elimination of the Vandyke Brown and substitution of Cadmium Red for Vermilion.)

With this palette he imitated the following colours. His opinions as to the degree of his success are his own.

1. Naples Yellow: Flake White, Cadmium Yellow and a trace of Yellow Ochre. Exact.

2. Lemon Yellow: Flake White, Cadmium Yellow, trace of Viridian. Less brilliant.

3. Cadmium Orange: Cadmium Yellow and Vermilion. Less brilliant.

4. Light Red: Vermilion, Yellow Ochre, Vandyke Brown.

5. Venetian Red: Vermilion, Yellow Ochre, Rose Madder, Vandyke Brown.

6. Indian Red: the same with a little black—less transparent.

7. Cobalt Blue: Ultramarine, trace of Viridian, White. Less transparent.

8. Prussian Blue: Ultramarine, Black, trace of Viridian. Somewhat less deep and translucent.

9. Burnt Sienna: Yellow Ochre, Rose Madder, Vandyke Brown.

10. Emerald Green: White, Cadmium Yellow, Viridian. Less brilliant.

11. Malachite Green: White, Cadmium Yellow, Viridian, Yellow Ochre.

12. Cobalt Green: Ultramarine, Viridian, trace of White.

13. Indigo: Ultramarine, Viridian, Black. Very closely matched.

This game of 'making colours on the palette' is very instructive. It may hardly be assumed that Mr. Hammerton exhausted his possibilities in the above experiment. Having tried the same game and being of a naturally insincere character, I have derived, from attempting to fool my fellow painters with it, doubtless much more pleasure than they from being through politeness forced to guess about it. Actually, if anyone would like to know, I myself use a different palette for every picture. What could be more logical than that?

§6. *PIGMENTS AT A GLANCE*

The following tables give most of the usual pigments used in painting and show at once the following qualities: permanence, chief ingredient, opacity, covering power, drying speed, and special features. The following three symbols are used, +, × and −. Thus in permanence + means absolutely permanent, × means durable (or as permanent as possible in the tint), − means unreliable and should be avoided. In opacity + means opaque, × means semi-opaque, − means transparent. For oil-painting, on the whole the opaque colours are the most useful, the proper use of transparent colours needing more thought and deliberation: in water-colours the transparent colours are best, the opaque colours generally losing some of their colour-

ing capacity when used in thin washes and mixtures. Covering and drying capacity refers only to oils; in these columns + means good or fast, × means medium, — means poor or slow.

Dura-bility	Pigment	Principal ingredient	Opacity	Cover-ing	Dry-ing (oil)	Remarks
	WHITES					
×	Flake Cremnitz Blanc d'argent	Lead	+	+	+	Good in oils. Should not be used with water-colours or fresco. Should not be mixed with vermilion, pale madders or cadmiums.
+	Zinc Chinese	Zinc	×	×	×	Best in water-colour or tempera. May crack in oil. Don't use in fresco.
+	Mixed	Lead and Zinc	+	+	+	The mixture seems to correct faults of two preceding pigments.
+	Titanium	Titanium	+	+	×	New product, but promises excellently. May go grey if poor quality.

214

	Yellows	Base				Remarks
×	The Cadmiums	Cadmium	+	+	×	Orange the most permanent. Lighter tints may darken if not first class. Don't mix with emerald green or flake white. Don't use in tempera.
+	Aureolin / Cobalt Yellow	Cobalt and Potassium	×	+	+	
|	The Chromes	Lead	+	+	+	Lighter tints tend to fade. All chromes uncertain unless first class.
+	Permanent Lemon	Potassium and Barium	+	+	|	Better in oils than in water-colours.
|	Strontium	Strontium	+	+	×	In water-colour is a stain. Dangerous in mixtures.
|	Naples (true)	Lead	×	×	+	May be dispensed with.
+	The Ochres / The Mars colours	Iron	+	×	+	Safe in almost all mixtures. Don't mix heavily or tint is spoiled.
+	Raw Sienna	Iron	|	×	|	In oils very dangerous, takes up 200 per cent of oil.

Dura-bility	Pigment	Principal ingredient	Opacity	Cover-ing	Dry-ing (oil)	Remarks
×	Spectrum Azo Alazarin Hansa	Coal-tar	×	+	×	Coal-tar products are now much better than they used to be.
\|	Gamboge	Organic	×	+	×	Dangerous in oils, fades in water-colours.
	REDS AND	ORANGES				
+	The Red Ochres Venetian Indian Light Red Mars Red	Iron	+	+	+	
+	Pozzuoli Terra Rosa	Natural cement and iron	+	+	+	

Pigment	Composition					Remarks
Cadmium Red and Orange	Cadmium	×	×	+	+	In best quality considered durable. Don't mix with malachite or emerald greens or Prussian blue.
Vermilion	Mercury	×	+	+	+	Tends to darken. Don't mix with flake white or emerald green.
The Madders	Organic Alizarin	×	−	×	−	Light tints are the more fugitive. Don't mix with flake white.
Spectrum Azo Helio-Fast	Coal-tar	×	×	+	×	Good in water-colour. In oils may stain superimposed colour.
Harrison Red	Coal-tar	×	×	+	+	Tendency to stain superimposed colour. Don't mix with ochres or siennas.
Alizarins	Artificial Alizarin	×	−	×	−	Substitute for madders. Don't mix with ultramarine
Crimson Lake Carmine	Cochineal	−	−		−	Don't use on any account.
Potter's Pink	Ceramic glaze	+	×			A permanent substitute for rose madder.

Dura-bility	Pigment	Principal ingredient	Opacity	Cover-ing	Dry-ing (oil)	Remarks
+	Burnt Sienna	Iron	−	×	+	Apt to be intrusive as a colour.
+	Mars Orange	Iron	−	×	+	
	BLUES					
+ ×	Cobalt Ultramarine (true)	Cobalt Lapis lazuli	× −	+ +	+ +	Works well in all media. May be affected by sulphurous atmosphere. Very expensive.
×	Ultramarine (artificial) French Blue New Blue Permanent Blue	Sulphur and Sodium	−	+	+	Don't use in tempera. Dangerous mixed with emerald green, chrome yellow alizarins and even flake white.
+	Cerulean Phthalocyan-ine Blue	Cobalt	+	+	+	Difficult to use in water-colour washes.

Name	Composition	1	2	3	4	Notes
Prussian Paris Berlin Antwerp Cyanine	Iron and Cyanogen	+	+	−	×	Fades in light, regains tint in darkness. Don't mix with vermilion. Don't use in fresco.
Indanthrane Blue Lake	Coal-tar	+	+	×	×	May be used as a substitute for Prussian blue.
Smalt	Coloured glass	+	+	×	+	
Indigo	Organic	+	+	×	\|	Should be rejected as also should be papers tinted with it.
GREENS						
Viridian Emerald Oxide of Chromium Transparent Oxide of Chromium Vert Emeraud	Chromium	+	×	−	+	One of our most permanent colours. Must not be confused with emerald green.
Opaque Oxide of Chromium	Chromium	+	+	+	+	Might be more popular.

Dura-bility	Pigment	Principal ingredient	Opacity	Cover-ing	Dry-ing (oil)	Remarks
+	Emerald Green Veronese Green Vert Veronese	Copper	+	+	+	Used by itself a brilliant colour. Destroys most other colours in mixtures. In oil should be locked up in varnish.
×	Chrome Green	Prussian Blue and Chrome Yellow	+	+	+	More permanent than might be thought.
×	Cobalt Green	Cobalt	+	×	+	Somewhat sensitive to damp.
+	Permanent Green	Zinc or Baryta and Chrome	+	+	+	Only permanent if genuine.
×	Terre Verte	Iron and Chrome	×	×	+	May darken owing to large oil content.
	Phthalocyan-ine Green					It is powerful in tinting; it is permanent.

	Composition					Remarks
VIOLETS						
Cobalt	Cobalt	+	+	+	+	Should not be touched with a steel palette knife. Don't mix with flake white or ochres. Goes hard in tempera tubes.
Mars Violet	Iron	++	++	++	++	
Permanent Mineral	Manganese					
Azo	Coal-tar	×	+	×	×	Durable except when thinly applied.
BROWNS						
The Umbers	Iron and Manganese	+	+	×	+	In oil may tend to darken.
Prussian Brown	From Prussian Blue	+	+	—	+	No good in oils. In water-colour easy to wash but not quite permanent.
Sepia	Organic			×	×	
Vandyke	?	?	+	×	?	At least three principal varieties, one very dangerous. Don't use any that will not dry readily.

Dura-bility	Pigment	Principal ingredient	Opacity	Cover-ing	Dry-ing (oil)	Remarks
	BLACKS					
+	Ivory	Animal Carbon	+	+	+	Brownish tint in oils.
+	Peach	Vegetable Carbon	×	+	+	Yellowish tint.
+	Vine	Vegetable Carbon	×	×	+	Thin in oils, best in water-colours, a neutral black.
+	Blue Black	Vegetable Carbon	×	+	+	Blue tint.
+	Graphite	Mineral Carbon	+	+	×	
+	Black Lake	Coal-tar	—	+	+	Makes fine greys.

NOTE. All the 'lakes' are dye colours precipitated on to hydrated earths or tannin, with which they combine as insoluble compounds.

PIGMENTS AT A GLANCE

Some *very interesting* new colours have come to my notice within the last few months. I have not as yet had sufficient opportunity to test them with any degree of thoroughness but they are all claimed to be 'permanent' by the makers. Several of them seem to satisfactorily fill spaces in the theoretical spectrum which have never been adequately taken care of before. Among those worth investigation are:

Cold Reds: 'Permanent Ceranium Lake', made by Reeves, 'Spectral Red' (Sargent's) 'Rose' (Talen's).

Blue-Greens: Talen's and Sargent's.

Blue (Greenish): 'Monastral'.

A 'Trichromatic Palette' with which it is theoretically possible to mix all colours, consisting of the pigment primaries, lemon yellow, cyane blue and magenta. This set of paints having been perfected by Dr. Herbert E. Ives and manufactured by the Ruxton Products, Inc., of Cincinnati, Ohio, U.S.A.

CHAPTER XI

CONCLUSION

I can only hope that this book may prove useful in a practical way, as well as interesting to certain artists. Although a number of painters are born natural technicians and endowed with a great manual dexterity, they still need to know the mechanical and chemical basis of their craft. These people have no need or desire for mere technical counsels as technique seems a second nature to them. Often they are more craftsmen than artists. Another group of artists, however, only exteriorize their thoughts with great technical difficulty. They are clumsy, and their craft remains a constant struggle to control the inanimate but often perverse materials involved. Such painters, whose work may have a high æsthetic value, need all the help possible which might aid them towards successful expression. They rarely get the necessary instruction in schools.

The use of durable materials requiring more or less manipulation on the part of the painter has factors to recommend it other than mere durability or good craftsmanship, desirable though these are admitted to be. A direct connection of the means and method with the æsthetic side of graphic expression should be an inherent part of the job.

Louis Arnaud Reid (M.A., Ph.D., Lecturer on

CONCLUSION

Philosophy in the University College of Wales, Aberystwyth) has commented upon this inseparable relation between materials and expression in a most interesting way. In an article in *Psyche*, June 1925, he says:

'There is a peculiar satisfaction and a rich reward in mastering the idiosyncrasies, the Order imposed by a material, and in making it reveal in its own particular way the felt experience of the subject. It is not that there is a mere overcoming of difficulties, though that is worth something. It is not even that the spiritual essence of the experience can be brought out in the process of formal expression in a way which would have been impossible without it. It is more. It is that a new value and a new meaning, different from the previous experience and not discoverable in it, comes into being in the act of experimenting with the materials. The artist "builds better than he knew": as the marble or paint or sound takes form there is born under his hands a subtle new thing of delight which but for his manipulation of material could never have existed.'

This somewhat anti-Crocian point of view is clarified by Bosanquet when in his *Three Lectures on Æsthetic* he remarks:

'We should begin, I am convinced, from the very simplest facts. Why do artists make different patterns, or treat the same pattern differently, in wood-carving, say, and clay-modelling and wrought-iron work? If you can answer this question thoroughly, then I am convinced you have the secret of the classification of the arts and of the passage of feeling into its æsthetic embodiment; that is, in a word the secret of beauty.' Each thing, he goes on to explain, challenges and

CONCLUSION

coaxes one to deal with it in a specific and appropriate manner. William Morris made a similar observation concerning molten glass regarding its tenacity and ductility and the temptation which these qualities offered.

The artist thinks and feels in terms of his materials. He must understand them in order fully to comprehend his art. Manipulations such as the grinding of your own colours, the preparation of the support, and even the simple operations incumbent upon the purifying of oils and essences are thus all of psychological importance, as through them may be attained an understanding of materials not to be gained in any other way.

As Reid well points out, Croce must therefore be considered in error. His point that the great artist differs from the rest of us only owing to his more refined cognitive intuitions is not sufficient. The great artist also differs from the rest of us in his 'ability to think and feel in terms of line and form and colour, without which material and physical facts he could not be an artist at all'. A highly special feeling, and an imagination projective in terms of its relation to the materials involved are necessary for a complete and powerful expression.

APPENDIX I

THE PROBLEMS OF COLOUR

The only laws of colour which should really be discussed in this book are the ones telling which colours may or may not be mixed, how they may be mixed, and with what implements and mediums. A summary discussion of the principles accepted as scientific concerning the harmony of colours, strictly in relation to their possible representation in existing pigments of a permanent nature, should, however, prove useful, because of the very general and current misconceptions about this problem.

The artist may need to know the laws of colour but only as limited by the pigments procurable.

§1. *COLOUR PERCEPTION*

Daylight—reflecting objects and other local factors debarred—was formerly supposed to be white light, or more exactly, uncoloured light. At the end of the seventeenth century, Newton passed a ray of light through a prism and showed that, generally speaking, a ray of sunlight was composed of seven coloured rays, respectively: violet, indigo, blue, green, yellow, orange and red. If a disk painted with these seven colours is made to revolve rapidly, the eye has the sensation that the disk is white. Thus white light is really composed of these seven colours of the spectrum.

APPENDIX

Refraction and Reflection

If a transparent body is placed in the path of a ray of light, the speed and direction of this ray of light are modified; this phenomenon is called *refraction*. When on the contrary, the body interposed is opaque, the light ray cannot pass through it. It bounces back in the direction from which it was emitted; this is the phenomenon of *reflection*. The angle at which the ray of light strikes the body being equal to the angle at which it is reflected, the first is called the *angle of incidence* and the second the *angle of reflection*.

An opaque surface which is not perfectly smooth reflects the light in all possible directions, and appears *dull*, or mat. A smooth surface reflects the light in parallel rays, an image reflected is clear, the surface is shiny or brilliant.

No solid body is either completely opaque or completely transparent. It follows that a generally observed phenomenon is the result of these two facts. The ray of light is partly reflected from the outside surface. Another part is refracted to the inside, strikes the surface there and from it is reflected back to be once more refracted as it comes out into the air again. Another part of the ray refracted into the interior is refracted again as it passes out again from the interior surface. Thus from one side the observer may recognize two rays, that reflected from the surface, and that reflected-refracted from the interior. On the other side—if the body is translucent or semi-translucent—he may recognize the doubly refracted ray, but in the case of an opaque body this is absorbed.

But it is also easy to recognize that the sensation given by the original light must be more powerful

than that given by the subsequent rays after having been reflected or refracted or both. A proportion of the original light ray has been 'lost' or 'absorbed'. These explanations may make the manner in which we perceive colours easy to understand.

Bodies do not have colour in and of themselves. Following their nature they absorb a part of the coloured rays which compose white light. The colour which they seem to have is the residue, the rays which they reflect. To take the two extremes: a body which has absorbed *all* the rays of the spectrum would appear black, it would reflect no rays; a body which has absorbed no rays would be white, all rays in combination making white.

Other colours are perceived in the same way: a body absorbing all the rays of the spectrum except blue, reflecting only the blue ray, would of course appear blue.

The greys are produced in a similar way but with a difference. The object then absorbs a portion of the light that it receives, reflecting all the rest. The more it absorbs the darker the grey. Assuming that the hues are absorbed in a properly balanced measure our eye then perceives a difference in luminosity but not in colour. Thus a surface (which we would call white in full light) might, in shadow, be *receiving* exactly as much light as another body, a grey, in full light might be *reflecting*. The two would then appear to our eyes as the same tint and colour. Colours which look greyed because they are absorbing much more light than they are reflecting are called 'degraded'.

A surface apparently white may be also absorbing and reflecting colours in small quantities. Thus many

whites appear more or less yellowish or rather creamy in tint. Blueing, as used in washing, makes the clothes appear to be whiter by neutralizing the yellow, which it really transforms into a very faint, practically imperceptible grey. Also in painting yellowish whites are sometimes made to seem whiter by the addition of a trace of blue-black. This fact is well known to housepainters.

§2. *THE METHODICAL CLASSIFICATION OF COLOURS*

We are said to owe the basis of a methodical classification of colours to Chevreul, who employed a circle called 'The Chromatic Circle' divided into twelve segments. He accepted red, yellow and blue as the primary colours, which by admixture could give all the others. Thus:

> Red and yellow give orange
> Yellow and blue give green
> Red and blue give violet

New shades mixed with the first give a new series of shades.

The chromatic circle of Chevreul was constructed as follows.

Imagine the circle as a clock face. The primary colours were placed, Red at one o'clock, Yellow at five o'clock, Blue at nine o'clock. Exactly opposite red (one o'clock) is seven, just half-way between yellow at five and blue at nine. An equal mixture of yellow and blue makes green. The other complementaries are fixed in the same way. These divisions may again be

divided into two, so that all round the circle we get twelve divisions, starting with red (one), through red-orange (two), orange (three), orange-yellow (four), and so on back to red once more. Instead of sticking to minutes Chevreul divided his sections into six parts each, so that between one (red) and two (red-orange) he could define six different shades of red. The whole circle gave him thus seventy-two divisions, or seventy-two different colours.

From these he proceeded to modifications of the 'tones', weakening the full colours with white and black by twenty measured grades, thus he reached 1440 measurable tints. But both pure and weakened 'tones' may be further distinguished by the addition of black, or rather by stages of degrading, and also by stages of weakening these degraded tints so that he arrives at 14,400 measurable tones.

To go closer into the method is not necessary here as, although it opened up the field for investigation, Chevreul's methods were soon found to be imperfect from many angles.

In the first place the additions of white or of black to a colour do not have the opposite effects on which his theory depended, but have different effects, really different in kind, which lead to a criticism of his terminology. Black mixed with a pigment does diminish its luminosity, but white, while diminishing its purity and richness, *increases* its luminosity. Furthermore, he did not take into consideration the effect of background and all the other environmental factors which affect the appearance of colours, nor the variations of chroma, or intensity, which differ very greatly. Vermilion, for instance, is twice as strong as its comple-

mentary the blue-green viridian so that twice as large an area must be covered by the latter colour to balance a given area of vermilion.

Admitted that a perfect white would reflect 100 per cent of the light received, and the deepest practical black only 2 per cent, an exactly middle grey should reflect 51 per cent. But it has been found that excitation increases much faster than sensation; so practically speaking, such a grey actually reflects no more than 14 per cent.

In 1909 the Congress of Geneva, basing its system on a modification of Chevreul's, announced the number of tones possible to differentiate were 80,000.

The complications involved will be readily appreciated. Young, Lambert, Maxwell, Miles and more lately Ostwald and Munsell have modified and improved Chevreul's system. The terminology of colour has also been correspondingly modified. In the case of Munsell for instance, *hue*, *value* and *chroma* are the terms adopted. Munsell's system is represented in a sphere. This is imagined to be neutral at the *core*, the colours are pure round the *equator*, the one *pole* is white and the other black. This proves to be a very convenient conception giving excellent possibilities for classification and labelling.

Ostwald's method

Starting with white at one extreme and black at the other Ostwald has divided the non-chromatic 'values' —that is to say the neutral shades of grey—into a scale of *equal* intervals, beginning with the purest white, designated by the letter *a*, and arriving at the deepest black, designated by the letter *t*. The scale would thus

contain *twenty* shades which in practice may be sim-
plified to *ten*:

$$a, c, e, g, i, l, n, p, r, t.$$

The degrees are felt as equidistant and the ensemble
gives an impression of harmony and balance. But what
should be clearly understood about this sequence of
tones is that it can perform a double function. Starting
from *a*, it can indicate diminishing proportions of
white, starting from *t* and working backwards it can
give diminishing proportions of black.

The chromatic colours are then set on a chromatic
circle of eight colours, the circle having one hundred
divisions. If we divide into three divisions the spaces
between each of these eight colours we have twenty-
four degrees or gradations of colour.

As one hundred is not divisible by twenty-four, we
have for each gradation numbers going by fours. Thus
beginning with yellow we have the yellow 00 as the
first, a yellow 04 as the second and yellow 08 as the
third, from which the table:

	1st	2nd	3rd
Yellow	00	04	08
Orange	13	17	21
Red	25	29	33
Violet	38	42	46
Blue	50	54	58
Turquoise	63	67	71
Sea-green	75	79	83
Leaf-green	88	92	96

which permits a colour to be indicated only by a
number and two letters, the first letter indicating

white content and the second *black* content. Example:

$$42\ e\ p$$

means the second violet, one-third more blue than pure violet, weakened with the amount of white contained in the grey *e* and darkened with the amount of black contained in the grey *p*.

So that any colour may be expressed by the formula:

$$r + w + b = 1$$

in which *r* represents a pure colour, *w* the constituent of white and *b* the constituent of black.

When $w + b = 0$ the colour is pure to the point of saturation.

When $r = 0$, the colour is a grey.

When $r + w = 0$, the colour is black.

When $r + b = 0$, the colour is white.

Let me advise you to get some good treatise on the subject, such as Dr. Wilhelm Ostwald's *Colour Science* in two volumes, and study it carefully and at length. How much practical use you'll be able to make of your knowledge will depend on what medium you work with and your circumstances in general. I am not quite as 'normal' on this subject as might be desirable for I would like very much to have one of Ostwald's set of paints to work with. It consists of some 680 different colours and must certainly offer great possibilities and an enormous economy of time . . . but many difficulties in the way of acquiring one may be easily imagined.

Nevertheless for a painter to memorize a good colour chart in this way is a good thing. It takes little time and sometimes such knowledge may aid the instinct

of innate colour sense. Without a real colour-sense it is a good idea to give up handling colour entirely as a person with no ear for music might occupy his time to more profit than in trying to learn to play some musical instrument.

§3. *THE PROBLEMS OF CONTRAST*

How colours are perceived by absorption and reflection has been explained. The colour of the light rays which are *absorbed* is called the complementary of that of the rays which are *reflected*.

It follows that an equal mixture of complementary colours should give white.

Of course there are an innumerable number of complementary colours. For instance:

> Red is the complement of green
> Orange is the complement of blue
> Yellow is the complement of violet
> Red-violet is the complement of green-
> yellow, etc.

It follows that, say in the complementary colours orange and blue, the warmer the orange becomes the colder will be its complementary blue, until we imperceptibly pass to red and green—and, of course, the colder the yellow the warmer the violet and so on.

The perceptions of colour under various conditions give rise to certain curious effects, which are known as the phenomena of contrast.

Just as the nose can become accustomed to and at last fail to register a persistent smell, so the eye cannot be concentrated long on one colour before the retina

begins to lose sensitivity to it. There follows a temporary diminishment of power to register this particular colour. Some colours have a much more powerful stimulus than others and are naturally able to bring fatigue more quickly.

The results may be illustrated by a well-known experiment. Place a yellow square on a white ground and stare it out of countenance for some time. Then take off the square from the ground. The white ground still reflects all the colours of the spectrum but the part of the retina concentrated on the square has lost some of its response to the colour yellow. That part of the retina now responds to all the other colours more readily than to yellow. In consequence a fictitious loss of yellow has been established at that part, and the eye there perceives the complement, as it would have had there been an actual absorption of yellow. Fatigued by a colour the eye tends to impose the complementary tint. The square where the yellow was will appear to be violet, the rest of the ground retaining its original whiteness.

Or if a white disk is applied to a black surface and stared at for a sufficient length of time, and then if a white surface is suddenly looked at, a grey disk will be seen upon it. The eye having lost some of its faculty of perceiving white, that is to say, the combination of all the colours of the spectrum, has been desensitized to any—hence the sensation of darkness. Black and white, by drawing the bow a bit, may be conceived as complementary colours.

This phenomenon is called 'successive contrast'.

The eye tired of one colour tends to substitute its complementary colour. From this follows the fact that

if you look at one colour for long then turn to another colour, the latter will not be perceived at its exact value. The eye will have a tendency to superimpose the complementary colour of the tint first stared at, and the result will be a perception of the new colour slightly modified by the complementary of the first. This is called 'mixed contrast'.

From this follows the fact that if two complementary colours are juxtaposed, staring at one will make the other appear more intense in colour, while two similar colours will lose strength, each being unconsciously overlaid with a thin veil of a very similar complementary.

Imagine further two colours different in tone and colour juxtaposed. Call them X (to the left) and Y (to the right). Now set out on white grounds the same colours X_1 to the left of X, and Y_1 to the right of Y. The contrast of tones will be such that tonal differences are exaggerated, so that if X is lighter than Y, X_1 will appear darker than X, and Y_1 lighter than Y.

These contrasts of hue or tone are called 'simultaneous contrasts'.

Another phenomenon of contrast which is called rotative contrast' is furnished by a rotating disk. Say his is painted half red and half white. At comparatively low speeds (60 to 120 revolutions a minute) two colours will be perceived. The red as painted, but the white section appears as the complementary, green. This is supposed to give a simple way of finding the complementary of any colour. At high speeds (400 revolutions) the disk will appear pink. This is of no importance to painting, but plays a considerable role in the cinematograph.

These simple laws of contrast are usually read by students but are soon forgotten. They may be remembered years afterwards when experience has shown their possible usefulness. But they account for many of the difficulties encountered by students in producing accurate studies of tone and colour contrast and an intelligent appreciation of their implications might save some heartburnings. However the later rediscovery is usually hailed by the conscious mind as being in the nature of a personal and highly praiseworthy feat. Perhaps they ripen in the unconscious.

Their application to actual painting is simply that they may sometimes clarify a problem and allow the natural colour sense to work more quickly with this conscious help than it might otherwise do.

§4. *COLOUR AND 'TEMPERATURE'*

Tudor Hart—in his lectures, which I do not believe have ever been published—has interestingly brought out that for a painter to know the warm as distinguished from the cold colours may be not unimportant, but without some such fundamental definition as that provided by Hart the matter is not as simple as it at first appears. Hart's somewhat individual terminology will be passed on without comment. Fortunately, the need of a precise vocabulary does not make itself felt in such an elementary discussion as the present one. If it did, considerable research would be necessary to its establishment. The primary colours in their 'pure' form are first discussed. That is to say, that the red should contain as little yellow or blue as possible, the blue as little green or violet, and the yellow as little

red or blue. Our normal colour ideas actually use a light and a dark orange respectively instead of true 'yellow' and 'red' and a greenish blue for 'blue'. Hart's contention that pure red is not 'warm' but neutral is surprising but most interesting when considered closely. His classification of the pure colours is:

	Colour	Value	Hue	Quality	Temperature
P R I M A R I E S	Yellow	Pale	Sulphur Yellow	Light	Warm
	Blue	Dark	Between Cobalt and ultramarine	Shadow	Cool
	Red	Deep Rich	Pigeon's blood ruby	Intensifying	Neutral by absence of temperature.
B I N A R I E S	Violet	Darkly deep	Bluest Wild wood violets	Intense Shadow	Cold
	Orange	Bright, pale and deep	Orange Vermilion	Sunlight rich light	Hot
	Green	Middle	Billiard table	Indifferent	Neutral by presence of warm and cold.

Hart's colour circle differs from Chevreul's. His manner of dividing it into a warm and cold side and of indicating the point of greatest warmth and greatest cold is of very practical interest to the painter. A division of the palette into warm and cold sections is a proceeding quite generally recommended, a proper consideration of the balance, or relative proportion, of

warm tones and cool tones in a picture helping much towards a fine sense of colour harmony.

HART'S COLOUR CIRCLE

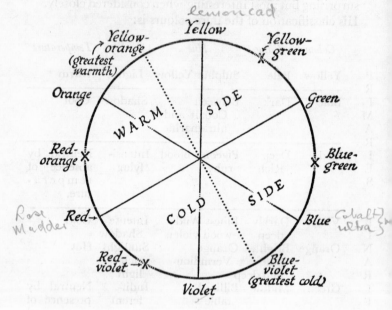

In pigments, Hart's colours may be most nearly approached by: red (medium rose madder), yellow (light lemon-cadmium in some brands of colours, although this colour in most brands contains too much red to correspond to his 'pure yellow'), blue (between a cobalt and an ultramarine, to be arrived at by a mixture of the two pigments). Such a palette would, of course, not be practical for actual painting of any but a most limited sort.

COLOUR AND 'TEMPERATURE'

Colour and Pigment

In practice, pure colour theory cannot be followed to any great extent in mixing colours, for the reason that no pigments made are pure in tint, but they all contain a variable quantity of colour impurities which degrade them, or introduce more or less quantities of grey. If we represent any such impurity by x, blue as it comes from the tube is blue \times x, medium madder would be red \times x and a mixture would give:

$$\text{Blue} + x + \text{red} + x = \text{violet} \times 2 \ x$$

Measuring thus the relative amounts of colour and grey in a pigment a colour like yellow ochre should be considered as a degraded orange, or an orange containing much black and white; ultramarine (artificial) as a blue containing red; cobalt, as a blue containing yellow; all the so-called vermilions and cadmium reds as deep oranges and so on.

The handling and labelling of pigments and the manner in which they are discussed in daily conversation has given rise to misconceptions which, as they are deceiving, should be cleared up in the mind of every painter. This is what I mean. There is in my paint-box a tube labelled 'Prismatic Red' which is not red at all, but falls little short of being a typical orange.

Colour Theory and Harmony

The value of colour theory in actual painting may be summed up by saying that generally speaking there are two main methods of obtaining colour harmony in a picture.

1. By unity of colour, that is to say, that the entire

picture is in harmony because the colours employed are all to be found on the same side of the circle. For example: a landscape which is throughout kept in the segment of cold greens—or

2. By contrast, or a carefully balanced use of complementary harmonies, or of cold and warm tones.

Such considerations account for the fact that all theorists advise keeping the warm and the cold colours in two separate series on the palette. It is then far easier to be conscious of what you are doing.

In the art of painting we must recognize that there are two different orders of rules. There are the rules which we have been discussing in the first half of the book. These rules are principally concerned with the chemical laws and processes which concern the endurance of pictures. They are founded on actual practice and technical considerations and may not be broken without considerable risk to the picture concerned.

But with regard to the other rules, the rules of æsthetics have no such authority. They are valuable as serving for a point of departure and a consideration of them will sometimes help to show what is wrong, why one feels that a picture is out of harmony, or why, perhaps, the colour of a certain area should be modified. But considered as *rules*, like all rules of the art of painting they are only made to be broken by the man who feels himself sure enough to do so.

The eye is always the final judge in any æsthetic problem having to do with colours. There are no established laws of æsthetic feeling, and while human beings remain biologically different one from the other, there never can be. Psycho-prismatism is bunk. Different people react to colour in different ways. The

sexes react differently, and people of different ages react differently. Children are supposed to like stronger colours than old people, the reason given being either that the optical equipment of the aged being somewhat worn, over-stimulating colours irritate or tire it, hence a preference for neutral colours, neutral greys, lavender, black and green, or that it has become more subtle and is able to enjoy differences imperceptible to youth. In conjunction with Dr. Veevers, head of the London Zoo, I had the pleasure of performing some experiments in connection with the colour sensibility of the anthropoid apes. The results, though interesting, were somewhat confusing.

Most masterpieces of painting seem to have a dominant colour—a fact which fits poorly with the theory that the colour balance of a picture should be composed of well-adjusted complementary colours which, mixed together should always give grey. The effects of harmony in painting, as in music, seem to be heightened by the occasional introduction of discords. The problem must remain one that can only be solved by feeling, æsthetic rather than optical. It cannot be reduced to rules.

§5. *COLOUR: SUMMARY*

The foregoing brief discussion of colour problems is merely a series of hints which can give the student no more than an outline of this fascinating, but somewhat involved and controversial subject. As far as possible it has been confined to those phases which find the most direct application in the actual use of pigments. A more thorough treatment would require far more

space as well as greater scientific knowledge than the writer has at his disposal, for unless it were quite complete it would be of quite doubtful value.

The Spectrum Theory of Colour values, which occupies such an important place in many art schools, I have been at some pains to avoid. In my opinion its study in connection with painting has done far more harm than good for as J. Scott Taylor, scientific director of Winsor & Newton, justly says: 'It is a good servant but a bad master ... a magnificent instrument in the hands of the scientist, but a dangerous and misleading guide for the Art Schools. . . .'

This is true in the first place because the spectrum arrangement, contrary to current opinion is a highly artificial one. No colours approaching the spectral hues in brilliancy are furnished by even the most brilliant and fugitive pigments. Furthermore, theory and practice are too far apart, colour as light (or reflection) acting in a very different way from colour as pigment. Vermilion and ultramarine, for instance, which, when blended for experimental purposes by means of the apparatus known as the colour wheel, give a brilliant purple, provide no more than a dull slate-coloured grey when mixed as actual paints.

The whole subject, as far as anyone *using a set of paints* is concerned, must remain relatively dogmatic, even the well-known 'complementary harmonies' being roughly, rather than precisely, established. So much depends on circumstances. The colour of the walls of the room in which the picture is hung, the time of day, the weather; is the sky clear and deeply blue, or full of white or grey clouds? what colour is reflected by the building across the way? how far is the beholder

standing from the painting? what size is the picture? and so on, all play their parts.

By way of apology for bringing this to so apparently vague a conclusion, allow me to quote a specialist, Dr. Houston, who says in his book *Light and Colour* (Longmans, 1923): 'Readers of popular expositions have about as much hope of getting near the gist of the matter as the proverbial blind man in a dark cellar, looking for a needle that is not there.'

APPENDIX II

NOTES ON NEW MATERIALS, ETC.

A number of artists' materials have come on to the market in recent years which will not be found in earlier editions of this Pocket Book.

Paint manufacturers frequently produce new versions of existing materials, of course, with perhaps new brand names. It is impossible and unnecessary to attempt to list here every variety of new brush, paper, ink, easel and so on. Many of these are what we already know, but under such new names, or are at most variants of what we are used to.

Some materials, such as brushes, palettes and easels, soon proclaim themselves to be well made or otherwise by their performance and artists can by inspection or rapid experience judge between the merits of the various proprietary brands of such things. With pigments, that is to say with the prepared paints ground in media that we now almost universally employ, judgement is more difficult. We cannot all be our own analytical chemists to determine the purity or genuineness of a tube of paint.

However the leading colourmen (paint manufacturers) have become increasingly anxious to declare the content of their wares, and they publish catalogues and lists which state the sources and ingredients of their colours. Thus we know, when we are buying

tubes of colours of familiar nomenclature, that they are composed of iron oxide, ochre, sulphides, stated artificial compounds and so on; and that we are not being fobbed off with simulated tints.

So it remains best to buy, where possible, from the colourmen (paint manufacturers) who are prepared to tell us what they are selling and whose claims to relative permanence of pigments are based on thorough and expert research. With the recent colours we are indeed dependent on such systematic chemical and physical testing: there is nothing else to take the place of time.

This is equally true where existing pigments are bound in new media; if we are to use these now we cannot wait for time either, but must rely again on research and testing.

Emulsions

The principal innovation in artists' materials in the last few years lies in the development of manufactured emulsions.

Commercial resinous emulsions have of course been developed on an industrial scale to take the place of more traditional building and decorating paints. They are of many proprietary brands, and the pigments (usually carried in a base of white) may contain more or less cheap extenders according to their quality. Basically the emulsions take the place of linseed oil, and industrially their principal advantage is that of quick drying, even texture and adaptability of finish. They have naturally varying degrees of staying power according to their quality: the evidence of time so far supports the claims of durability for the best of these

paints. At any rate their ease of handling and cheapness has brought them into such general use that it is now often difficult to obtain a tin (can) of traditional builder's white lead undercoat.

As artists' materials these emulsions have not yet to the same degree superseded the traditional artists' oil paint, but they have become extremely popular and have proved themselves more readily adaptable than oil to certain kinds of painting.

P.V.A. and Acrylic Emulsions

Artists' colourmen (paint manufacturers) are increasingly widening their production of tubed and tinned pigments bound in these forms of emulsions.

P.V.A. (polyvinyl acetate) paints are now produced as artists' materials and like other emulsion paints are cheaper than oil, since a larger proportion of the 'body' for a given amount of paint lies in the emulsive medium than in the pigment. P.V.A. will tolerate the incorporation of both organic and inorganic pigments and in this respect is no less practicable than oil. The body of paint may be extended, somewhat like oil paint with a marble medium, by emulsion 'bases' made of low covering white pigments mixed with media in proportions which not only build the paint but vary its finish, producing a more matt surface than the pure emulsion.

Acrylic emulsions possess similar handling properties to P.V.A. and also tolerate a variety of pigments. A reputable colourman's pamphlet suggests that acrylic emulsions have a more permanent resistance to change and are less likely to become brittle than P.V.A., although heavy impastos of P.V.A. may be

initially more elastic. Acrylic paints are also claimed to have a high degree of colour permanence, presumably no less than that of oil-paint, perhaps better.

These artists' emulsions are produced under various brand names and painters will naturally acquire their own preferences. But they share approximately similar advantages over oil-paint, and have much the same limitations in relation to it.

First of all they are very quick drying: indeed it is possible to superimpose paint over thin coats without disturbance within a few minutes. This has obvious advantages to many painters, particularly since it is possible with practice to build up a succession of thin coats without that 'deadening' of the surface which can be so discouraging in the handling of oil-paints.

Then, the texture also becomes rapidly established: there is little tendency for some passages to change from gloss to matt as they dry. The colours in good acrylic paints do not alter their tone or tint appreciably in drying out, in the way one expects for instance with gouache.

They are capable of a fair degree of impasto, though there is a limit of thickness in relation to durability which may show itself fairly quickly. Also the quality of surface in impasto is inferior to that of oil-paint: where properly mixed heavy oil impasto is rich and expressive, the emulsions tend by comparison to become leathery and characterless.

But they have the great advantage over oil of being mixable with water, or with water and emulsion medium according to the texture needed. This means that they can be used almost like water-colour at one end of the scale, and with a complete opacity and

moderate impasto at the other. This makes the emulsions very suited to thin underpainting which may be rapidly superimposed on: a process which with oils might cause the technical delay of a day of two between stages can be carried out at a speed which can hardly lag behind the mental agility of the quickest painter.

The emulsions, in spite of accepting water as a thinner, are highly waterproof when dry, and properly used are suitable for outdoor walls and surfaces.

As to supports, anything that can be used for oil-paint is suitable for emulsion. Card (cardboard), paper, canvas, wood panels, hardboard can all be used. It is possible to apply acrylic paint directly to any of these surfaces, but if the need for a white priming as a basic surface is called for, then an emulsion primer, manufactured by the colourman (paint manufacturer) for the purpose, must be used. It is inadvisable to use an ordinary white builder's emulsion priming unless its quality and constituents are known to be suitable.

Emulsion paints must not, of course, be used on oil-primed grounds, which will resist adhesion, although the reverse is considered good practice; that is, an emulsion ground will serve as a base for oil-paint. It is also possible to begin a painting (or an emulsion priming) with an emulsion underpainting, and to complete the body of the work in oil-paint. This is claimed to be a permanent method and, naturally, greatly increases the possibility of working quickly.

Emulsion paints seem particularly suitable for work in which large areas of flat matt paint are involved. Abstract and decorative painters are com-

monly concerned to create even surfaces of immaculate and consistent finish: acrylic pigments make this task, so difficult with oil-paint, technically far easier. Where painters wish to work directly on to raw canvas, a procedure technically unsound in oils, acrylic paint performs the job apparently without damage either to pigment or support.

The fast drying properties of emulsions carry with them some caveats. A mark once made on the support becomes rapidly beyond removal; the medium does not lend itself to preliminary 'rubbing and scrubbing'. Also, while it is cheaper, it is easier to waste. Squeezes of acrylic on a palette harden fairly quickly, and the painter must adapt himself to constant replenishment from the tubes, whose caps must be kept screwed tight on when not in use. In fact it is as well to check when buying emulsion paint that the tube is soft to the feel, as an imperfectly secured cap may easily give it a short 'shelf life'.

Brushes must be washed out constantly during use in clean water, as they will quickly harden if left.

The qualities of the emulsions, even of acrylic, are also their limitations. Fast drying is precisely what some painters do not want. Direct painting, 'wet in wet', is best left to oils, and while emulsions preserve brightness and tint, they lack the luminous richness and textural variety of oil-paint. But appropriately used they are certainly time and money savers, and they are claimed to possess at least the strength and permanence of oil-paint.

Thixotropic Media

Manufacturers have introduced 'thixotropic' oil and

resin media and primers over the past few years. As a medium thixotropic oil is a semi-dried jelly sold in tubes. When squeezed out and subjected to the mixing pressure of brush or knife it liquifies and combines readily with ordinary tubed pigment. Its advantage is to dry very rapidly (a proportion of thixotropic medium can be adjusted to ensure that an opaque surface dries in a day) and to build up the body of the pigment. Experience suggests that it is an excellent substitute for raw oil, and it does its job of rapid drying while keeping up the 'key' of the colour. But when used to excess as a 'body-builder' to an impasto it tends to make for a leathery top surface.

Thixotropic media are now used to produce fast drying oil primers, and these, normally using titanium as a covering pigment, seem to provide an excellent working surface very rapidly. A surface primed thus seems perfectly strong and resistant twenty-four hours after application.

Oil Pastels

Pastels bound in oil have recently been produced by a wider range of colourmen. Introduced some years since from Japan, they are a more malleable and less tricky form of the traditional medium. They have the advantage that they will bear more mixing together on the working surface without 'going dead' and they do not need fixing. Their brilliance may not equal true pastel, but they combine the feel of pastel with that of oil-paint, and seem a valuable addition to the range of materials. They are produced under such names as Craypas, Panda (Talens), Filia, and Sakura.

NOTES ON NEW MATERIALS, ETC.

These pastels do not seem to need an oil priming and their limited oil content is apparently held adequately enough by the pigment to prevent its staining ordinary good quality paper.

Nylon Brushes

Brushes with hairs made of nylon have appeared on the market: the present reviser has never found one that he could recommend.

Paper

With paper we must record a sad reversal of additions: first quality rag paper has been disappearing from the market. Whatman is no longer made, and other papers mentioned in the section on painting have gone from the colourman's lists or are difficult to get. But mention of them is left, as private stocks of such papers are still sometimes advertised. Green Boards and RWS papers remain, also Turner, Bockingford, Kent, and Saunders. Expensive paper may seem inhibiting to use, but it is a pity to do good work on poor paper. Oil paintings may be relined, but there is no rescuing a water-colour when its support rots.

GLOSSARY

AGGLUTINANT. Uniting as glue; causing or tending to cause adhesion. Any viscous substance which causes objects to adhere.

BEESWAX. The wax secreted by bees and of which the honeycomb is constructed.

BINDERS. Anything which causes cohesion in loosely assembled substances. The agglutinant used to cause pigments to cohere.

BLENDER. A round, rather soft brush, blunt or flat on the end, which is used for blending the colours or smoothing the surface of the paint by effacing the marks left by the hairs or bristles of other brushes. Blenders are usually made of the hair of the badger and are commonly called 'Badger-hair Blenders'. The end should not be completely flat but slightly convex.

BRISTLE BRUSH. A brush made from bristles, or the short stiff hair of swine, as distinguished from the brushes made from soft hairs or fur of the badger, calf, sable, camel, etc.

BRONZE SPATULA. See Spatula.

'BUON' FRESCO'. True fresco. That is to say, paintings or mural decorations executed by the classic process in which the pigment is applied without a binder and simply mixed with water so that it penetrates the wet plaster and is held by the chemical action of the lime present in this substance, which is converted by the action of the air into a carbonate and acts as a binder.

GLOSSARY

CASEIN. In the sense here used, an agglutinant or glue made from cheese or precipitated from milk by the action of rennet and other methods.

CATALYSIS. Acceleration of a reaction produced by the presence of a substance, called the catalytic agent or catalyser, which itself appears to remain unchanged; contact action.

'CAUTERIUM.' An instrument or apparatus used for the application of heat to paintings executed in a wax vehicle. It is said to have usually consisted of a little metal basket or sort of brazier equipped with a handle. It was filled with red-hot coals of charcoal and passed over the surface of the painting a slight distance from it, in order to melt and drive the wax into the support; or, to speak more exactly, to render the wax liquid and allow of its absorption by the surface to which it was applied.

'CHASSIS.' The French term for 'Stretcher'. The wooden frame upon which the canvas is stretched tautly for painting. Stretchers should be equipped with 'keys' or little wooden wedges in the four corners, which permit of tightening the canvas when necessary by driving them in with a hammer and thus spreading the frame.

'COLLE DE PEAU.' A glue made from the skins of animals. It is current in France, where it is known as 'totin', 'colle de peau', and 'colle de Flandres'. In practice in England or America any good joiner's glue may be substituted for it; or any of the liquid glues which are sold in bottles under trade names. The glue made from parchment scraps as described herein may also be advantageously substituted for *colle de peau*.

COLOUR PERSPECTIVE. The effect obtained by using

colder colours for the more distant objects represented in the painting.

COPAL. A resin used for the manufacture of varnishes.

CUMOL or CUMENE. A colourless oily hydrocarbon $C_3H_7 C_6H_4 CO_2H$. Cumol, or cumene, is propyl iso-benzene.

ELEMI. A fragrant oleoresin obtained from various tropical trees, used in making varnishes.

EMULSIONS. Liquid preparations in which the minute particles remain in suspension as the fat globules do in milk. They are intimate combinations of the elements combined in a physical as opposed to a chemical combination. As a rule the union of an oily and non-oily liquid is obtained through the presence of an alkali or mucilaginous substance.

ENCAUSTIC. The name encaustic (from the Greek for 'burnt in') is applied to paintings executed with vehicles in which wax is the chief ingredient.

FIXATIVE. A liquid which, sprayed or otherwise applied to a drawing, pastel, or painting in a water medium, acts as a binding agent, fixing or making the work permanent by its property of causing the colour to adhere firmly to the surface to which it has been applied.

FRESCO. The art or method of painting on freshly spread plaster before it dries—called specifically *true fresco* or *buon' fresco*. In modern parlance, less correctly, painting on plaster in any manner.

'FRESCO SECCO'. The method in which the plaster is first allowed to harden and dry. Lime water or baryta water is used to mix the pigments.

GESSO. Plaster of Paris or gypsum especially as prepared for use in painting, by the extension of a plaster-like or pasty material upon a surface to prepare it for

painting or gilding. *Gesso duro*, 'hard gesso', a variation of the original formula of plaster and glue or chalk and glue which makes a harder gesso. *Gesso sottile*, 'fine gesso', prepared with slaked plaster. *Gesso grosso*, 'coarse gesso', less carefully prepared and used for the under or first coats. Prepared with unslaked plaster.

GLUTEN, TAUBENHEIM'S, ELEMI, etc. Preparations consisting of a wax and a resin dissolved in an essence of turpentine, spike, petrol, etc.

GOUACHE. A method of painting with opaque colours which have been ground in water and mingled or tempered with a preparation of gum. More loosely, a watercolour in which white is employed as a paint or pigment by contrast with the method of attaining the whites necessary by allowing the paper to show through, or by transparency.

GROUND. The surface upon which a picture is painted as a preliminary tone or gradation of colour laid on a canvas or other support. A surface prepared for painting or decoration by its being covered with a coating of a material suitable to receive and hold the paints.

GUM-RESINS. The coagulated juices and saps of various plants and trees consisting of a mixture of a gum with a resin. Gum-resins are, in accordance with their composition, partially soluble in alcohol and partially in spirits of wine. Sarcocolla is an example of a typical gum-resin.

HYDRATE. A compound formed by the union of water with some other substance and represented as actually containing water.

IKON. An image or painting representing the Virgin Mary or a saint or holy character.

GLOSSARY

'IMPASTO.' Broadly speaking, the surface of a painting; the layer of paint as laid on the canvas or panel, hence the handling or manner of painting peculiar to an artist. In a narrower sense, any particularly thick or heavy application of paint.

KEY. The little wooden wedge inserted in the inside corner of the wooden frame or stretcher on which the canvas is stretched.

LINER. A brush made of long hairs used for drawing lines.

LITMUS PAPER. Unsized paper saturated with litmus, used in testing for acids or alkalis.

'MAROUFLAGE.' A French term for the method of glueing a canvas uniformly and smoothly to a wall or panel.

MASTIC. A variety of resin used in making varnish, hence MASTIC VARNISH.

'MATIÈRE.' The surface of a painting consisting of the applied paint with particular reference to its inherent beauty or quality.

MEDIUM. A liquid, as oil or water, with which the pigment, or pigment prepared as paint, is mixed in preparing it for application. In a larger sense the sort of paint or graphic method used.

MEGILP. A preparation used usually in watercolour and gouache painting for mixing with the colours to retard their drying or facilitate their application.

MULSIFIED. See Emulsions.

MURALS. Paintings executed on or applied directly to walls.

NITRO-CELLULOSE. Consisting of celluloid dissolved in acetone or amyl acetate.

GLOSSARY

OPAQUE. Non-transparent. Impervious to the rays of light.

OXIDE or OXYDE. A binary compound of oxygen with an element or radical; as iron oxide.

OXIDIZE. To combine with oxygen or with more oxygen; to add oxygen.

PALETTE. A broad and flat object of wood, metal, glass, china, porcelain or similar material used by the painter for laying out and mixing his colours. The set or assortment of colours chosen or preferred by a particular artist or used in a particular method of painting.

PASSE-PARTOUT. A method of framing or putting drawings or water-colours under glass in which a band of cloth or gummed paper takes the place of the usual frame.

PETROL. Petroleum spirit such as is used for producing motive power in motor-cars. Gasolene.

PIGMENT. A colouring matter. Any powder or easily powdered substance used as a colouring matter in paint.

PSYCHO-PRISMATISM. The affective psychology of colour. The study of the reactions of human beings or animals to the various colours.

RESTORATION. An attempt by various means and processes to restore to an old or damaged painting its original freshness of colour and appearance.

RIGGER. A long-haired brush with a flat end for making lines or bands of various thicknesses.

SABLE BRUSH. A brush made with the fur or hair of the sable.

'SGRAFFITO.' A method of mural decoration by which a dark surface which has been covered with a

coat of lighter colour is allowed to reappear in the form of lines by scratching away the light-coloured coating.

SICCATIVE or DRYER. A preparation used to hasten or promote the drying of paints.

SILICATE. A salt or ester of any of the silicic acids.

SPATULA. An implement shaped like a knife, flat, thin and somewhat flexible, used for spreading paints, fine plasters, etc.

STEREOCHROMY. A process of wall painting in which water-glass is used as a vehicle and protective coating.

SULPHATE. A salt or ester of sulphuric acid.

SULPHIDE. A binary compound of sulphur, or one so regarded.

SUPPORT. The untreated object destined after preparation by the application of the ground, priming, etc., to receive the paint. It may be cloth, canvas, a panel of wood, composition board, or cardboard, paper, a wall, etc.

TACTILE VALUES. The contrasts or difference in the surface of the paint engendered by the manner in which it reflects the rays of light. For example, smoothly applied paint will reflect the rays of light in nearly parallel rays, giving a hard and brilliant impression. roughly applied paint will diffuse them in all directions, giving a soft and mat impression. As the qualities enter immediately into association with ideas connected with the sense of touch (roughness, velvety smoothness, etc.) the values thus arrived at are called tactile values.

TANNIN. Tannic acid.

TAPESTRY. A fabric usually of worsted worked on a warp of linen by hand, the designs being usually pictorial. A fabric of the same nature dyed or painted by

GLOSSARY

a method which colours without obscuring the weave or filling the interstices between the threads, in which case it is usually qualified as a painted tapestry.

TEMPERA. A method of painting in which the pigments are mixed or tempered with an emulsion, or the yolk or white of eggs, as distinguished from those methods by which the colours are mixed with yolk of egg and varying proportions of water.

TOOTH. Roughness of surface fitting it for the application of paint which will be held in place by the minute variations and irregularities afforded by such a surface.

'T' SQUARE. A sort of ruler with a piece attached at right angles to one end.

WASH. A transparent application of colour applied thinly, particularly in speaking of water-colour or india-ink technique.

WRITER. A long thin brush such as is used by sign painters and show-card letterers for writing in the round.

INDEX

INDEX

264

INDEX

INDEX